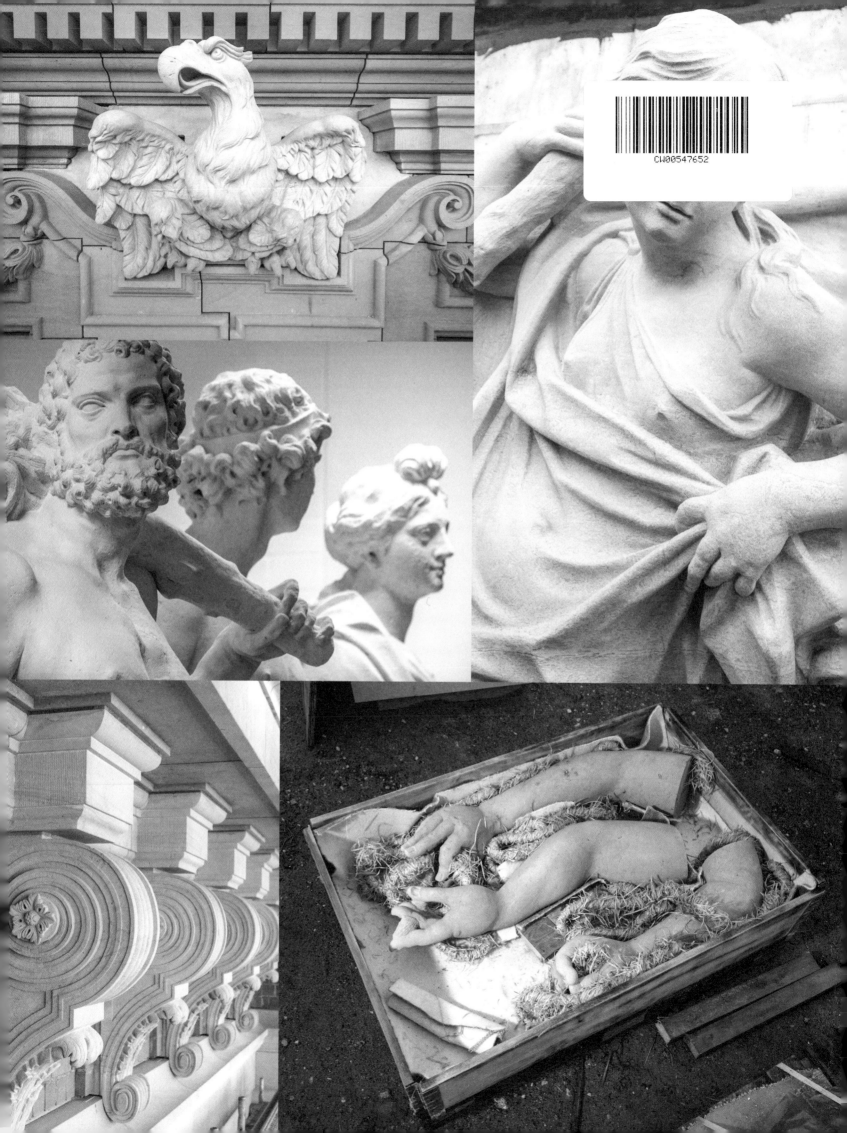

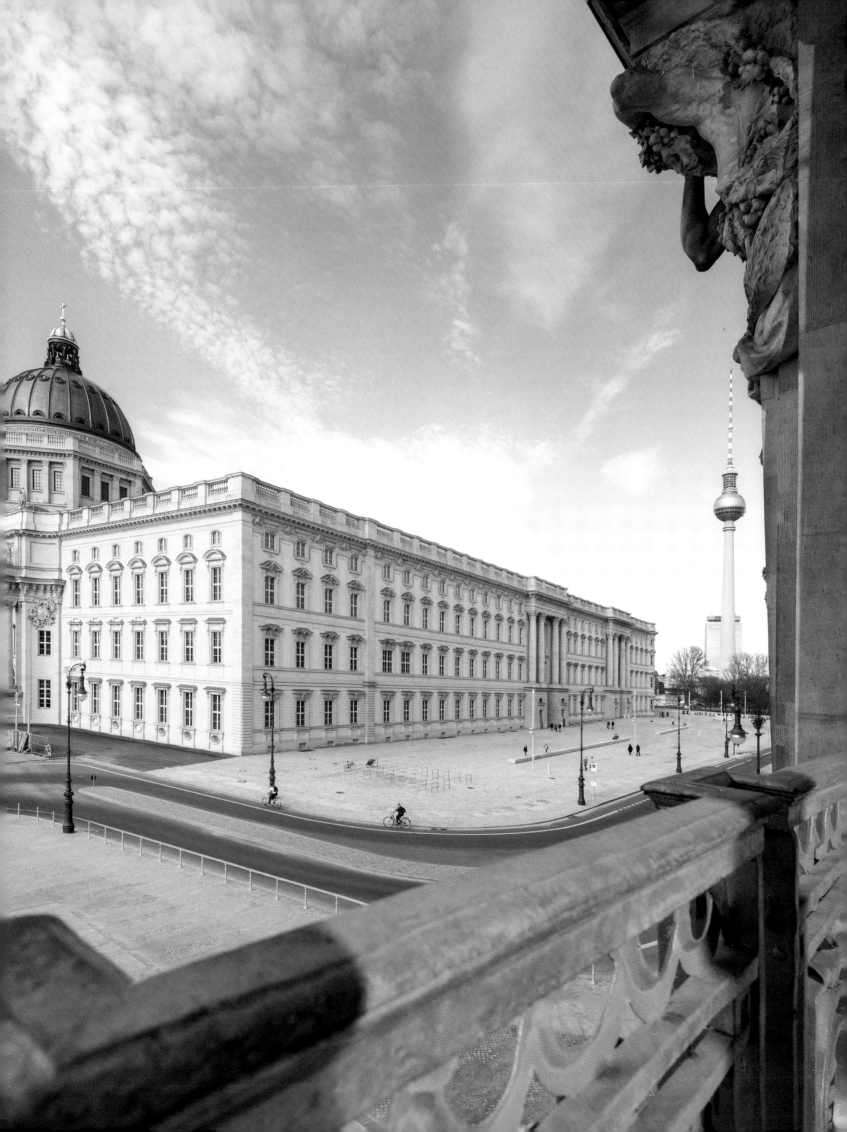

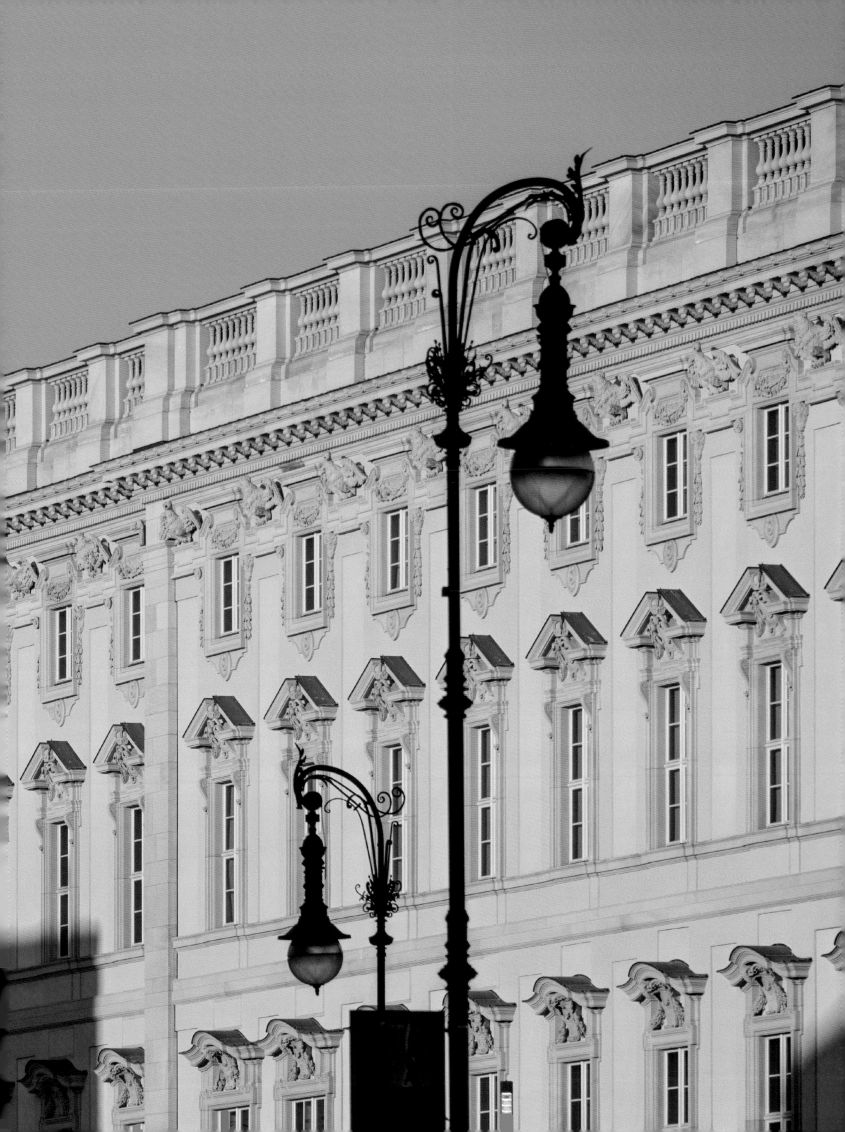

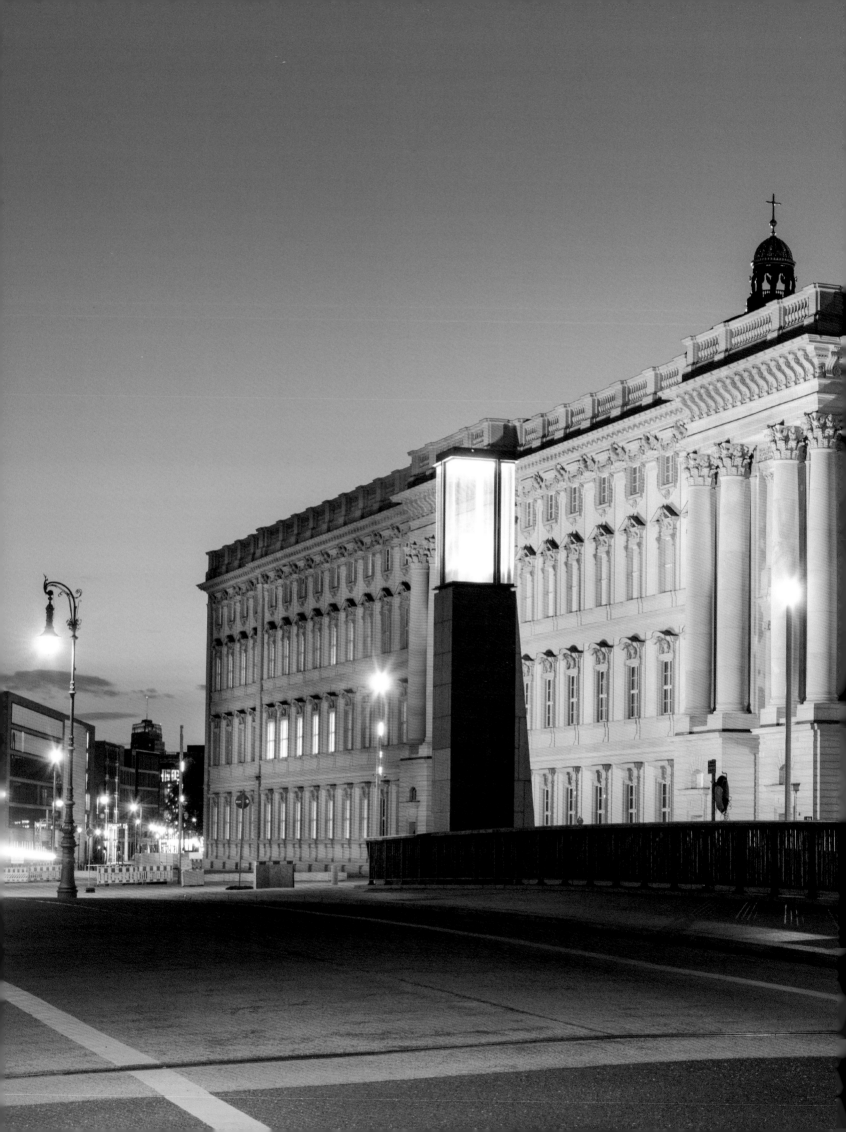

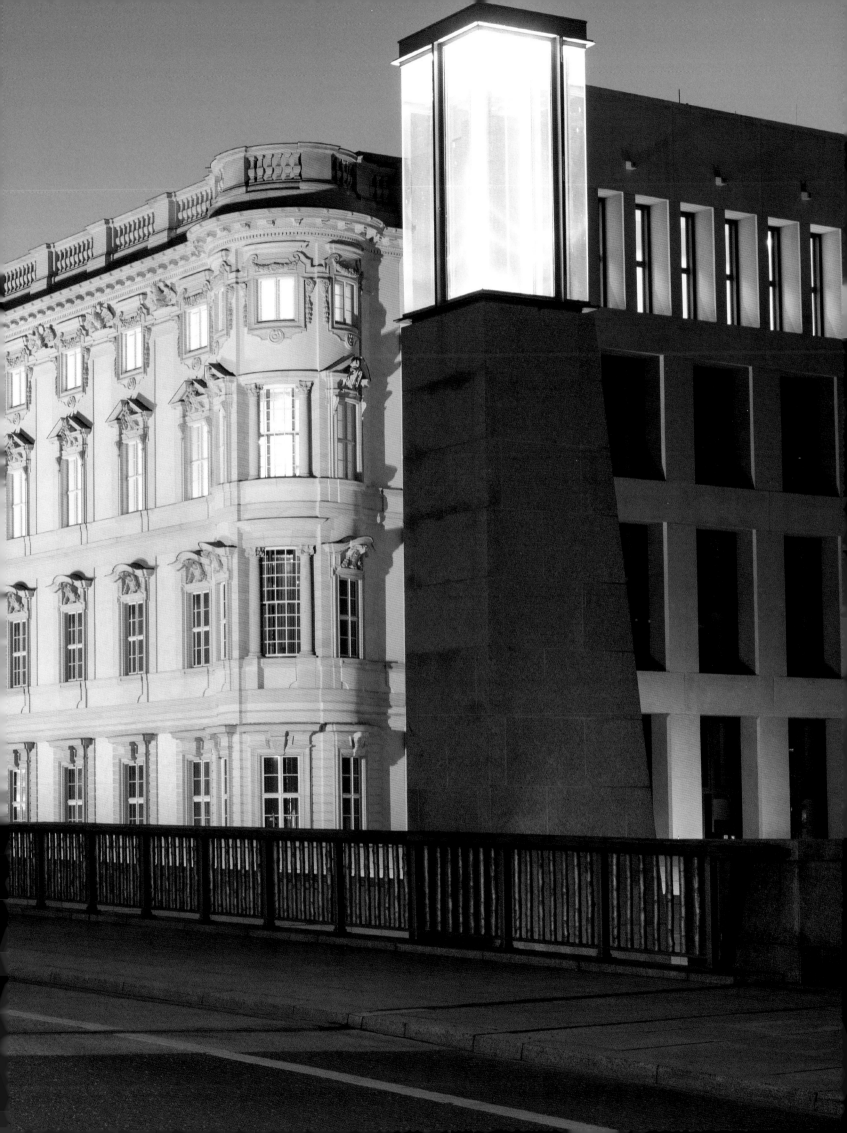

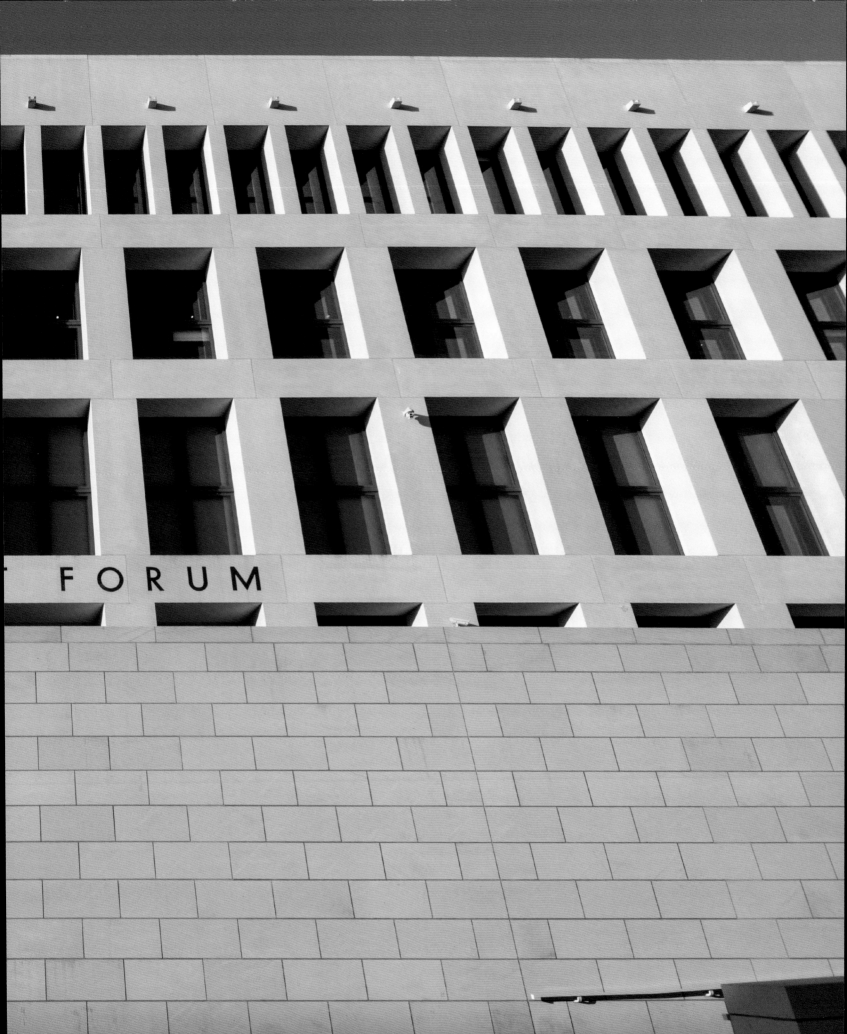

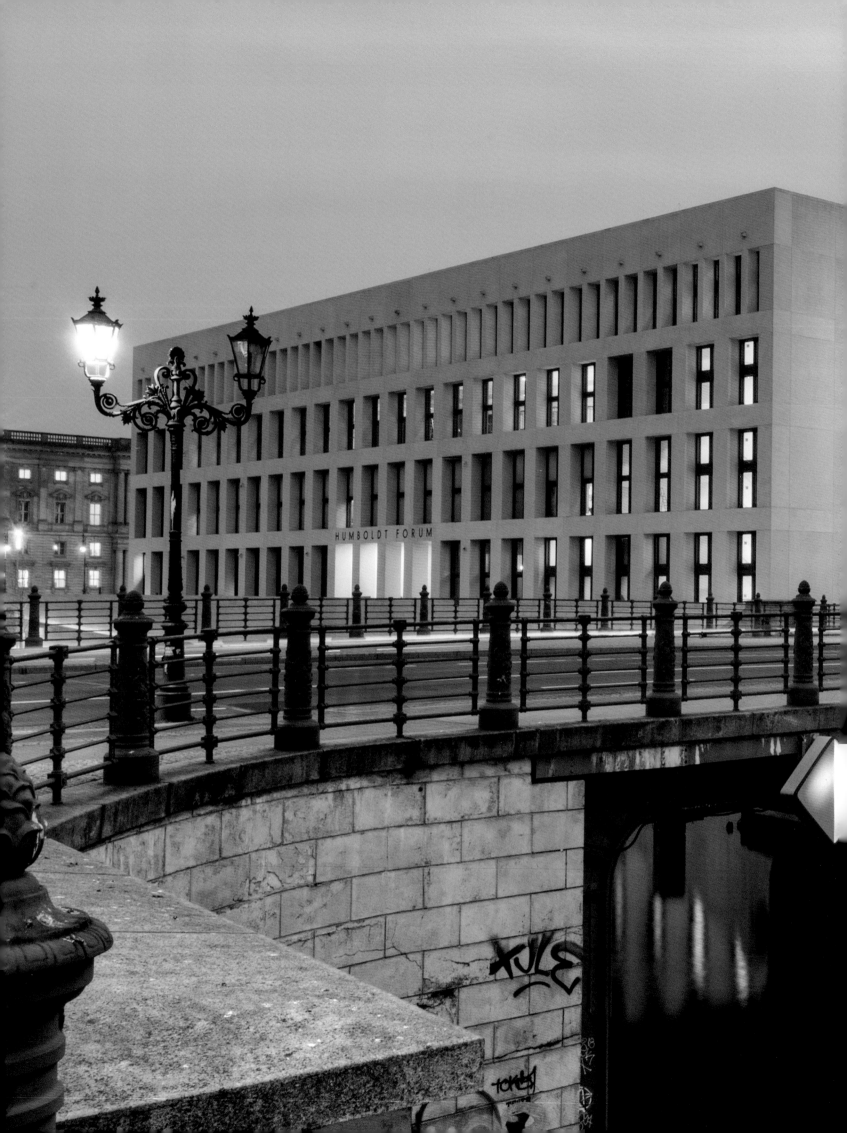

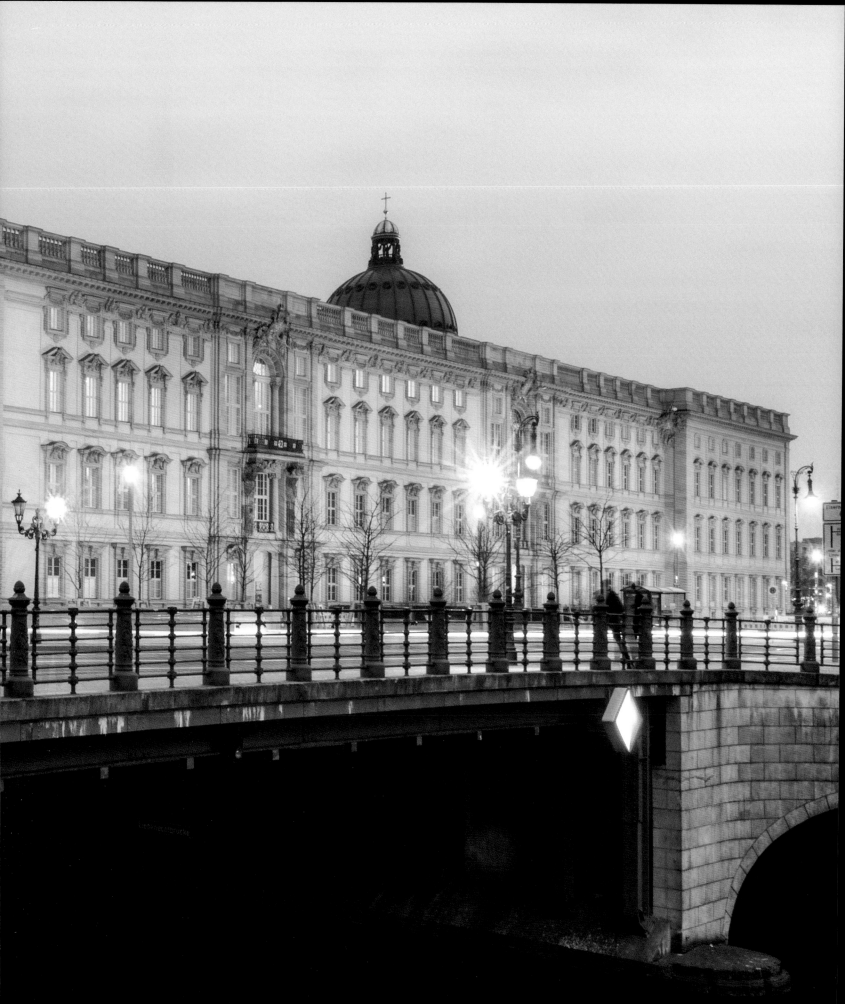

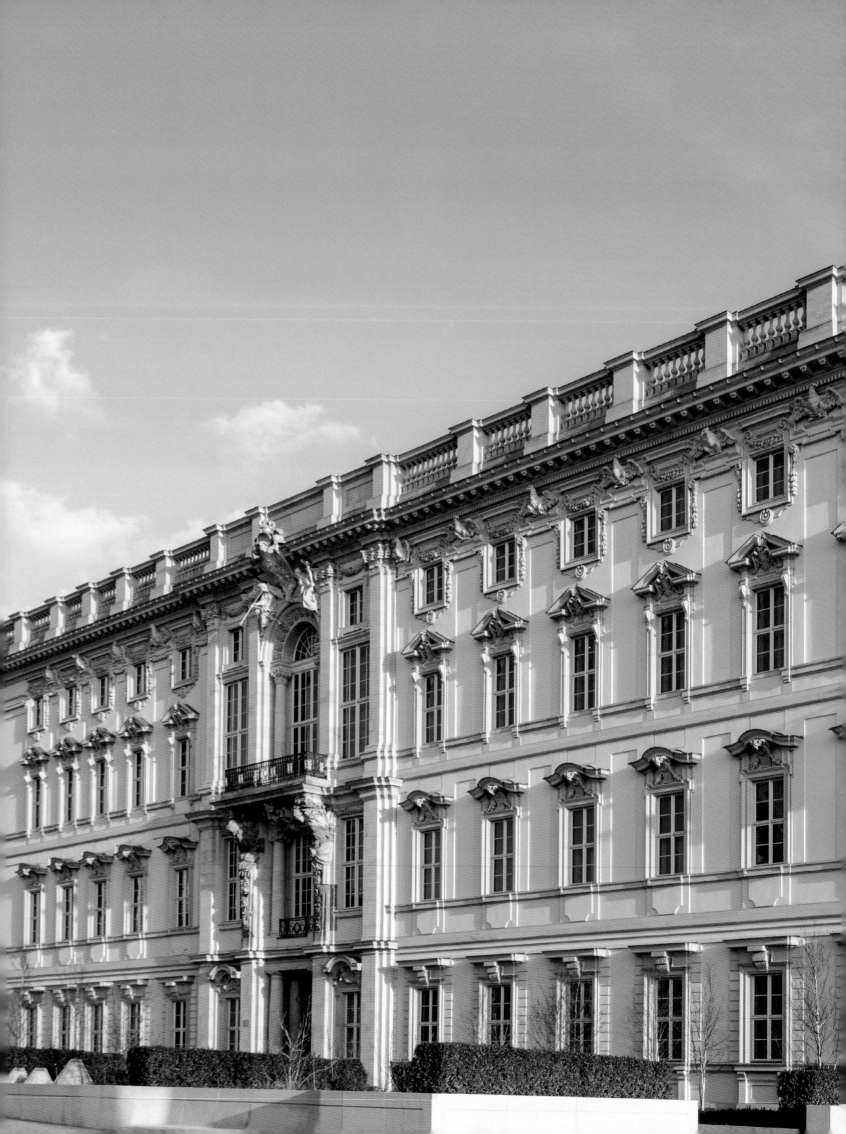

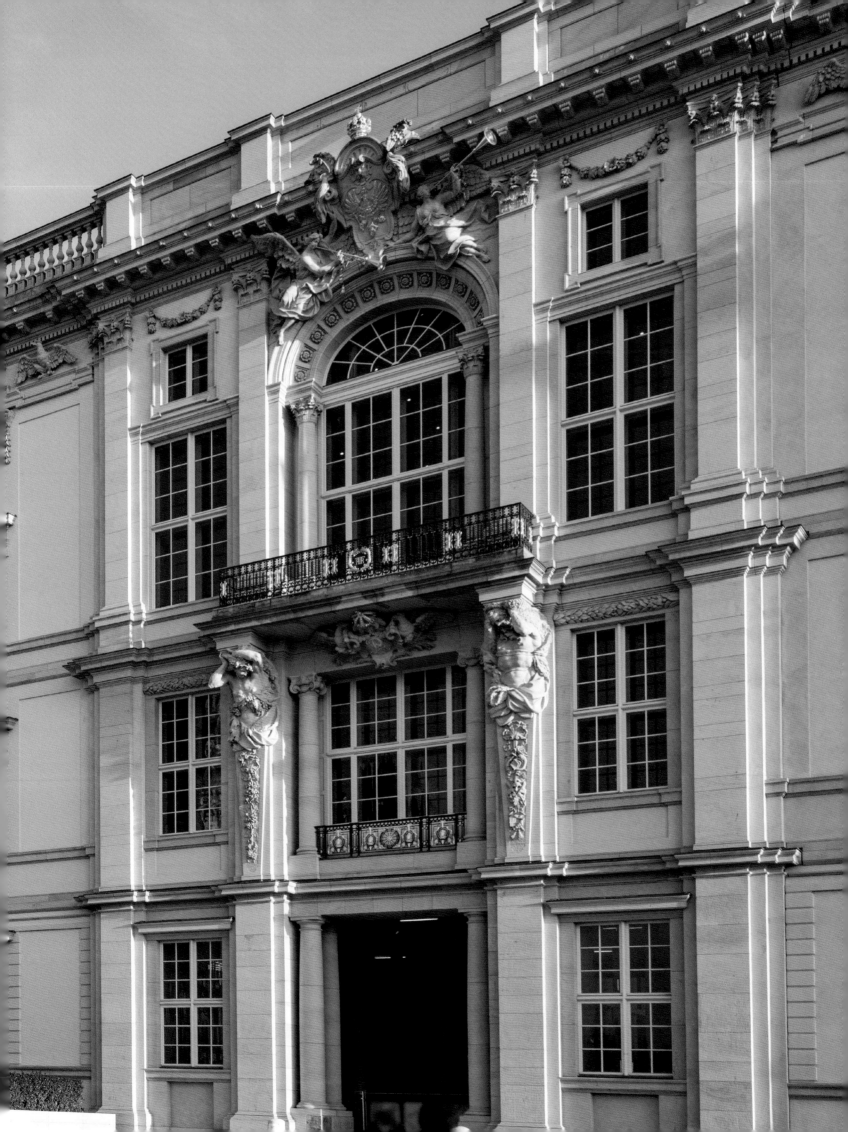

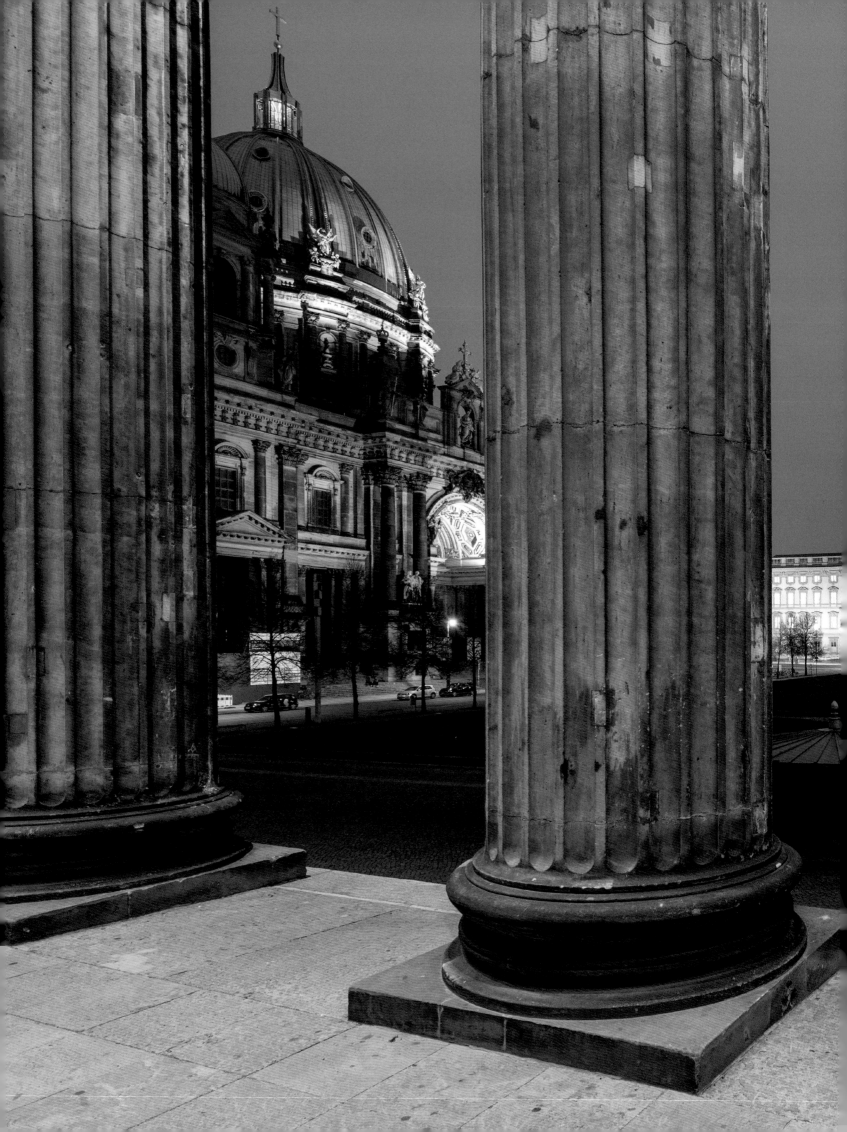

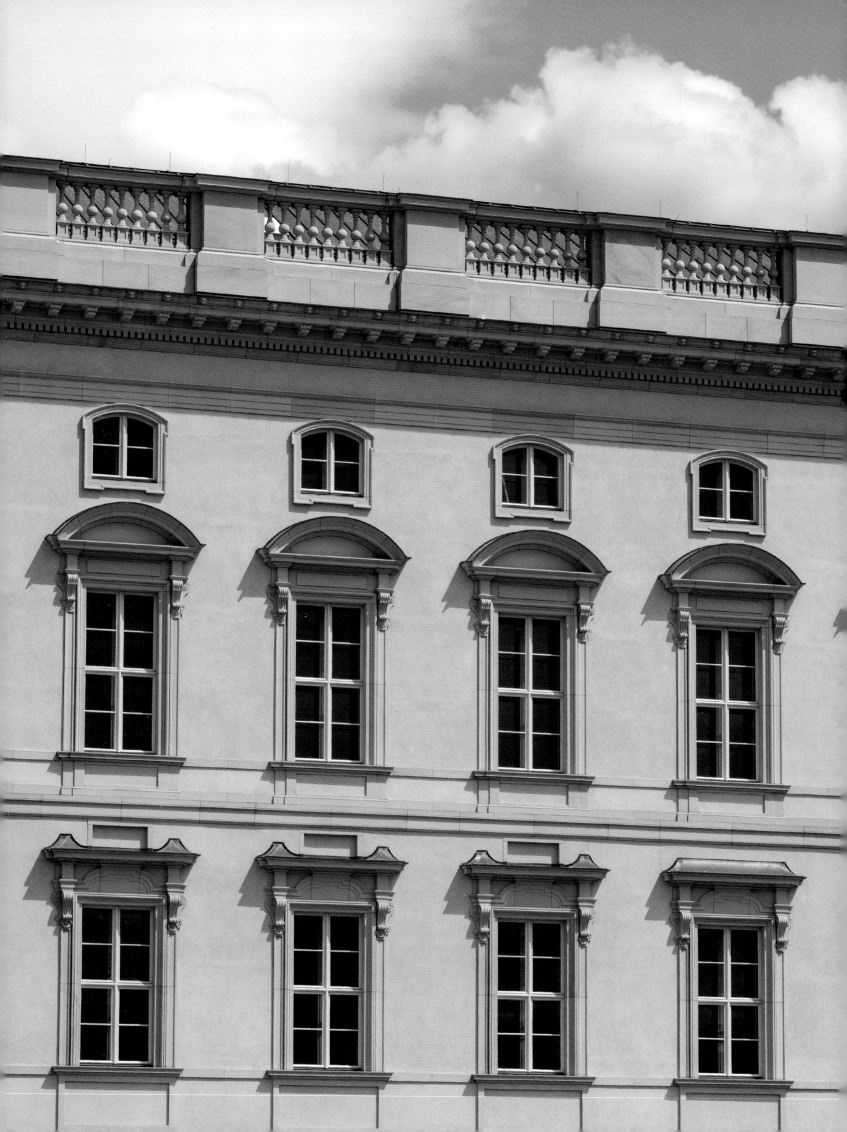

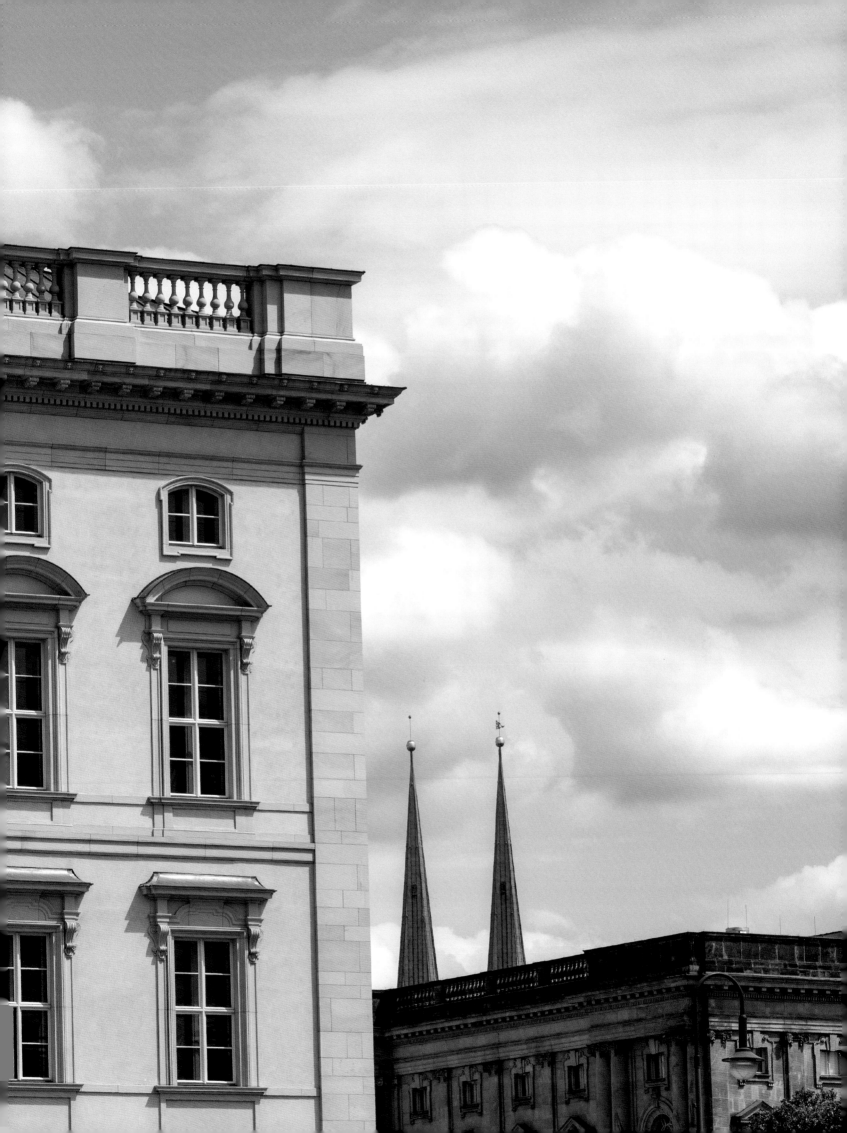

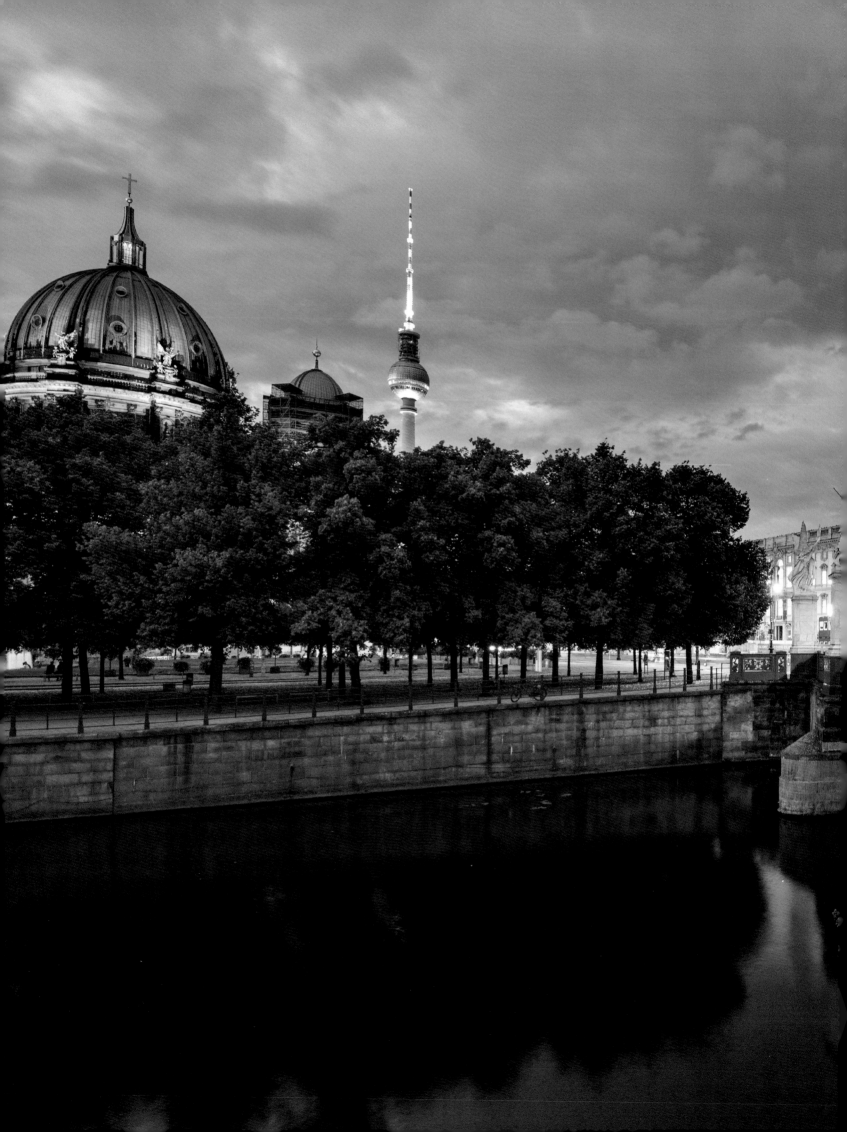

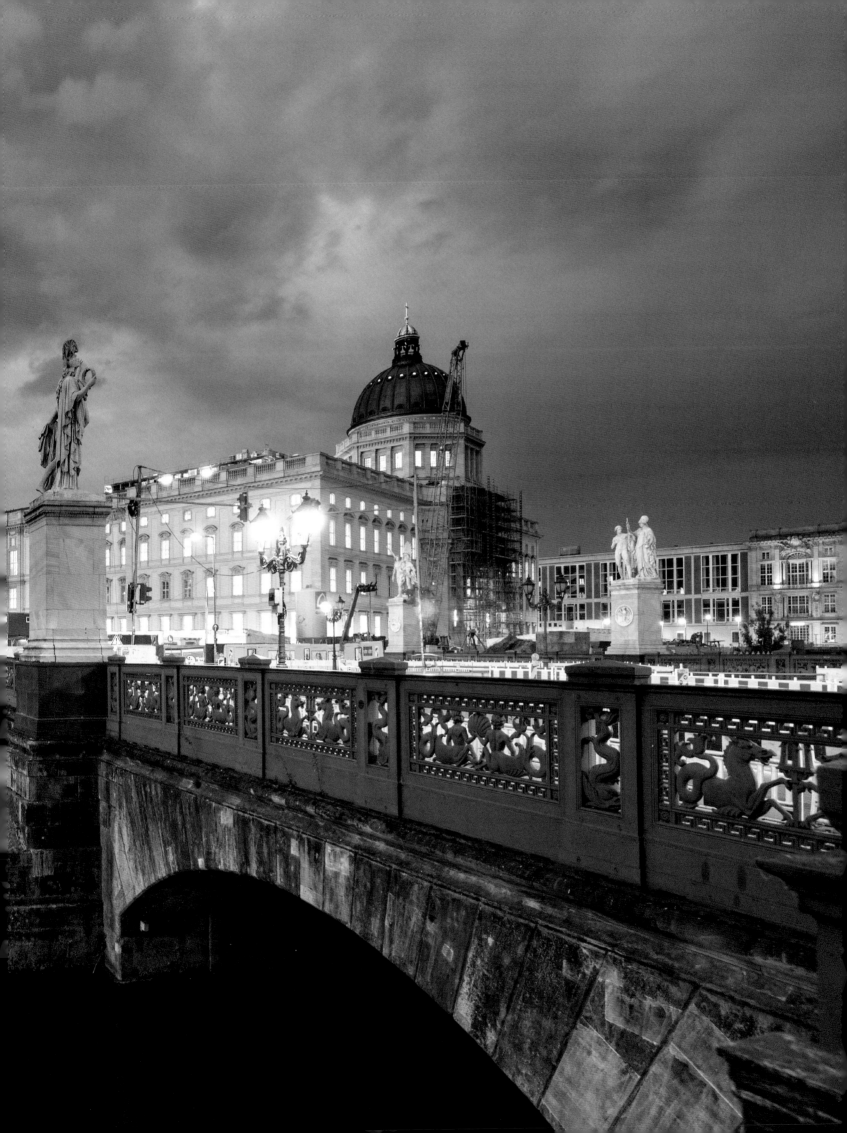

PHOTOGRAPHS
BY LEO SEIDEL

THE
RECONSTRUCTION
OF THE BER
LIN
PALA
CE

FAÇADE,
ARCHITECTURE
AND
SCULPTURE

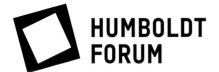

HUMBOLDT
FORUM

HIRMER

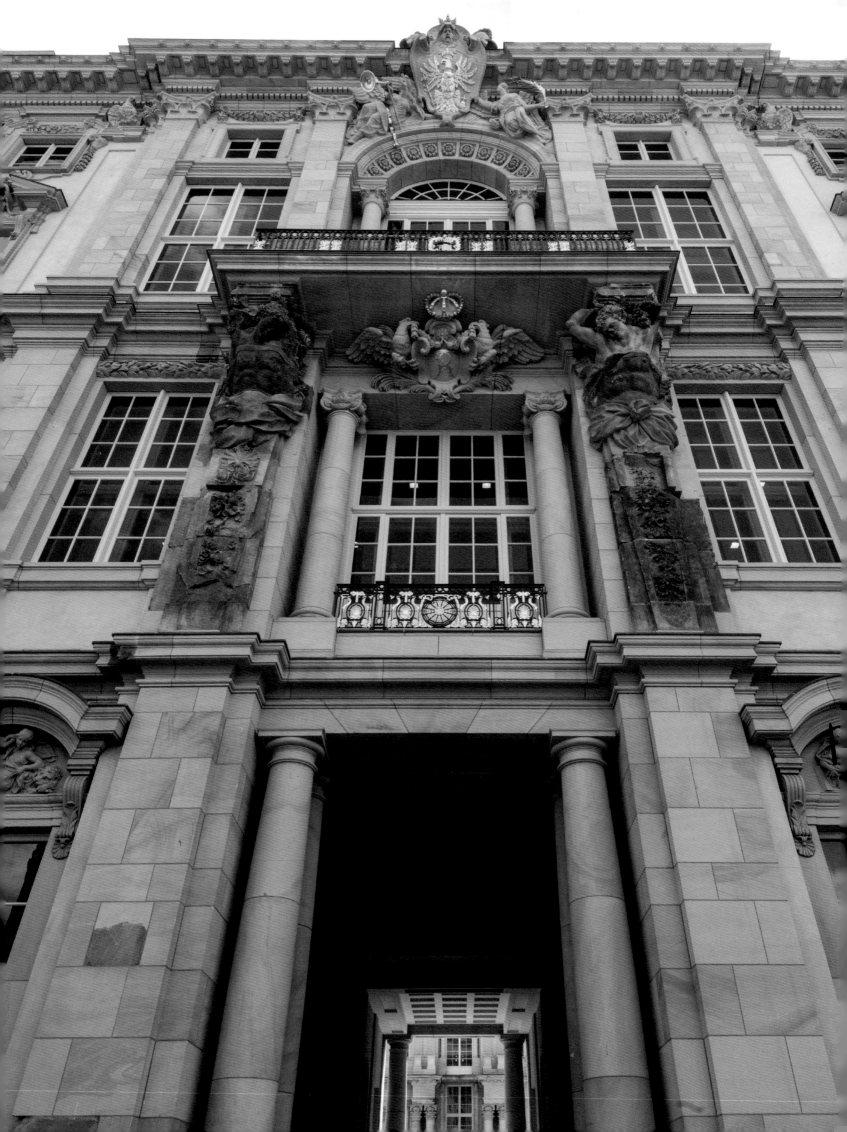

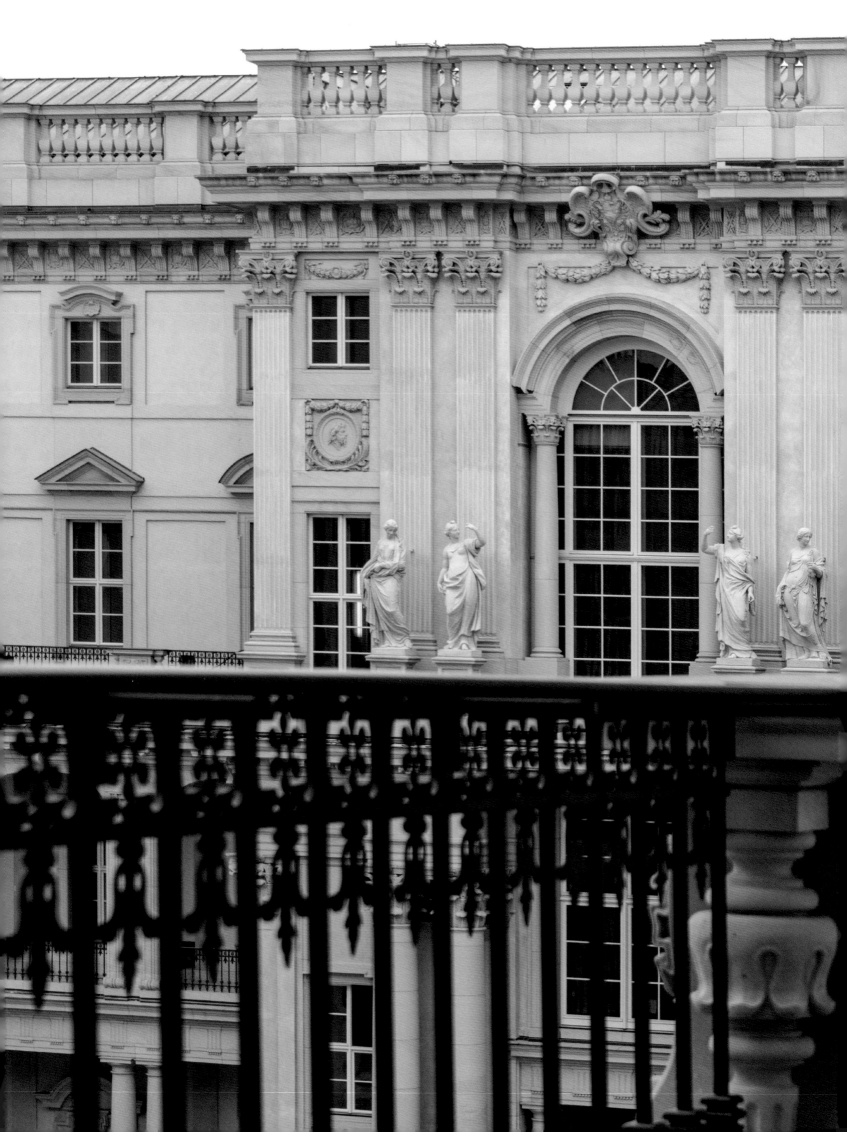

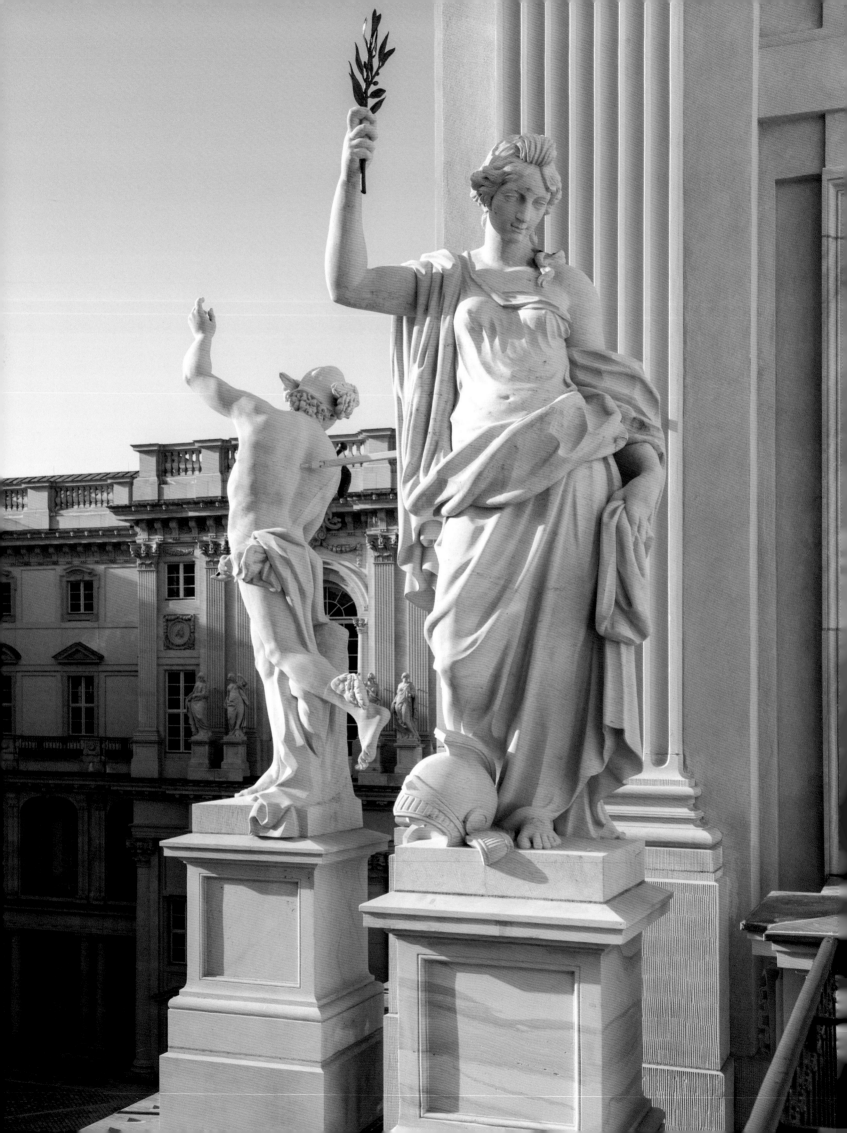

PREFACE

After a planning and construction period of roughly eleven years, a new building that will shape Berlin's cityscape can now be presented: the Humboldt Forum in the Berlin Palace. With a total floor area of 100,000 square meters, the building is not only large; it is also unique in its hybrid appearance. Some 750 linear metres of the baroque façades of the former palace were reconstructed, representing a masterpiece of its historical creator, Andreas Schlüter, as well as of the architects, artists and artisans of our time. After all, the task was both to bring baroque beauty back into the cityscape and to meet important modern requirements such as security, energy efficiency, and sound insulation – to name just a few.

Behind the baroque façades, as well as on the east façade and the long sides of the Passage, a modern architecture is revealed that, in its geometry and structure, continues the mentality of the baroque rationally and without any frills, with high-quality materials. Thus, on the one hand, the baroque is accentuated and finds a contemporary correspondence while, on the other hand, generous and functional rooms are created in the interior.

The recovered baroque façade was the subject of an emotional debate – not only in architectural circles but above all in society and politics. It is not every day that the German Bundestag deals with the architecture and function of a building. In 2002, it was decided by a large majority to erect the Humboldt Forum in the cubature and with three of the historically reconstructed façades of the Berlin Palace. Central arguments for the decision were the high architectural quality of the destroyed baroque palace façades and the possibility of giving the historic city centre between the Spree Island and the Brandenburg Gate an architectural point of reference.

History thus becomes legible in a new way, and not just in the urban space. Wherever it was possible and seemed reasonable, preserved original fragments of the historic building were fitted into the reconstructed façade. This can be seen particularly well on the exterior side of Portal 5. The herm pilasters incorporated there are from Schlüter's time. They testify to great artistry and pronounced aesthetic sensibility and at the same time, in their damaged state, to blind de-structiveness. The recovered façades are thus also a call to narrate and critically question the eventful and fractured history of the site.

The Humboldt Forum is intended to be a place of debate and discussion. This applies as well to architectural criticism. The debate has been in full swing since the project competition. It invites us to engage with the building and its design, to learn from history, to discover the great art of past master builders and to strike out in new directions.

The work of the architect Franco Stella is worthy of recognition in several respects. Not only has he managed to create a high-quality façade reconstruction that is true to the original; he has also created new urban spaces with these façades. This is particularly evident in the Passage and the Schlüterhof. The latter almost looks like a reconstructed Italian piazza. The artistic quality of the sculptures is particularly effective in such places. It invites visitors to linger and stroll. The Passage, with its portals open on both sides, has the appearance of a city gate opening onto the Spree Island.

All of this has been achieved as a result of both the good work of the planners and executors and the civic commitment of many thousands of donors, who deserve the highest respect and gratitude. With the largest fundraising campaign for a building in Germany, they have made its historic reconstruction possible in the first place. All of the structural measures for the historic reconstruction were realized entirely through donations.

This book with its impressive photographs by Leo Seidel takes us into the history of the reconstruction of the façade of the Berlin Palace and sheds light on the building history, as well as on the construction and architectural design of the façades of the Humboldt Forum. I would like to thank Hirmer Verlag for the idea and conception of the book, as well as Bernhard Wolter, who has been instrumental in its production. May it inspire an interested readership and invite them to visit the Humboldt Forum in the Berlin Palace many times.

Hans-Dieter Hegner
Chief Technology Officer of the Stiftung Humboldt Forum im Berliner Schloss (Humboldt Forum Foundation in the Berlin Palace)

← A robed female figure and Mercury on Portal 6 in the Schlüterhof

INTRODUCTION

At the beginning of the eighteenth century, the Prussian royal palace in Berlin designed by Andreas Schlüter was considered one of the most important baroque secular buildings north of the Alps. The reconstruction of its historic façades for the Humboldt Forum is an architectural *tour de force*. This book outlines the architectonic, architectural and art-historical, iconographic, and sculptural-technical foundations of this project.

Peter Stephan opens with a description of the historical situation: He provides insight into the architectural development of the design by Andreas Schlüter and his successors and explains the architectural structure and design of this masterpiece of European baroque. The specific architectural language of Schlüter, who, like all baroque master builders, was oriented towards the classical models in Italy, but nevertheless carried them forward and enriched them with his own compositional ideas and stylistic elements, becomes tangible here. In the process, the irregularities and asymmetries that make the baroque façades appear so much livelier than the nineteenth century neo-baroque ones are also elucidated. Bernd Wolfgang Lindemann focuses his attention on the iconography, the pictorial language of the figurative façade decoration of the Berlin Palace. He convincingly demonstrates the extent to which the baroque artistic programme here did not correspond solely with the representational needs of the young royalty and its content-related, so to speak ethical, ruling maxims. In particular, the sculpture ensemble on the visually dominant main *risalit* in the courtyard named Schlüterhof (Portal 6) prompts an interesting new interpretation of the princely intention behind the selection of the antique statues exhibited there. The architect Franco Stella from Vicenza, the city of the Renaissance master builder Palladio, and Peter Westermann introduce us to the conceptual 'urban planning' aspects of the enormous building's reconstruction. This includes, above all, the sequence of public and semi-public courtyards inside the palace. In addition to the task set in the competition of recreating the Schlüterhof, Stella was the only participant to come up with the idea of laying a pedestrian thoroughfare right through the building with the open passage between Portal 4 on the Lustgarten and Portal 2 on the Schlossplatz side. In

this way, he skilfully integrates it into the structure of the city and at the same time creates new interior public squares, which in turn already bring the constructional idea of the forum to life. By contrast to the rich baroque architectural and sculptural decoration of the historical façades, he maintains artistic restraint when it comes to his contemporary façades. Finally, Kathrin Lange, together with Bertold Just, describes the craftsmanship and artistic achievement of all the natural stone works when dealing with the material from the Elbe Sandstone Mountains – including the sandstone restoration, the sculptural work, the plaster moulding, and the stonemasonry work. Wherever possible, the few original sculptural elements were thus reinstalled in their original places on the façade or, like the valuable, colossal figures of the central *risalit* in the Schlüterhof (Portal 6), were restored and displayed inside, protected from the weather, with replicas replacing them on the outside. The essay traces the entire process of creating exemplary stone sculptures, from quarrying and the production of small, life-size models made of clay to their casting in plaster and the hewing of the sculpture from the sandstone block. A total of roughly 3,000 figurative sculptures adorn the reconstructed palace façades, for which more than 300 different models had to be made.

With its approximately 750 linear metres of new and old baroque façades, the reconstructed Berlin Palace is one of the largest reconstruction projects in the Federal Republic of Germany. Leo Seidel impressively presents the whole project with his photographs and unique eye for detail demonstrating the way in which the façades harmonise with one another. This book convincingly underscores the earnest and faithful dedication to the original with which the architect and his team, the stone sculptors, and all the other participants have turned this new construction of an old palace into a major architectural and artistic project that successfully bridges the gap between the past and the present.

Bernhard Wolter
Head of the Press and Public Relations Department of the Stiftung Humboldt Forum im Berliner Schloss (Humboldt Forum Foundation in the Berlin Palace) until 2021

← Detail of the herm allegorizing winter on Portal 4 of the Lustgarten façade

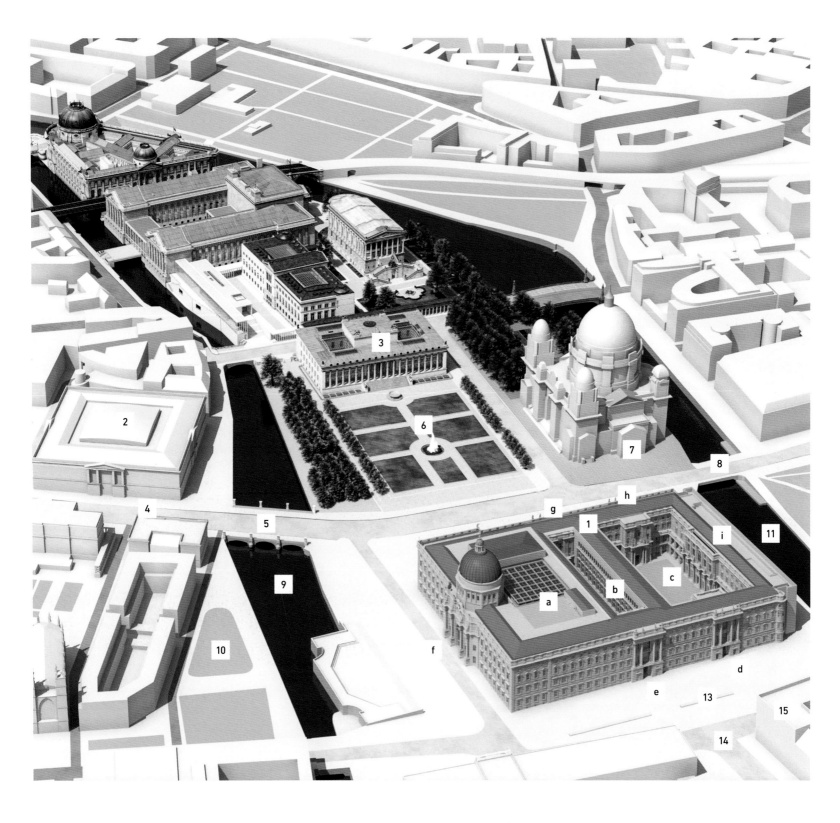

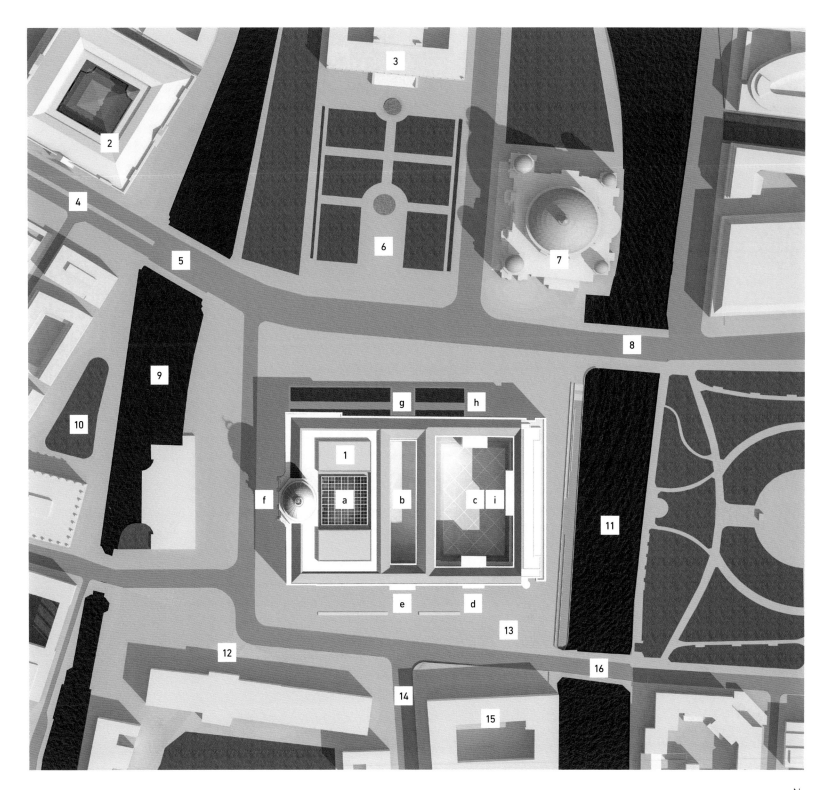

1	Berlin Palace	2	Armory
a	Foyer		(Deutsches Historisches Museum)
b	Passage	3	Altes Museum
c	Schlüter Courtyard (small palace courtyard)	4	Unter den Linden
d	Portal 1	5	Palace Bridge (Schlossbrücke)
e	Portal 2	6	Pleasureground (Lustgarten)
f	Portal 3 (Eosander Portal)	7	Berlin Cathedral
g	Portal 4	8	Liebknechtbrücke (Liebknecht Bridge)
h	Portal 5	9	Spree Canal
i	Portal 6	10	Schinkelplatz

11	River Spree
12	Historic Portal 4 of the Berlin Palace in the former GDR State Council Building
13	Schlossplatz
14	Breite Strasse
15	Academy of Music (Marstall)
16	Rathaus Bridge (Rathausbrücke)

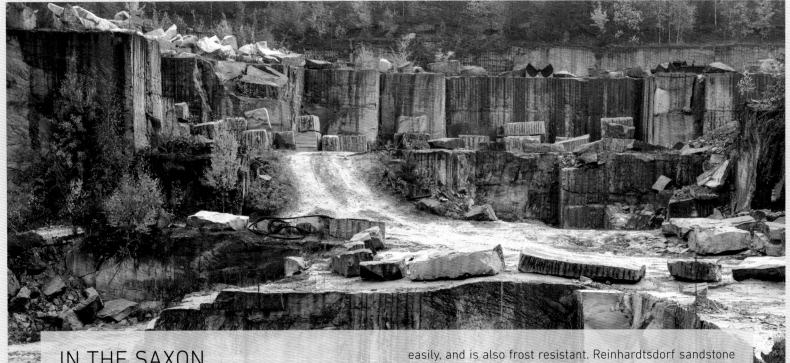

IN THE SAXON QUARRIES

The natural stone used for both the figurative and architectural decoration of the Berlin Palace's baroque façades' reconstruction came from several quarries in the Elbe Sandstone Mountains in Saxony, which had already supplied the material for the historic palace. The illustration here is of the Reinhardtsdorf quarry of the Saxon Sandstone Works in Pirna. Different qualities of sandstone are quarried in this area: The frost-resistant Cotta sandstone is easy to work by hand and enables the forming of even finely structured sculptural works. It patinates silver-grey and barely absorbs water but is susceptible to accumulating moisture. Posta sandstone is more difficult to work with manually because of its greater solidity and is therefore less suitable for sculptural work. It is, however, well suited for making architectural elements. Posta sandstone patinates black, absorbs water easily, and is also frost resistant. Reinhardtsdorf sandstone offers a welcome mixture of both qualities. It can also be handled easily, while being sufficiently weather resistant at the same time.

Posta sandstone was used in the Berlin Palace for the plinth areas and Cotta sandstone only for selected sculptural elements that tend not to be exposed to much weathering or are intended for interior use. The majority of the decorative elements of the façades were made with Reinhardtsdorf sandstone. Posta sandstone blocks are broken, with precise blasting, out of so-called 'banks' up to five metres high. Cotta and Reinhardtsdorf sandstone is to be found in banks which are only roughly two to three metres high. In turn, smaller blocks are chipped off before transport, depending on the intended use. Because of their size, the search for suitable sandstone blocks for the colossal figures at the castle was in fact occasionally quite arduous. In the past, the stone blocks were mainly shipped by water across the Elbe, for example to Berlin. Today, they are transported by road.

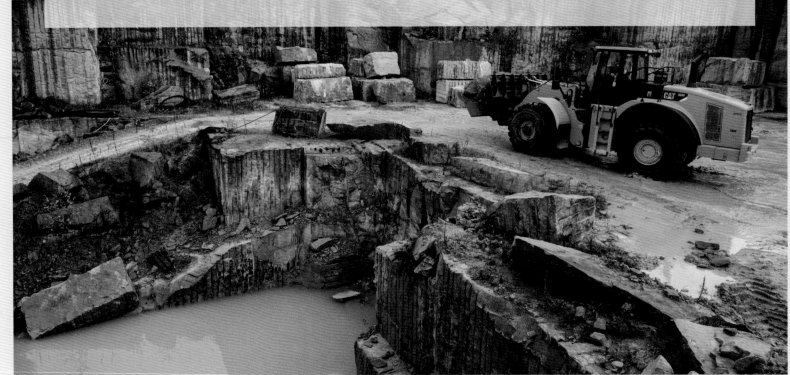

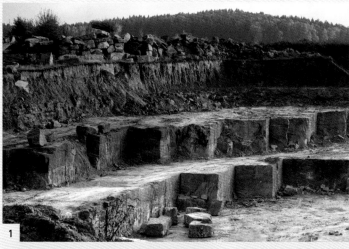

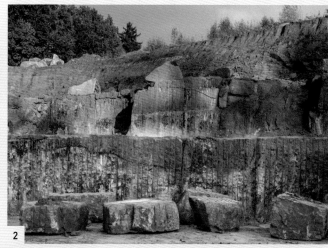

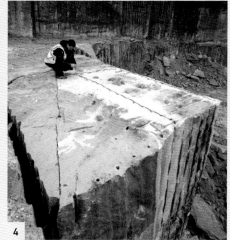

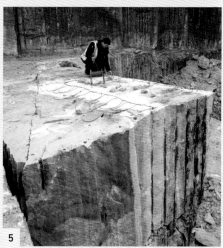

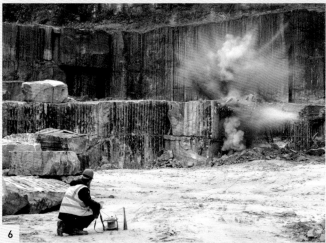

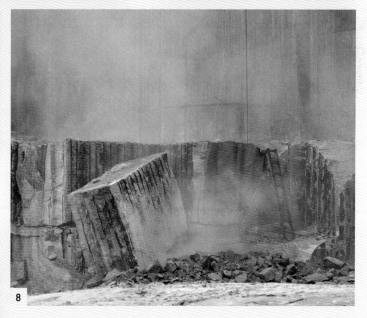

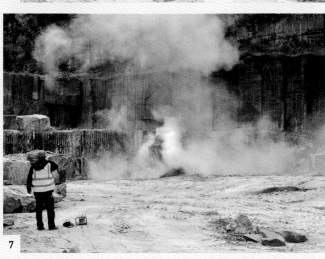

1+2 Under the overburden, the humus soil, the sandstone banks are clearly visible. Softer stone layers run horizontally between the banks.

3 Depending on the quality of the stone sediment, higher or lower sandstone banks result.

4+5 Blasting cords are threaded into the blast holes previously drilled with heavy, hydraulically operated drilling equipment.

6–8 The blaster triggers the explosion, which exactly breaks the blocks out of the wall with the accurately calculated use of dynamite.

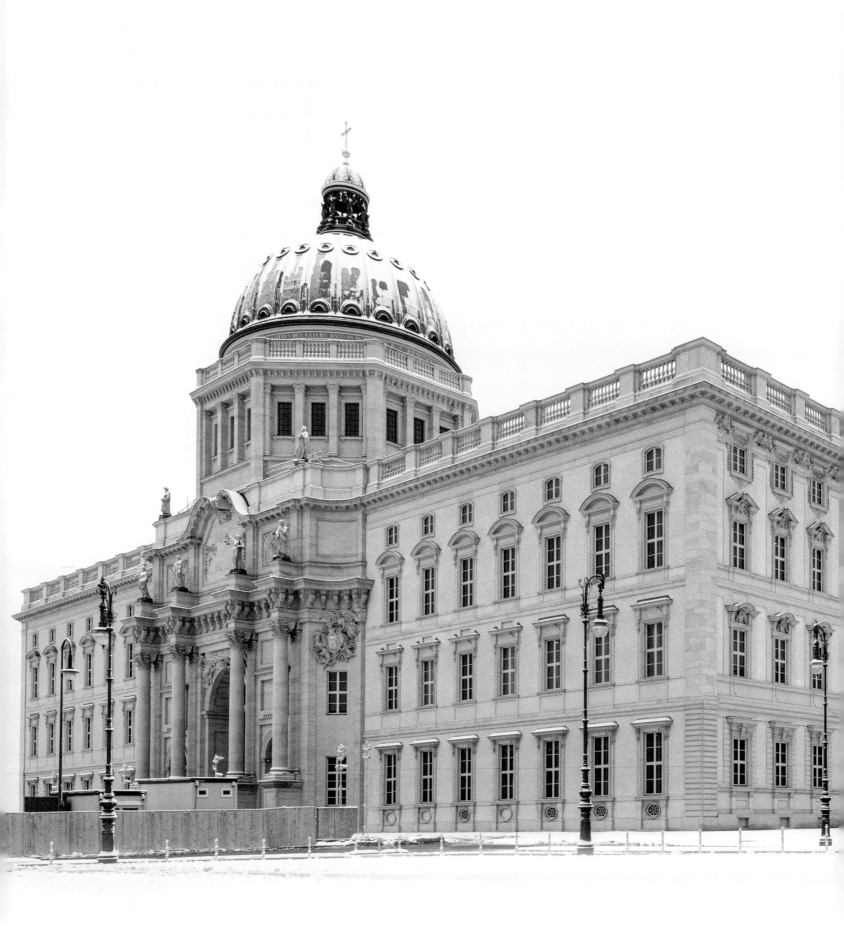

View onto the west façade with the Eosander Portal and the south façade with Portal 2 (left) and Portal 1 (right)

Peter Stephan

STAGED ARCHITECTURE

THE BAROQUE FAÇADES OF THE BERLIN PALACE

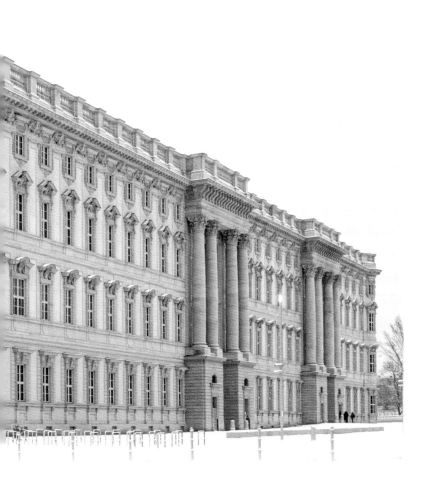

Anyone looking for the first time at the façades of the Berlin Palace created by Andreas Schlüter, Johann Friedrich Eosander von Göthe, and Martin Heinrich Böhme is in for a surprise. Unlike classical baroque residences (such as the Charlottenburg Palace), there is not one but three main façades: The so-called city façade facing south with the Portals 1 and 2 (counted clockwise), the west façade facing the Spree Canal with Portal 3 and the dome added in the nineteenth century, and the north façade facing the Lustgarten with Portals 4 and 5 (for a site plan, see pages 28/29). The latter can already be seen from the avenue Unter den Linden – not, however, in the otherwise obligatory frontal view, but rather at an oblique angle. Despite its prominent location – it is, after all, on one of Berlin's most impressive public squares – the Lustgarten façade is also much plainer than the other two. What takes the most getting used to, of course, are the asymmetries. As on the south side, the spacing of the window axes on the north side is irregular; here as there, a third *risalit* is missing in the western sections. In the Schlüterhof courtyard, which could once only be entered via its narrow sides, the *risalit* of the large staircase, which dominates the end wall as the most important structure, is noticeably shifted to the left.

THE OCCASION FOR THE CONSTRUCTION OF THE BAROQUE FAÇADES

These inconsistencies are not, however, an expression of haphazard arbitrariness, but rather the result of an extremely complicated building history that took place in a reciprocal

The south façade; behind it on the right, the Berlin Cathedral →

33

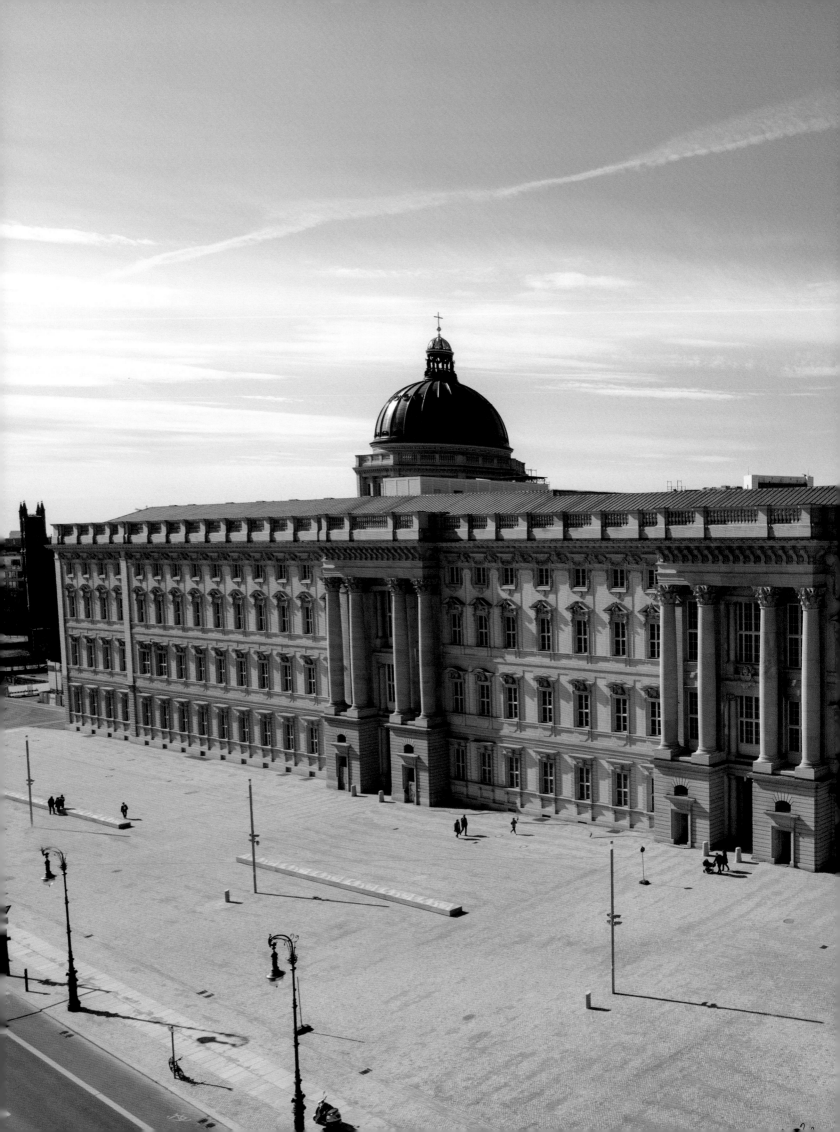

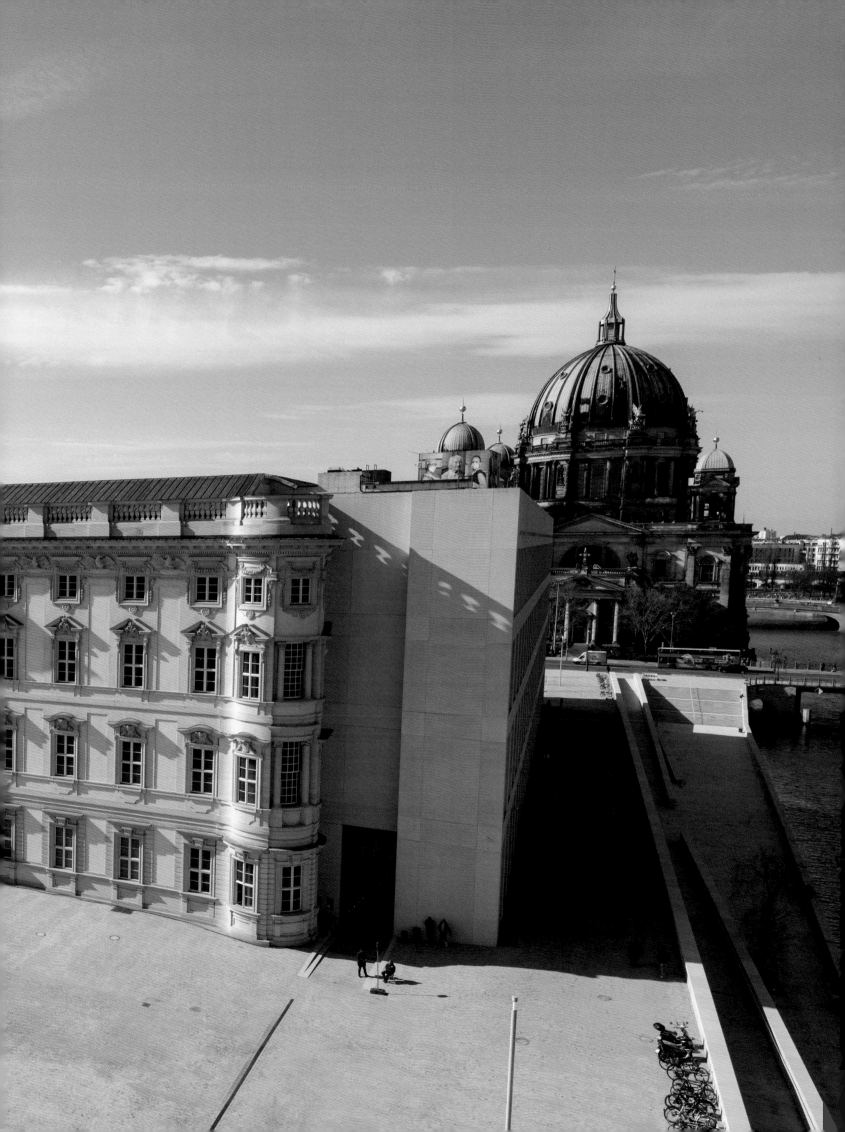

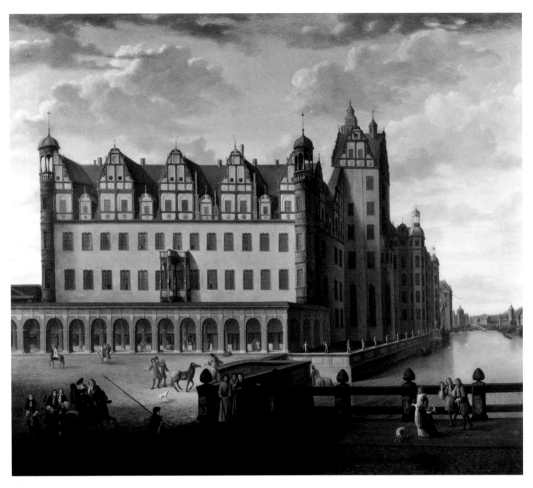

Abraham Begeyn, *The Berlin Palace, Seen from the Long Bridge*, c. 1690

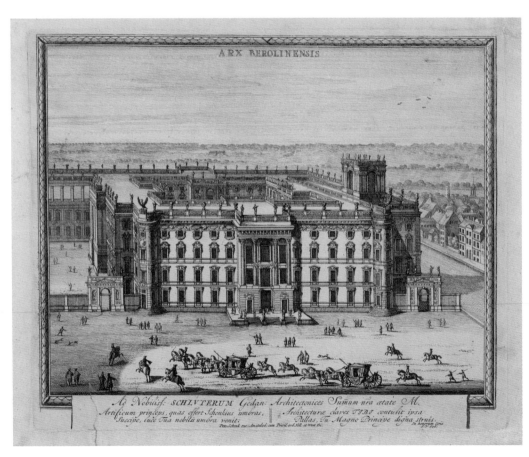

Johann Ulrich Kraus, after Constantin Friedrich Blesendorf, *Bird's-Eye View of Andreas Schlüter's Model of the Palace from the South*, 1701

relationship with the development of the city. To gain an overview of this and to appreciate the urban and artistic significance of the façades, we recommend a tour that begins on the Rathausbrücke (Rathaus Bridge). It was over this bridge, which at that time was the main access to the Spree Island and was decorated with Schlüter's equestrian statue of the Great Elector – now installed at Charlottenburg Palace – that the Brandenburg Elector Frederick III ceremoniously entered his palace on 6 May 1701, after he had crowned himself in Königsberg as Frederick I, the first King in Prussia. Without this event, the baroque façades would probably never have been built.

Since 1618, the Brandenburg Hohenzollerns had ruled the Duchy of Prussia in personal union, which roughly comprised the area of the later province of East Prussia and, together with West Prussia, which belonged to Poland, had emerged from the core area of the State of the Teutonic Order that had perished in the fifteenth century. In 1701, after long negotiations which Frederick had conducted with the Holy Roman Emperor, Leopold I, and other European powers, the eastern Duchy of Prussia had been elevated to the status of a kingdom. But the new title had a threefold stigma attached to it. The emperor had made it a condition that the coronation take place in Königsberg and thus outside the Holy Roman Empire. And because Frederick only ruled over the eastern part of Prussia, he was not allowed to call himself King *of* Prussia, but only King *in* Prussia, and only within the territory he ruled. And finally, by far not all European states were ready to recognise the new regality.

Frederick must have been all the more interested in asserting his kingship in other ways, especially in the core area

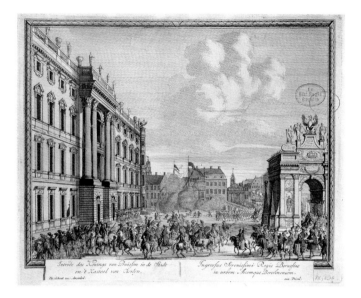

Pieter Schenck, *Entry of Frederick I into Berlin on 6 May 1701 Following the Coronation in Königsberg*, 1701

of his rule, the Mark of Brandenburg, and thus also on the soil of the empire. It was no less important to rid the royal title of the smell of pretension. To these ends, Frederick took a path that was as effective as it was unassailable: He refrained from building an appropriate residence in Königsberg himself and instead had his Brandenburg electoral palace sheathed in a façade architecture that expressed his royal rank in its monumentality, majestic style, and iconography.

On the one hand, the fact that Frederick did not rebuild the palace from the ground up, but 'merely' sheathed it, had

Johann Rosenberg, *View over the Palace Bridge with the Equestrian Statue of the Great Elector onto the City Façade of the Berlin Palace*, 1781

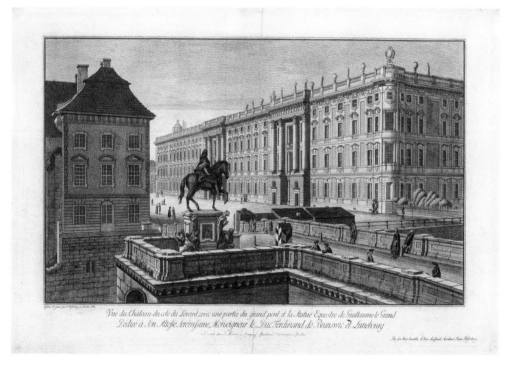

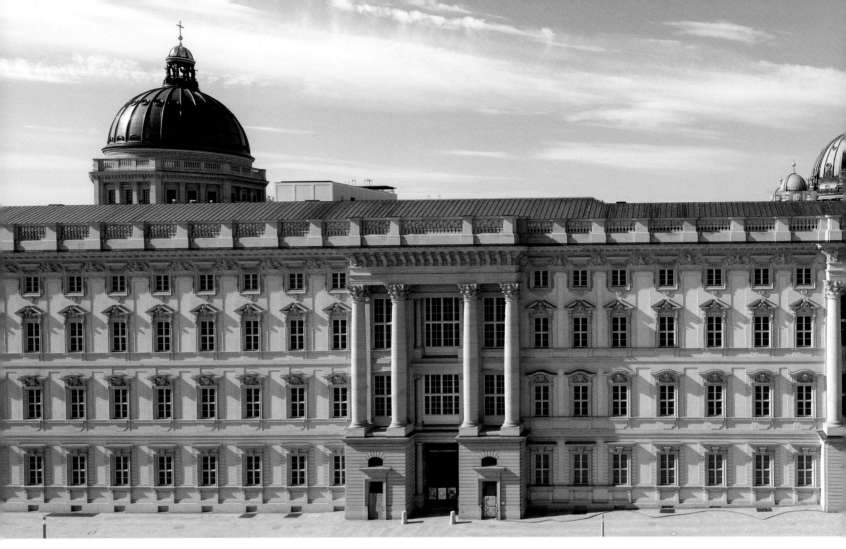

Frontal view of the south façade with Portal 2 (left), Portal 1 (right), and the corner roundel

economic reasons: A completely new building would have been too expensive. On the other hand, the act of sheathing had a high symbolic value in the baroque era. In sacred architecture, it stood for the *renovatio ecclesiae*, the spiritual renewal of the Church. As a sign of this, the Church wrapped itself in a festive wedding dress in order to prepare for its marriage to Christ at the end of time. By contrast, in secular architecture, it was more a matter of visualising political renewal, an increase in power, and social or cultural advancement. In order for the sheathings to be recognisable as such, however, it was necessary to leave out a part that dated back in time. The older this part was, the further back the historical continuity reached that could be invoked to legitimise one's rule. And the simpler the older parts were, the greater the progress embodied by the modern elements appeared. Apart from that, the consideration of older building stock was an expression of reverence shown to one's ancestors and predecessors in office.

For this reason, Frederick left the east side – the oldest parts of which date from the thirteenth century and in place of which Franco Stella's Spree façade now stands – largely untouched. He was far less considerate with the other parts of the palace. The south side was completely renovated –

although it had already been upgraded to a representative façade one and a half centuries earlier under Elector Joachim II. Its style was, however, no longer sufficient for the representational requirements of a king.

SCHLÜTER'S TRANSFORMATION OF THE PALACE

For this reason, Andreas Schlüter converted the old-fashioned corner oriels into elegant rondels, the right-hand one of which can be seen again today (the left-hand one fell victim to the westward expansion of the palace in 1716). In the centre, Schlüter positioned Portal 1. He covered up the different distances between the windows with panel-like recesses in the wall, which were variable in width. In addition, he fitted the frieze below the cornice with free-standing sculptural eagles, the wings of which he could spread differently depending on the distance. The irregularities are thus less noticeable.

Since Portal 1 was intended from the outset to serve as an entrée for the king on his return from Königsberg (in fact, this section of the façade was completed in time for the coronation), Schlüter followed the model of the baroque

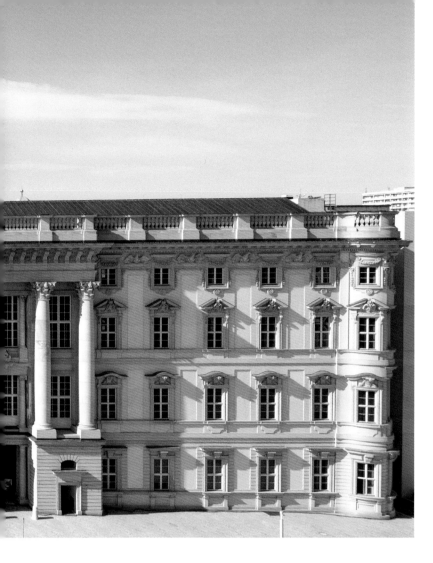

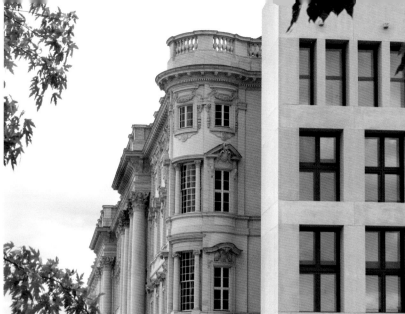

The corner roundel at the transition to the modern façade on the Spree side

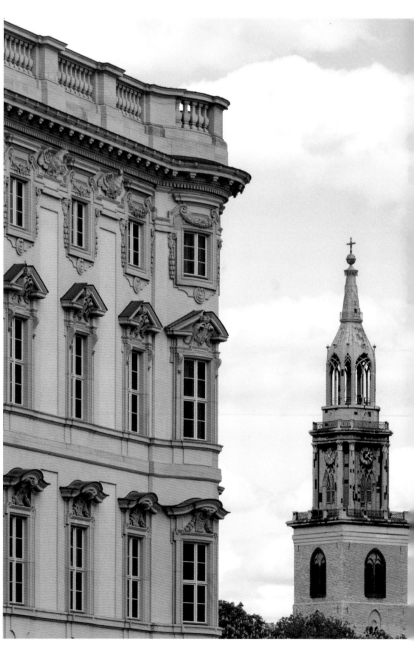

triumphal arch. He converted the entire ground floor into a plinth zone for four giant columns that reach up to the roof to be loaded with a massive entablature. In this way, an extraordinarily grave portico was created that takes up the entire height of the building and is almost unique in these dimensions. Since Roman antiquity, the concept of *gravitas* has encompassed qualities such as authority, credibility, imperturbability, and strength of character. In classical architectural theory, the grave style stood for dignity and grandeur. Moreover, the column itself was a common symbol of strength and steadiness. In Berlin, it acquired an additional statement by the fact that Schlüter occupied the capital corners with Prussian (!) eagles. Thus, the entire *risalit* portal became a symbol of Prussian virtue and strength.

What is remarkable is that Schlüter's architecture, notwithstanding the many compromises he had to make in terms of construction and the many iconographic specifications he had to take into account, does not seem forced or pieced together in any way. Rather, everything is harmonious and coherent. This is mainly due to Schlüter's unique architectural language. Like no other master builder of the baroque era, he produced his designs according to a strictly dialectical principle, with which ostensible or actual breaks

The corner roundel; on the right, the tower of St. Mary's Church

View onto the south and east façades from the right bank of the Spree; on the left, the Rathaus Bridge →

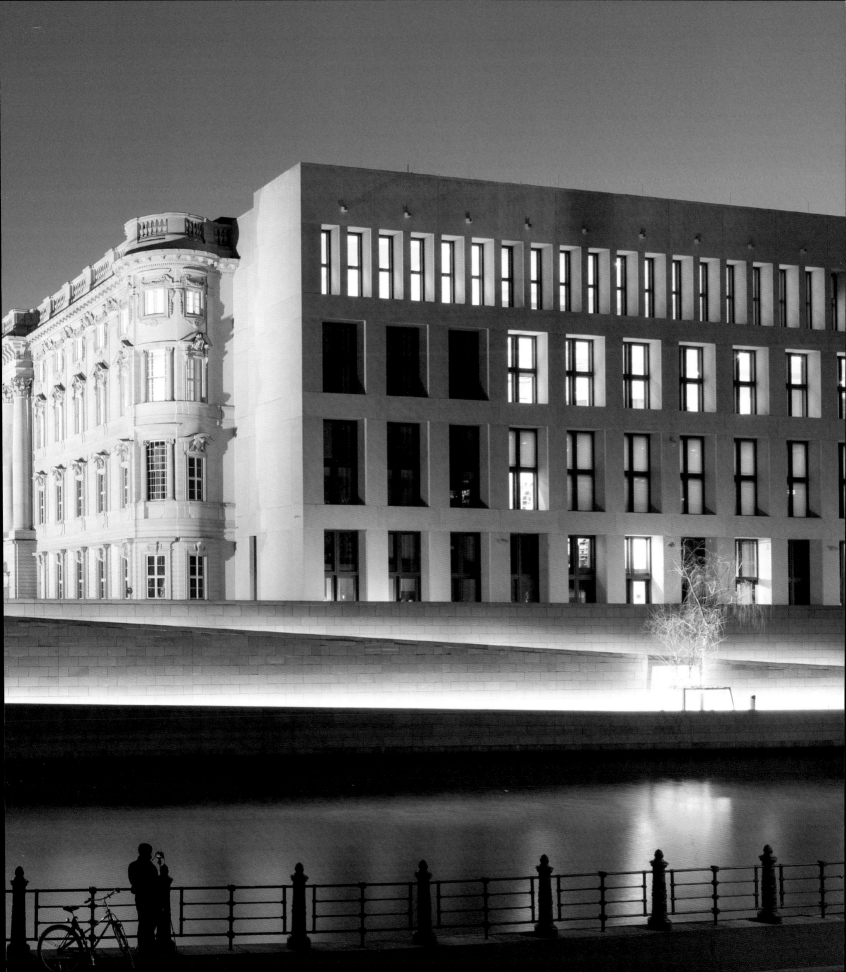

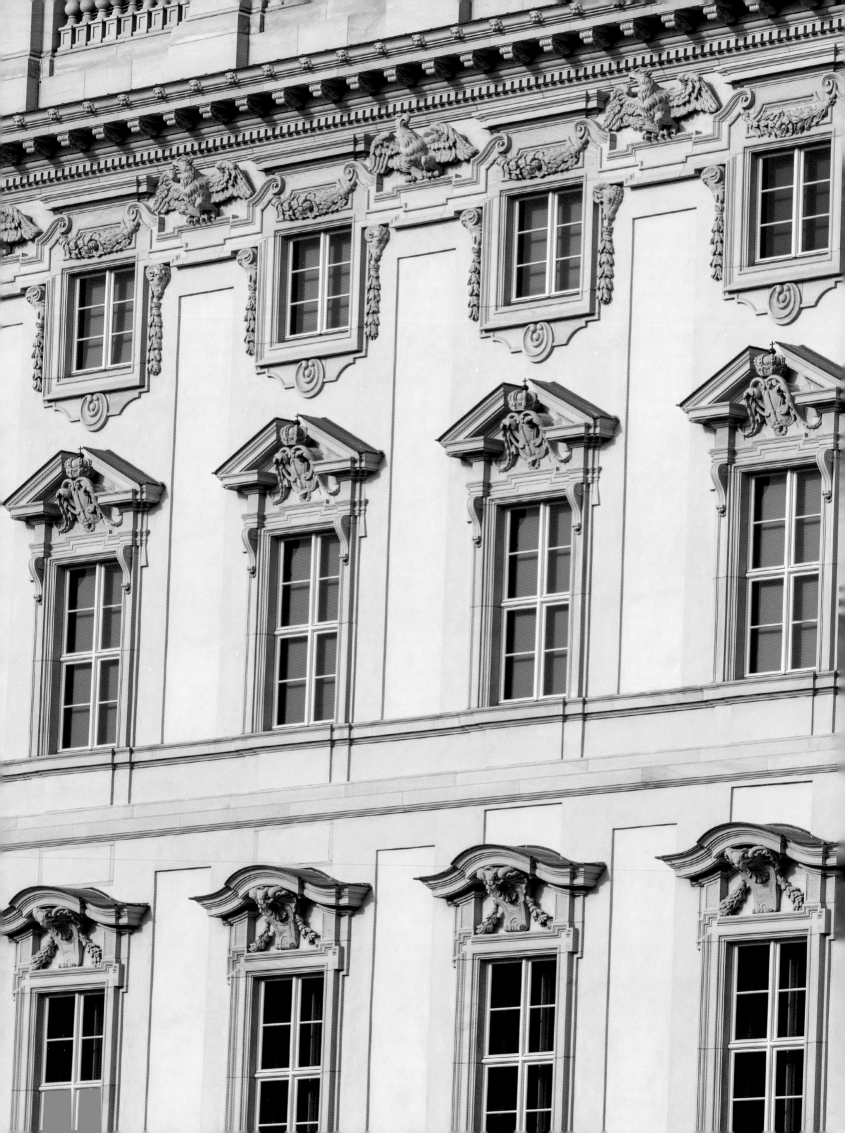

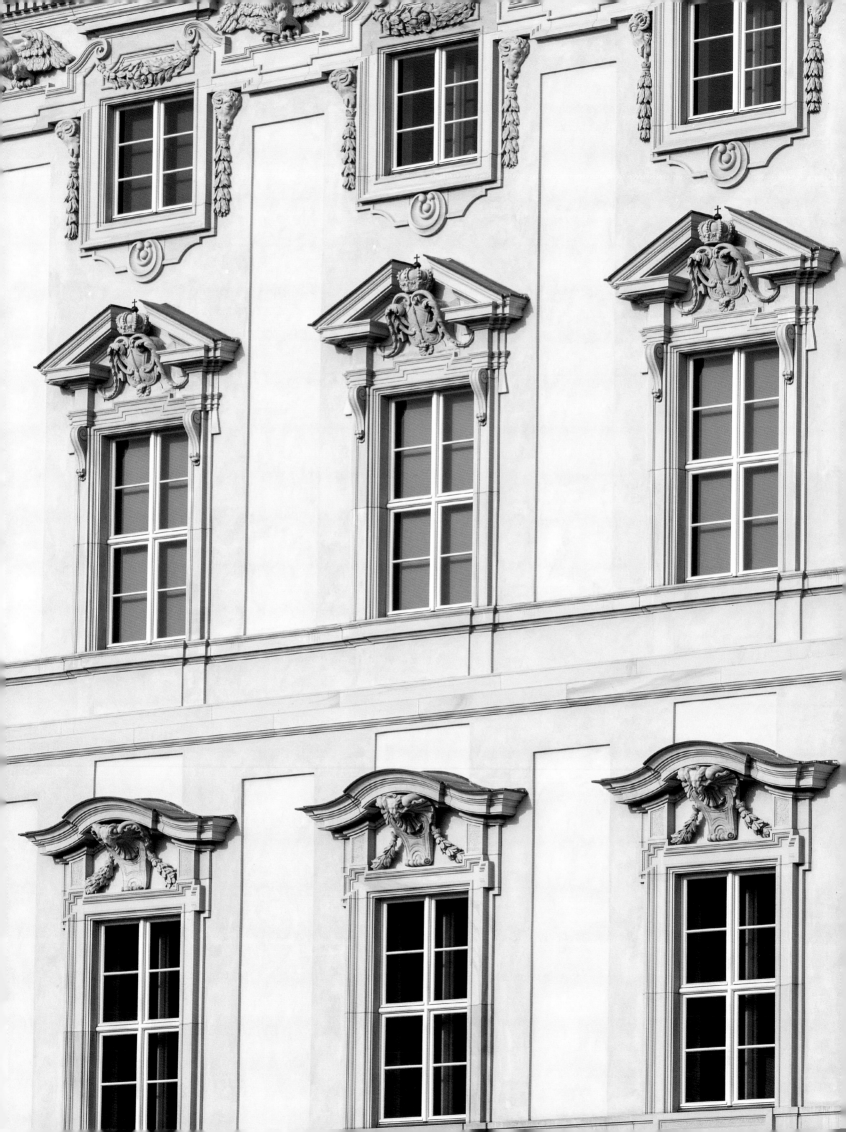

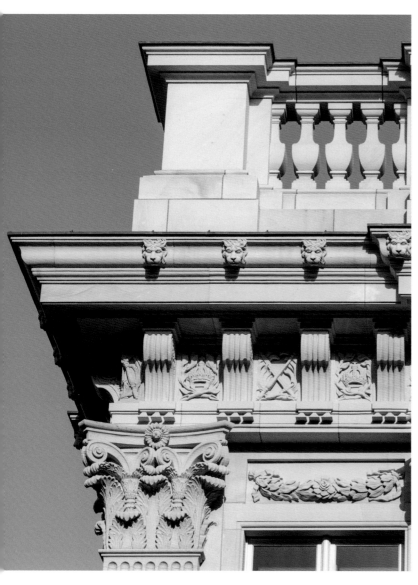

Detail of the entablature of the southern courtyard Portal 1

On the basis of this classical interrelation, Schlüter executed the *risalit* portal using an pillar construction style and the flanking recesses using a wall construction style. He thus backed the giant columns of Portal 1 described above with pillars, in the spaces between which he placed a framework of single-storey supports. In the central axis, these consist of regular full columns, which follow the classical sequence of Doric, Ionic, and Corinthian orders from bottom to top. In accordance with the logic of statics, they become progressively smaller towards the top, whereby the uppermost orders originally still carried a round arch. Another difference is the type of openings. The windows in Portal 1 are merely the glazed spaces between the columns and pillars, whereas the windows in the lateral offsets have been demonstratively cut out of the wall continuum and staged as independent architectural units by means of profiled frames and sculpturally elaborated gable roofs. In addition, banded ashlars, cornices, parapets, and offsets, in combination with the applied figural decoration, create a relief-like texture that is sculptural but not free-standing.

Schlüter intensified the contrast between the ornamental-relief wall construction of the rear courtyards and the tectonic, three-dimensional articulated construction of the *risalit* portal by designing the offsets exclusively in width, while giving the articulated construction not only a vertical extension in height, but also a spatial extension in depth. A closer look reveals that the *risalit* is composed of three layers. The front layer, facing the Schlossplatz, belongs to the urban space and is therefore designed to be seen from a distance. It encompasses the entire height of the building, consisting of the four giant columns, the lateral parts of the ground floor serving as plinths, and the entablature. The middle layer, which forms the actual core of the façade, is limited to the first and second floors. It is composed of the pilasters and pilaster strips behind the giant columns. Finally, the rear layer breaks down into three individual storeys, the height of which is determined by the interior spaces. Originally, the three pairs of storey columns standing in the central axis were even extensions of an interior architecture running through the entire structure.

The south-east rondel occupies a special position within Schlüter's façade dialectic. By drawing the wall at the transition from the south to the east façade around the corner oriels of the existing Joachim building like a malleable mass, Schlüter deprived it of its statically rigid character, and made it all the more recognisable as a mantle. At the central window of the first floor, the mantle has an opening through which the Ionic storey order of the *risalit* portal reappears.

This penetration of the structure by storey columns becomes even more apparent when one passes through Portal 1 and enters the courtyard named Schlüterhof. The passages were lined by Doric colonnades, which will be added to again in the foreseeable future. In the central axis of the courtyard *risalit*, which in a sense forms the rear of Portal 1, the Doric

and contradictions could be brought into a fruitful, charged relationship. First and foremost is the contrast between the 'wall construction style', which is characterised by two-dimensional, mostly horizontal surfaces, and the 'pillar construction style', which consists of fully sculptural, free-standing, and upright columns or posts. The wall encloses the room to separate it from other rooms – in contrast, the column divides it or opens it up to adjacent rooms. And while the wall is usually static and rigid, the column illustrates the laws of tectonics in an almost organic way: The curvature of its shaft appears compressed, as it were, under the load of the entablature that supports it, and the base appears at the bottom like a cushion that absorbs the pressure. In contrast, the taper of the shaft suggests that the column braces itself against the load. Both features reveal a resilient elasticity. The column also resembles a free-standing sculpture rather than a stacked mass.

← Detail of the south façade

Portal 1 on the south façade →

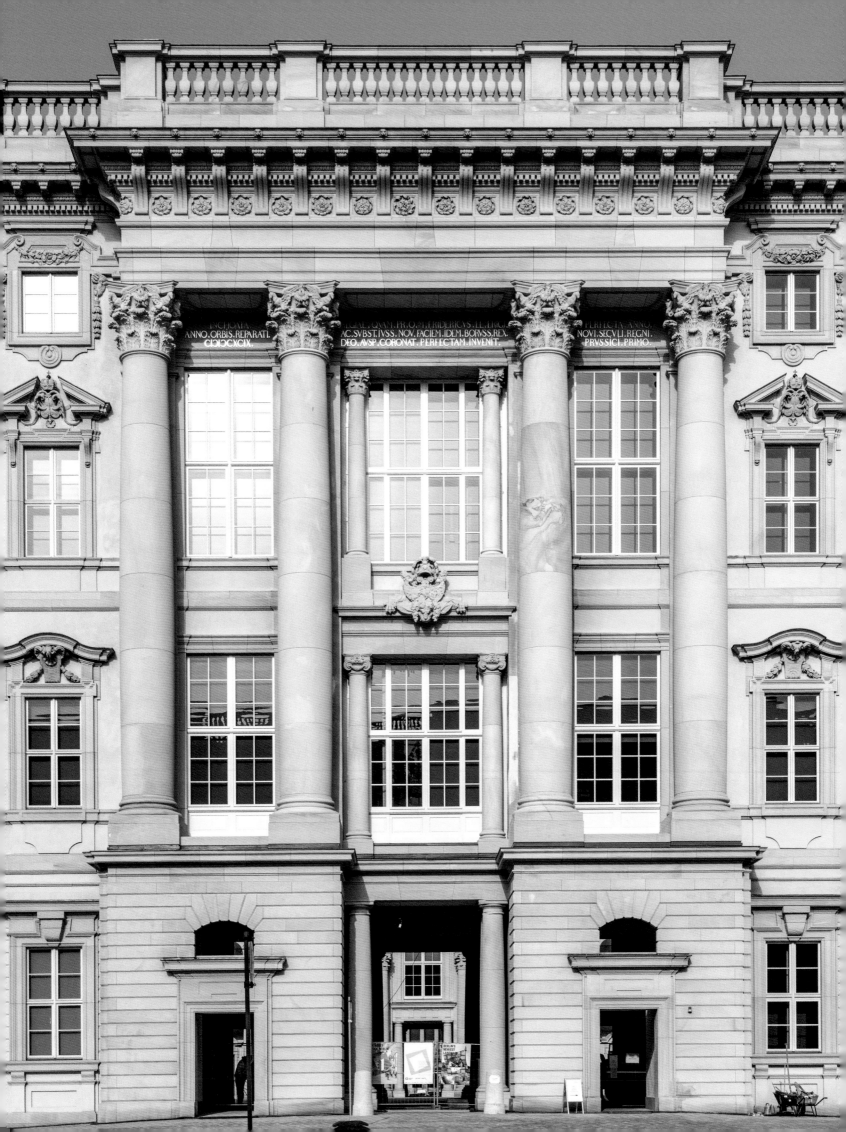

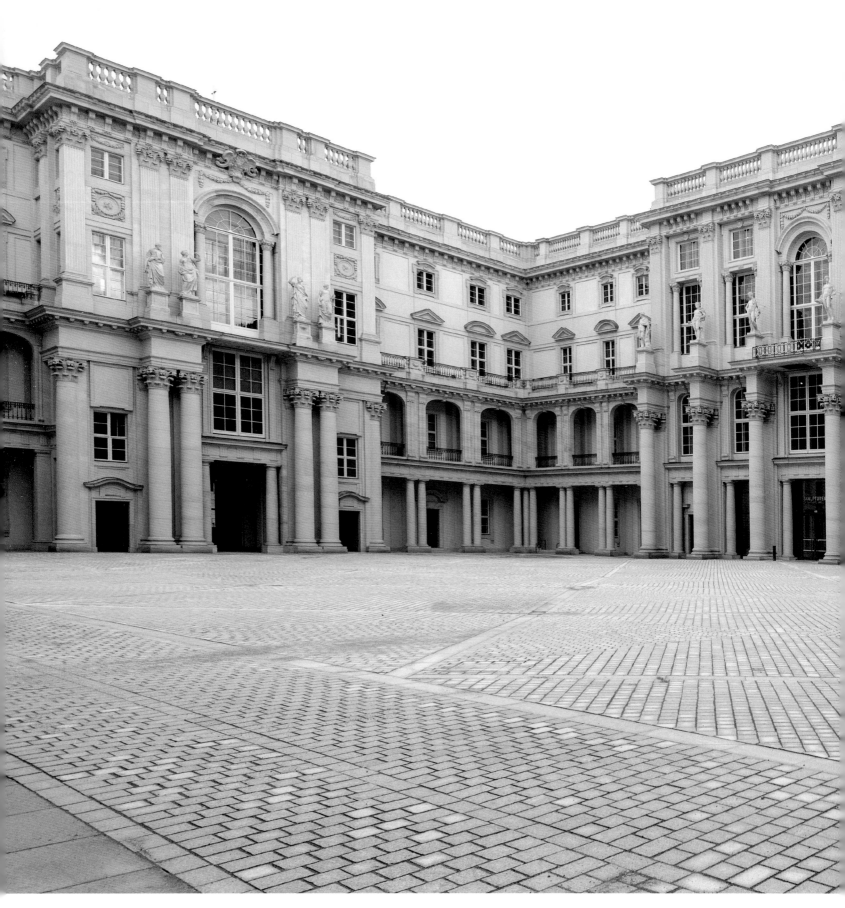

The Schlüterhof, view to the northeast; on the right, columns of the southern courtyard Portal 1

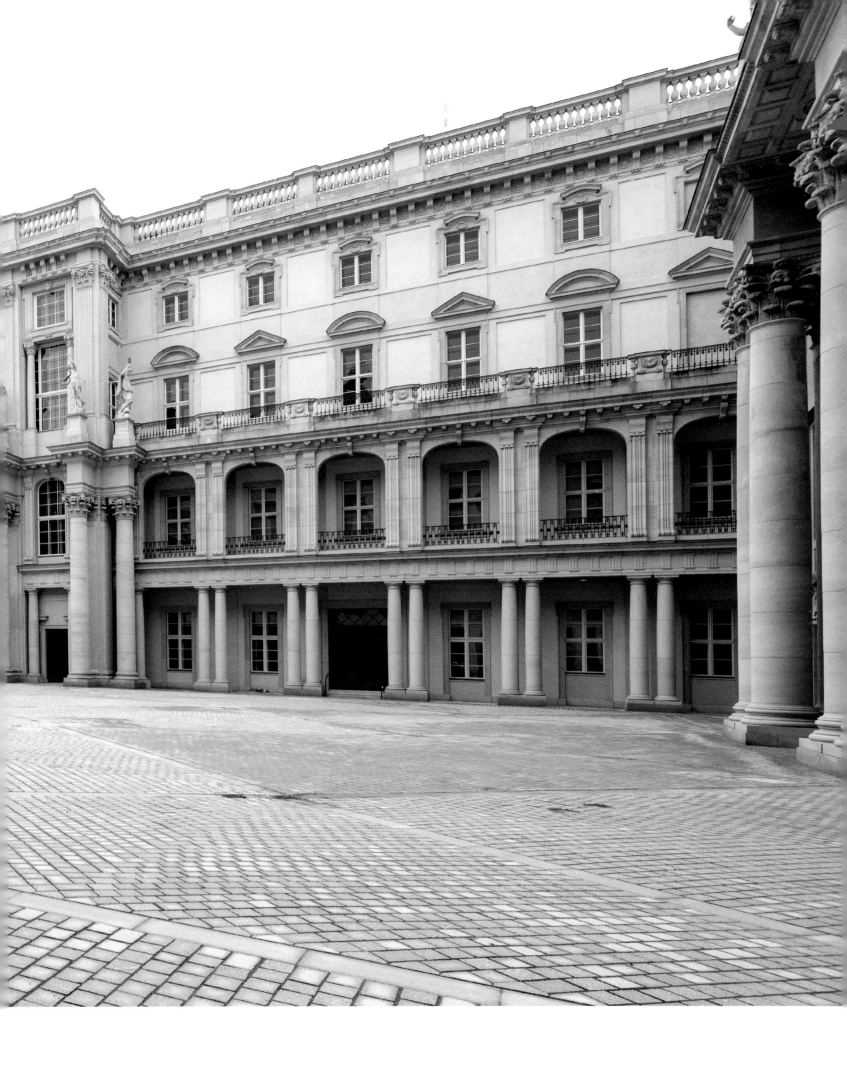

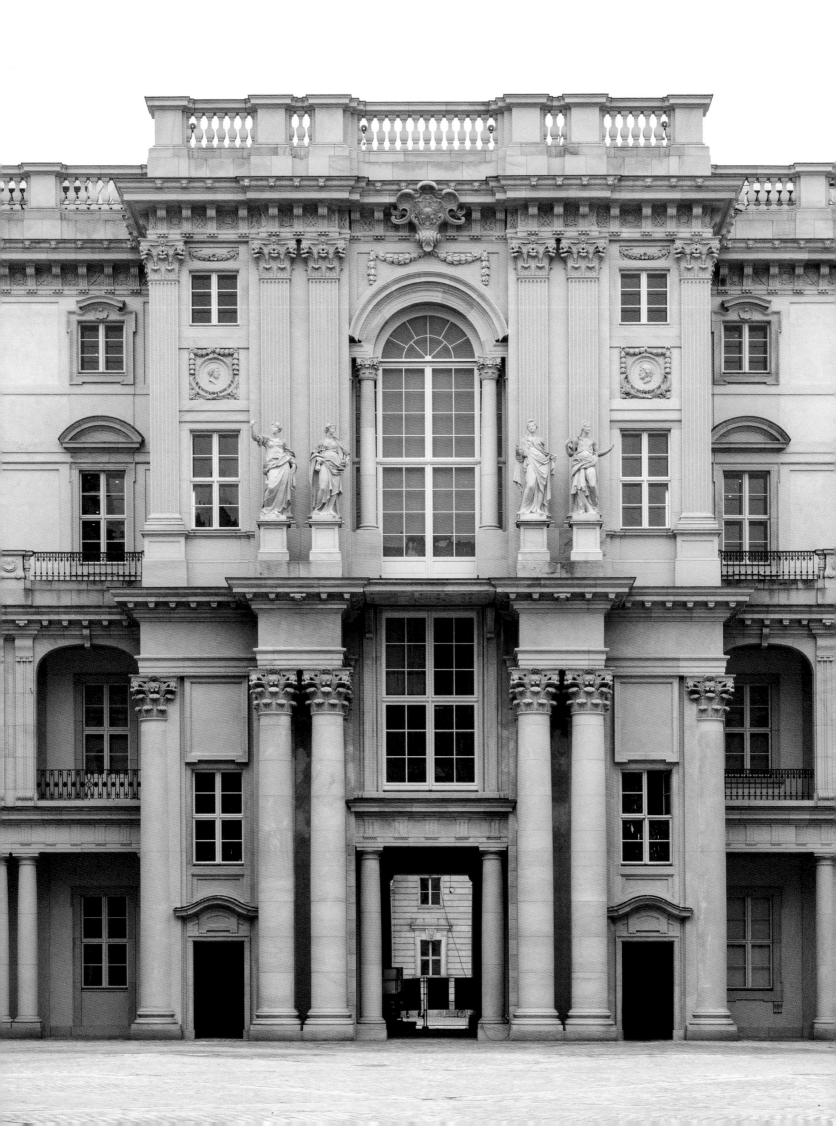

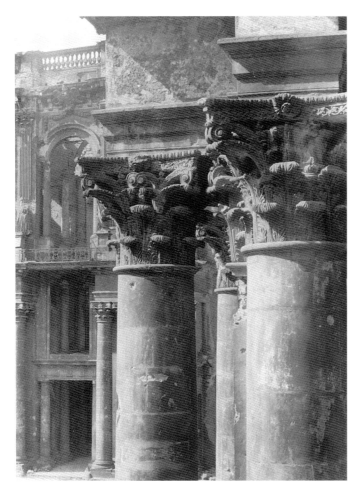

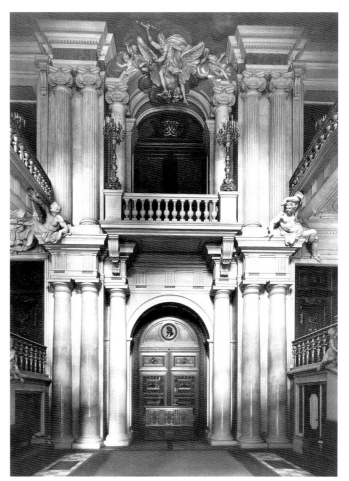

View of the northern staircase *risalit* (courtyard side of Portal 5) of the Schlüterhof, 1945

The front wall of the large staircase (behind Portal 6) with Jupiter Fighting the Giants, before 1945

ground-floor columns once again become part of the façade, together with the Corinthian columns of the second floor. The storey columns are now embedded, however, in two smaller superimposed colossal orders, which appear less dramatic and powerful than the giant columns on Portal 1 and are thus adapted to the smaller dimensions of the courtyard space. They are nevertheless characterised by an almost noble classicism.

Schlüter did not, however, content himself with reproducing the articulated construction of Portal 1 at its rear, but rather transferred it to the colonnades of the flanking two-storey galleries. These galleries, in turn, connect to the two storeys above, which form the actual boundary of the courtyard space in purely wall-like form.

On the east side of the courtyard, the galleries and the walls behind them – after bending at right angles – butt up against the large courtyard *risalit* (Portal 6), behind which the main staircase was once located. Since Schlüter, out of consideration for the disposition of the interior rooms, had to build a new staircase where the sixteenth-century spiral stone staircase had been until then, the *risalit* is shifted to the left. This irregularity is more than compensated for by the façade structure, which is unparalleled in its elegance

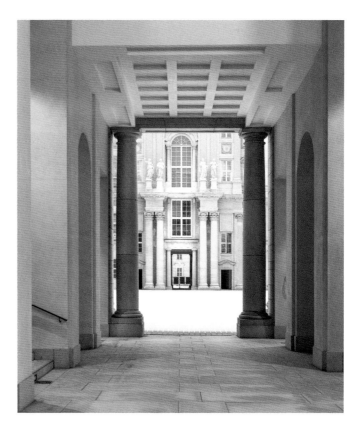

The passage to the Schlüterhof through Portal 5

← The Schlüterhof with the courtyard side of Portal 1

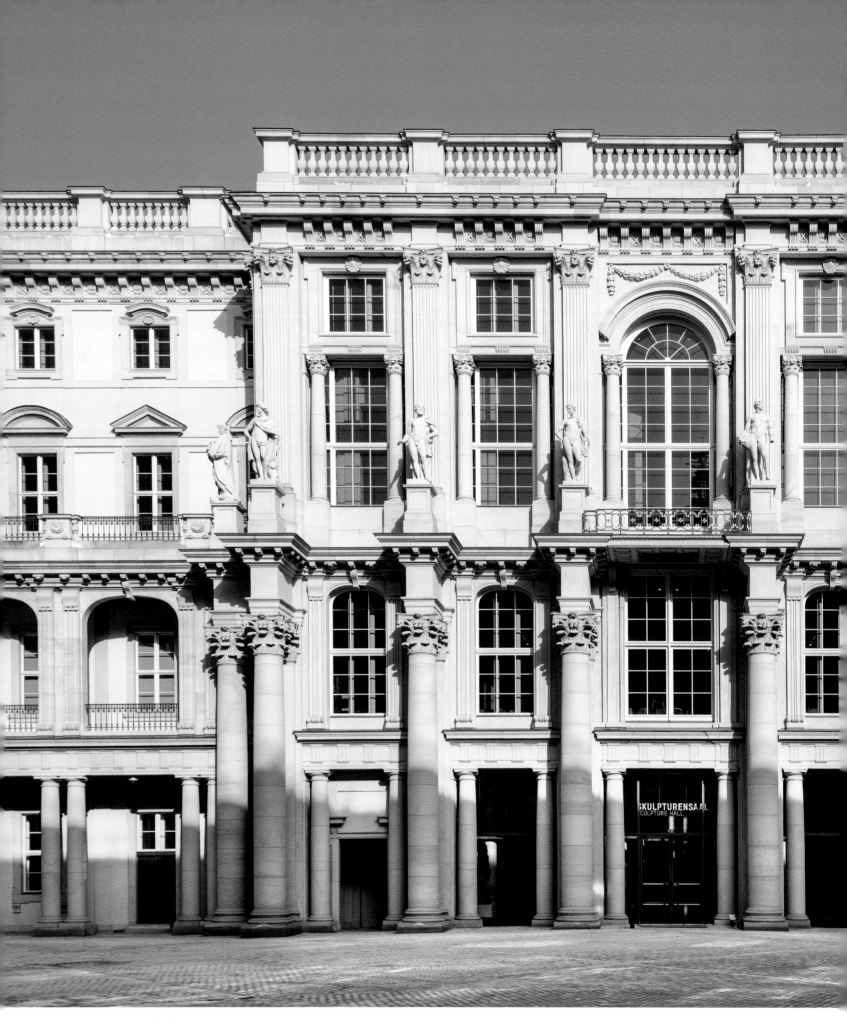

Portal 6 in the Schlüterhof

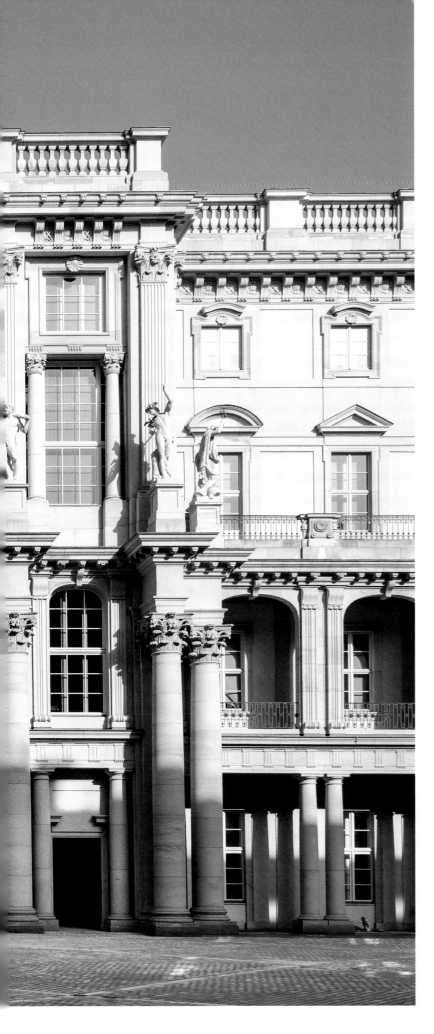

and clarity. More so than Portal 1 and its counterpart on the courtyard side, the large courtyard *risalit* is dissolved into a filigree architecture. Once again, it consists of superimposed colossal orders, the lower of which, however, is now completely intertwined with the colonnades and arcades of the courtyard galleries.

Furthermore, Schlüter perfected the principle of spatial depth in his completion of this *risalit*. Again, he worked with three layers. The front layer consists of the free-standing columns extending over the two lower storeys. The middle layer consists of narrow wall strips with pilasters in front. On the one hand, the latter serve as a backdrop for the colossal columns; on the other, they support the upper pilaster order. The columns, in turn, are crowned by statues that mediate between the two layers by allowing the front column architecture to taper upwards, thus revealing the view of the pilasters behind.

The third layer is again derived from the respective storey divisions, which originally extended even more obviously into the depth of the building than at Portal 1. For it is probable that the large courtyard *risalit* was not glazed at first – like many staircase architectures of the baroque period. From the outside it was thus easy to see that Schlüter repeated the Doric, Ionic, and Corinthian storey order in the staircase and the room above it. Equally, it was evident that he had not coincidentally returned to the structure of the courtyard galleries on the two lower floors, as these galleries continued behind the façade in the form of an interior gallery.

However, the intention of the open façade was not only to provide a view into the interior architecture. Outsiders could also follow the court ceremonial there, the most important venue of which was the staircase. Schlüter had turned the *risalit* into a proscenium through which one looked into the staircase as onto a stage. But court life itself also had theatrical features, which is why contemporary sources spoke of the 'state theatre'. In this context, the sculptures above the free-standing columns resembled actors who had stepped onto the proscenium stage to seek contact with the viewer. In the context of such a production, the arcades of the courtyard galleries became open-air boxes – an impression that still manifests itself today when the Schlüterhof is used for open-air performances.

Leaving the Schlüterhof, we walk through the northern courtyard *risalit*, which corresponds exactly to its southern counterpart, into the Lustgarten. Now we are standing in front of Portal 5, towards which the avenue Unter den Linden runs at an angle in axial extension and which is characterised by a special elegance. Since baroque garden façades did not have to meet the same representative requirements as city or courtyard fronts, Schlüter dispensed with colossal columns. Instead, he assembled the macrostructure from colossal pilasters and pillars. In the central axis, he adopted the storey architectures of Portal 1 – including the arcade that was still there at the time.

View across the Lustgarten onto the north façade;
in the foreground, the granite bowl with winter cover in front of the
Altes Museum →

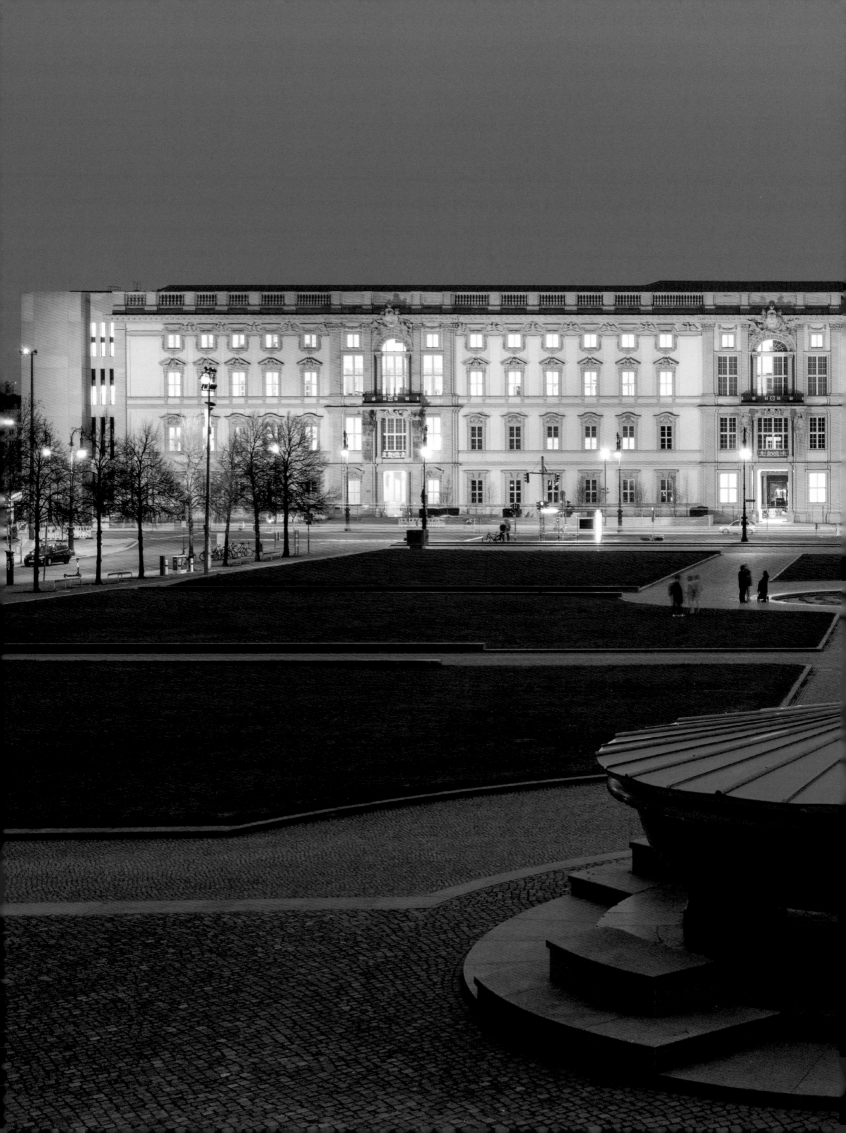

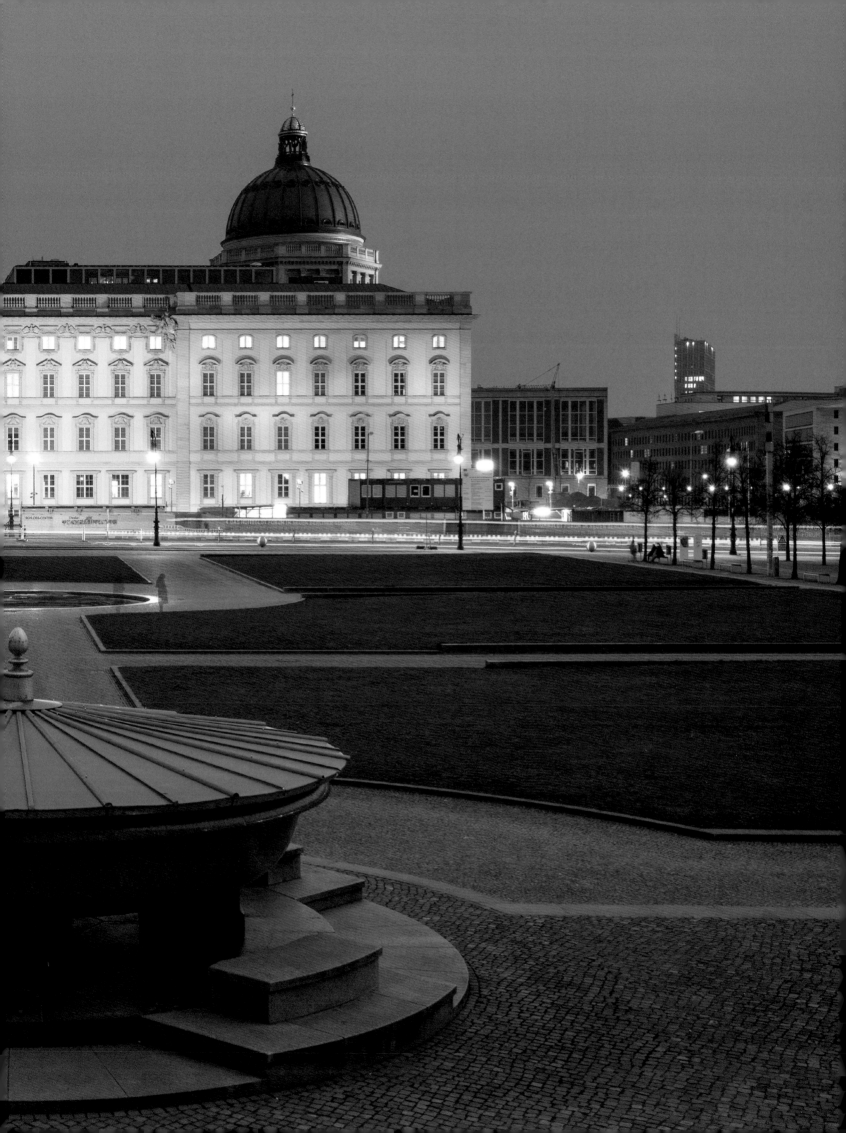

Detail of the Lustgarten façade with the Atlas herms of Portal 5 (left) and Portal 4 (right)

Here as well, the *risalit* is composed of three layers. The first includes the front pillars and colossal pilasters as well as the group of genii hovering above the Corinthian window arcade. Furthermore there are two Atlas herms supporting a balcony and a pair of eagles flying below the balcony slab, presumably representing the heraldic birds of Brandenburg and Prussia and presenting a shield surmounted by the Prussian royal crown with the initials FR (*Fridericus Rex*). The windows of the side axes and the covered arch of the Corinthian arcade belong to the second layer. The rear layer naturally consists once again of the storey orders of the central axis – including the inner arcade arch. And once

again, the storey orders prove to be extensions of internal column positions.

But despite these similarities, there are elements that do not appear stringent. The structure of the storey orders is interrupted by the balcony; and the function of carrying has shifted, at least in parts, from the columns to the Atlases as figurative elements. In fact, the balcony and Atlas figures are later additions from the workshop of Balthasar Permoser, the sculptor of the Zwinger in Dresden.

Far more than on Portal 1 and the court *risaliti*, the figure decoration follows the principle of increasing vivification and embodiment. This is analogous to the gradually spatialising

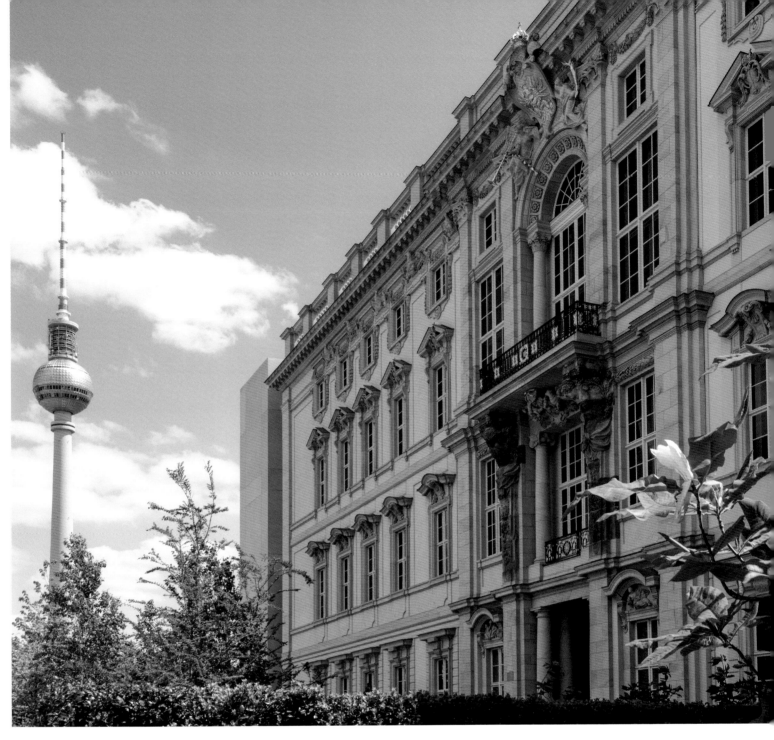

The eastern section of the Lustgarten façade with Portal 5 and view onto the television tower on Alexanderplatz

and embodying architecture of Portal 5. While the lion heads on the eaves cornice are still a purely architectural motif (on the Greek temple they served as gargoyles), the reclining allegorical figures of strength and justice in the gables of the lateral ground floor windows are already fully figurative. With the Atlantes, where the herm pilasters turn into fully sculptural male figures, the figural decoration literally grows out of the architecture, but it is still integrated into the tectonic structure, as is the pair of eagles, which can neither really detach themselves from the Ionic storey architrave nor from the balcony slab. The balustrade figures (they are still missing but will be added at a later date) are already

completely detached; but as crowns of the pilasters, they are still integrated into the architectural structural system. Only the genii are autonomous. They give the impression of having been flown in from elsewhere to hang the Prussian royal coat of arms above the arcade.

Furthermore, Schlüter also used spatialisation for iconographic purposes. In a portrait created by Friedrich Wilhelm Weidemann in 1702, Frederick I wears the coronation mantle over knightly armour, complete with the chain of the Order of the Black Eagle. The message conveyed here is that the Kingdom of Prussia emerged from the Teutonic Order of Knights. This message was also conveyed by the Lustgarten

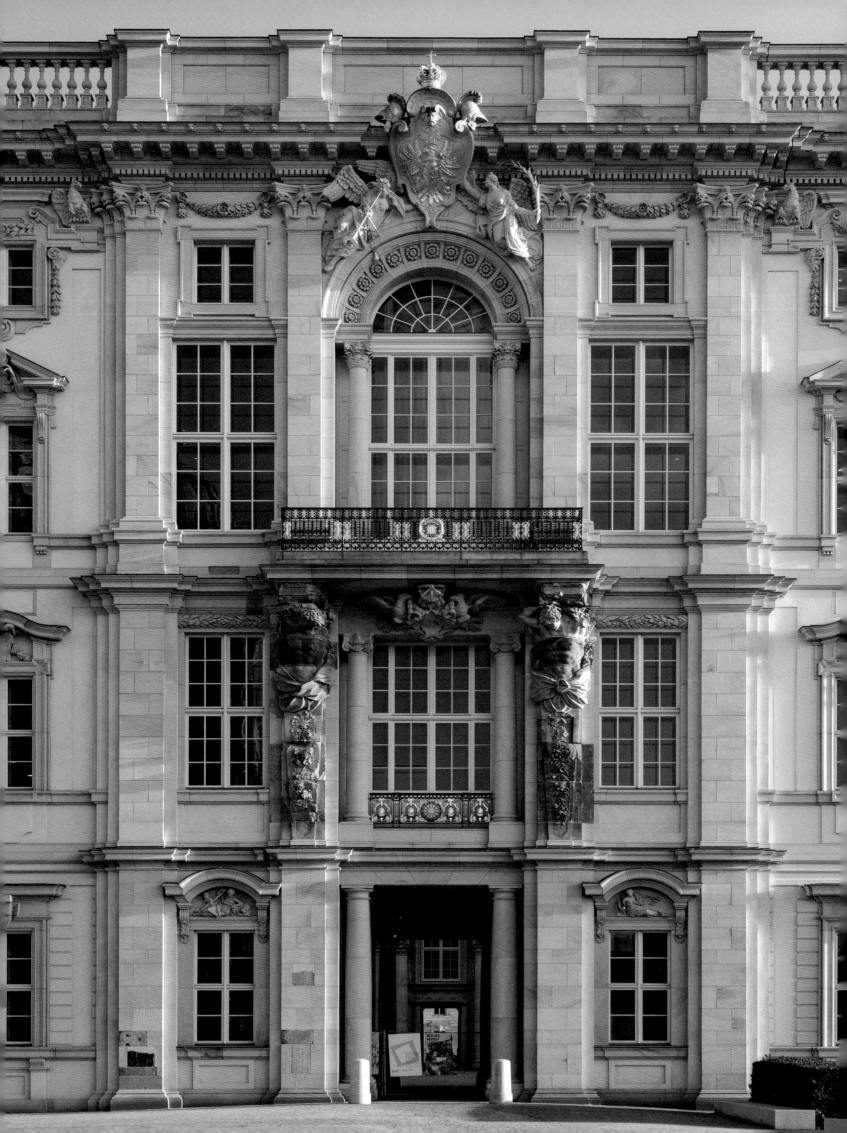

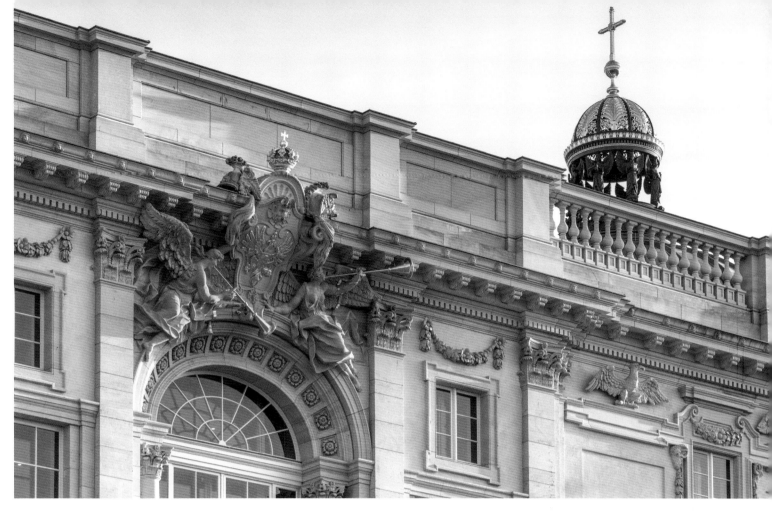

Genii with the Prussian coat of arms on Portal 4 and view onto the dome

façade with Portal 5, which appears in the background of the painting. Behind Portal 5 was originally the Knights' Hall. It was covered by the façade in a similar way as the knight's armour was covered by the royal regalia in Weidemann's painting. The decoration of the Knights' Hall reveals that this analogy was intentional. In the ceiling painting, Minerva brought the king's mantle down from heaven to earth, the fabric flowing smoothly from the two-dimensional painting via a stucco relief into the fully sculptural architecture of the window arcade. This was mirrored exactly to the outside. The mantle thus merged with the façade, as it were. At the same time, the eagle frieze on the outer walls paraphrased the chain of orders. Ultimately, Schlüter not only combined the façade and interior decoration into a *Gesamtkunstwerk*, but he also lent the architecture the symbolic power of a painting.

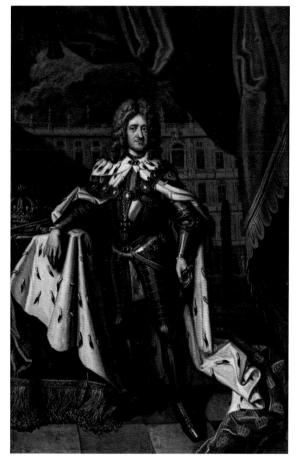

← Portal 5 of the Lustgarten façade with herm pilasters, genii, and the Prussian royal coat of arms

Friedrich Wilhelm Weidemann, *Portrait of King Frederick I*, 1702

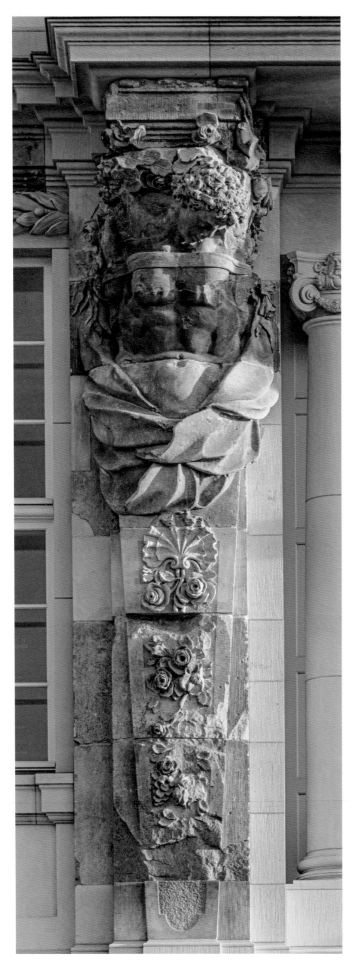
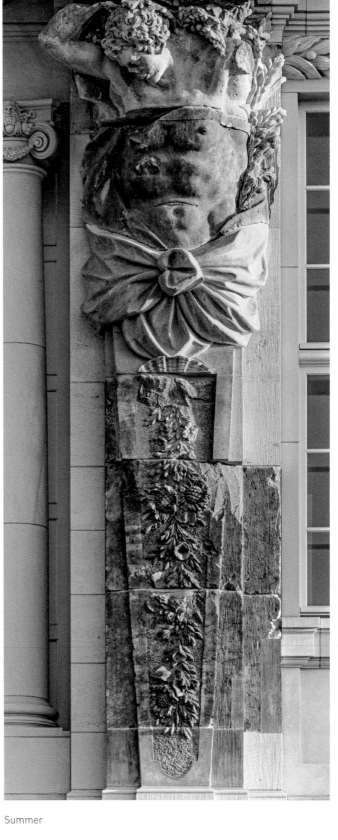

The four Atlas herms on Portal 5 (left) and Portal 4 (right)
with the attributes of the four seasons:

Spring Summer

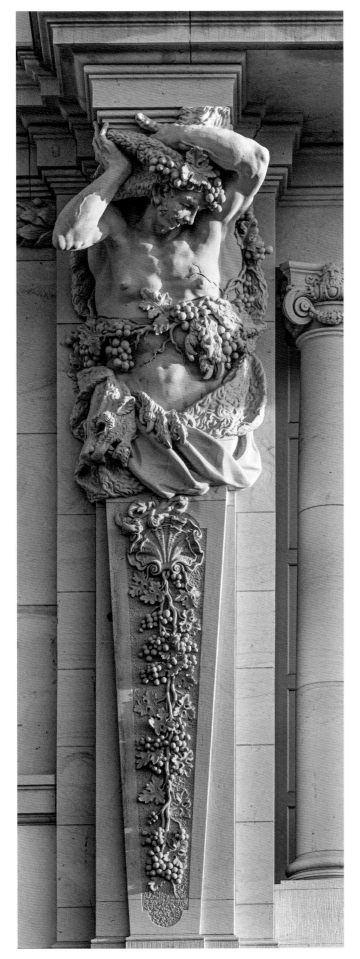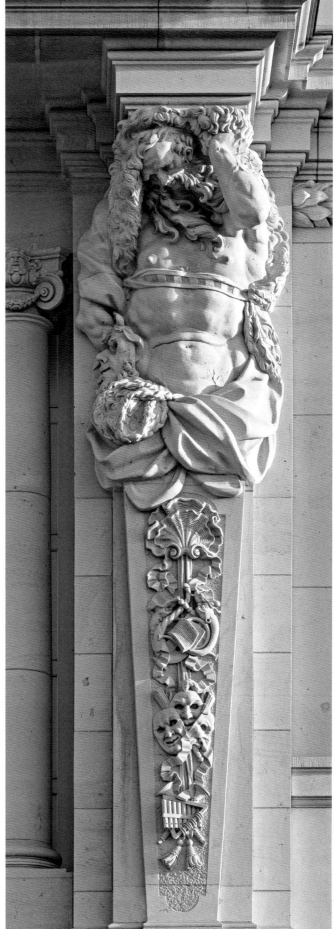

Autumn Winter

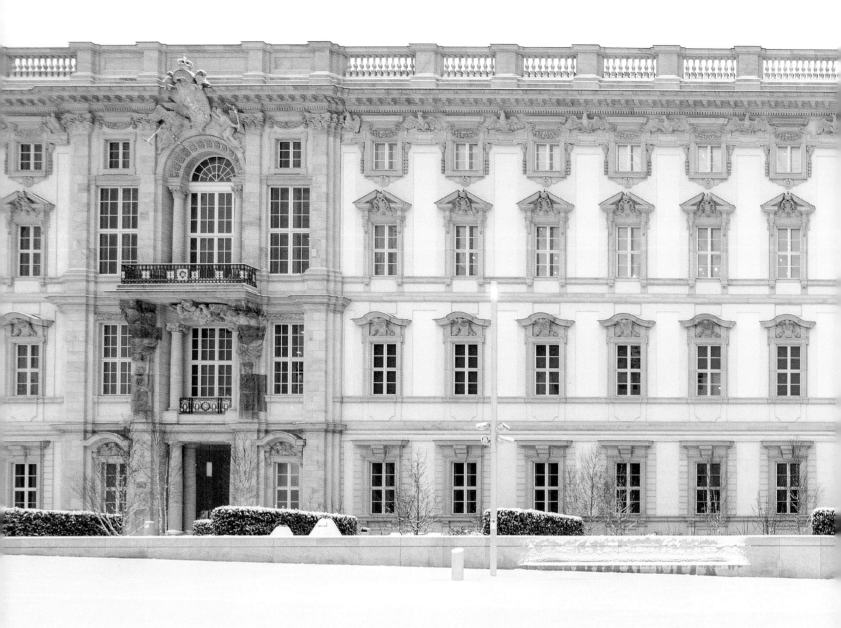

The Lustgarten façade with Portal 5 by Schlüter, Portal 4 by Eosander, and corner cartouche (above right)

THE EXPANSION OF THE PALACE BY EOSANDER AND BÖHME

Despite his ingenious talent, Schlüter was relieved of the planning and construction management of the palace in 1706 after the medieval Mint Tower, which he had raised to roughly one hundred metres, had to be removed again due to acute danger of collapse. He was succeeded by Johann Friedrich Eosander von Göthe, whom the king now commissioned to more than double the size of the palace to the west and to create a second inner courtyard (the so-called Eosanderhof, today the Foyer). It is possible that the king wanted to compensate for the loss of the Mint Tower, which was to have been a particularly magnificent landmark. But he was cer-

tainly also reacting to the development that the urban environment had taken in the meantime.

When Schlüter began remodelling the palace in 1698, the Lustgarten was the remote northern end of the Spree Island. It lost this peripheral status when Frederick pushed ahead with the expansion of Dorotheenstadt, built by his father along the avenue Unter den Linden, and founded Friedrichstadt directly next to it. With the extension of the palace, the king wanted to reduce the distance between his residence and the two suburbs as well as to Friedrichswerder, located on the opposite bank of the Spree Canal.

In 1708, Eosander began work on the Lustgarten side. With six window axes next to Schlüter's Portal 5, he erected another *risalit* (Portal 4), largely adopting the structural

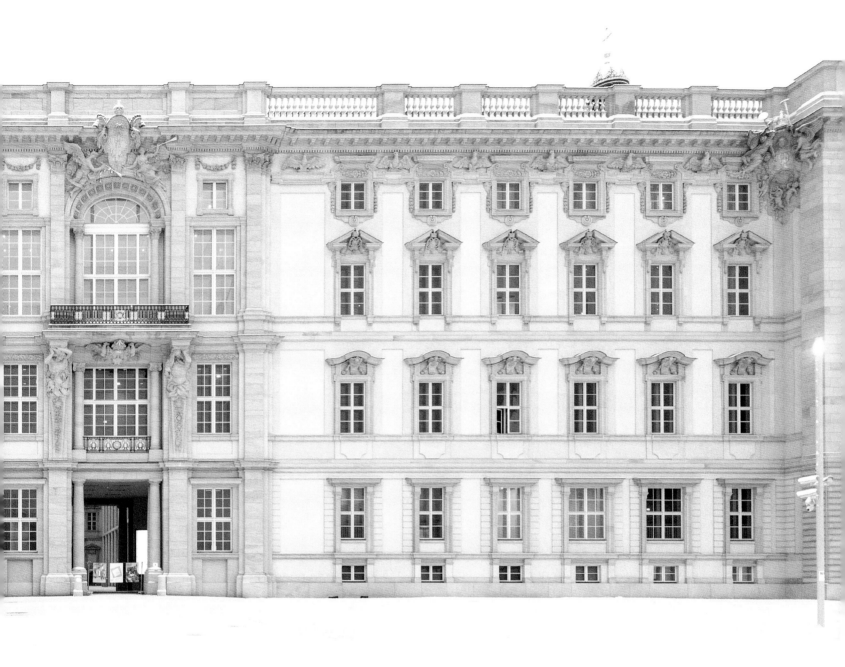

system of his predecessor. However, he added a balcony supported by Atlas herms. For the sake of symmetry, he also later had this motif added to Portal 5 – as already mentioned, by Permoser. The articulated construction character of the architecture was considerably weakened by this intervention in favour of a more decorative architectural language.

At the same time, Eosander gave the new *risalit* a broader central axis, so that the round arch of the Corinthian arcade was widened. In the area of the portal passage, the widening presumably served to improve access to the new palace courtyard. It is also possible, however, that Portal 4 was initially intended as the middle of a total of three *risaliti* and in this capacity was to set a stronger accent. However, Eosander was not able to extend the palace to the extent that there

would have been enough space for a third *risalit* including an adjoining rear courtyard. The Lustgarten façade thus became an asymmetrical torso.

In order to distract from this shortcoming, Eosander upgraded the west façade facing the Spree Canal to the new main façade: He designed Portal 3 there as an oversized triumphal arch that surpasses even Portal 1 in its monumentality. To further enhance the effect of this quotation, Eosander reduced the articulation of the façades on both sides. The eagle frieze and the panel-like recesses in the walls were omitted, and the window frames were given slimmer profiles in which all figural decoration is missing. Schlüter's subtle dialectic was replaced by a rather striking, yet imposing gesture of domination. Regardless of the row of

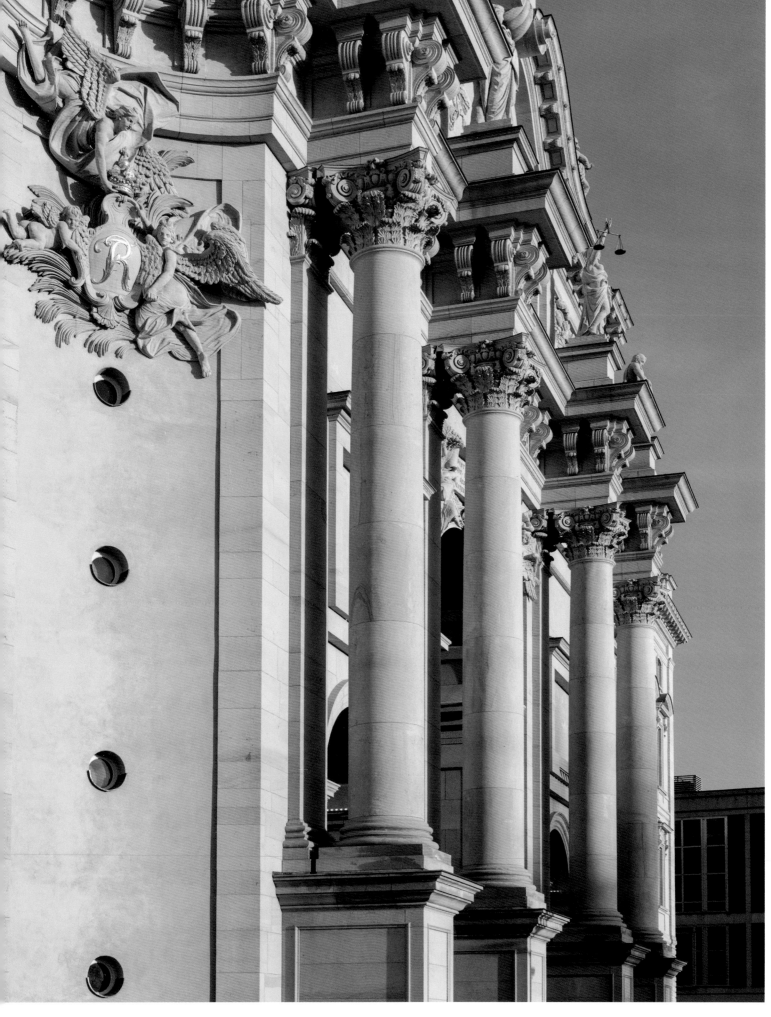

Row of columns on the Eosander Portal (Portal 3)

The façade structure of the Lustgarten façade with rhythmisation via the window axes →

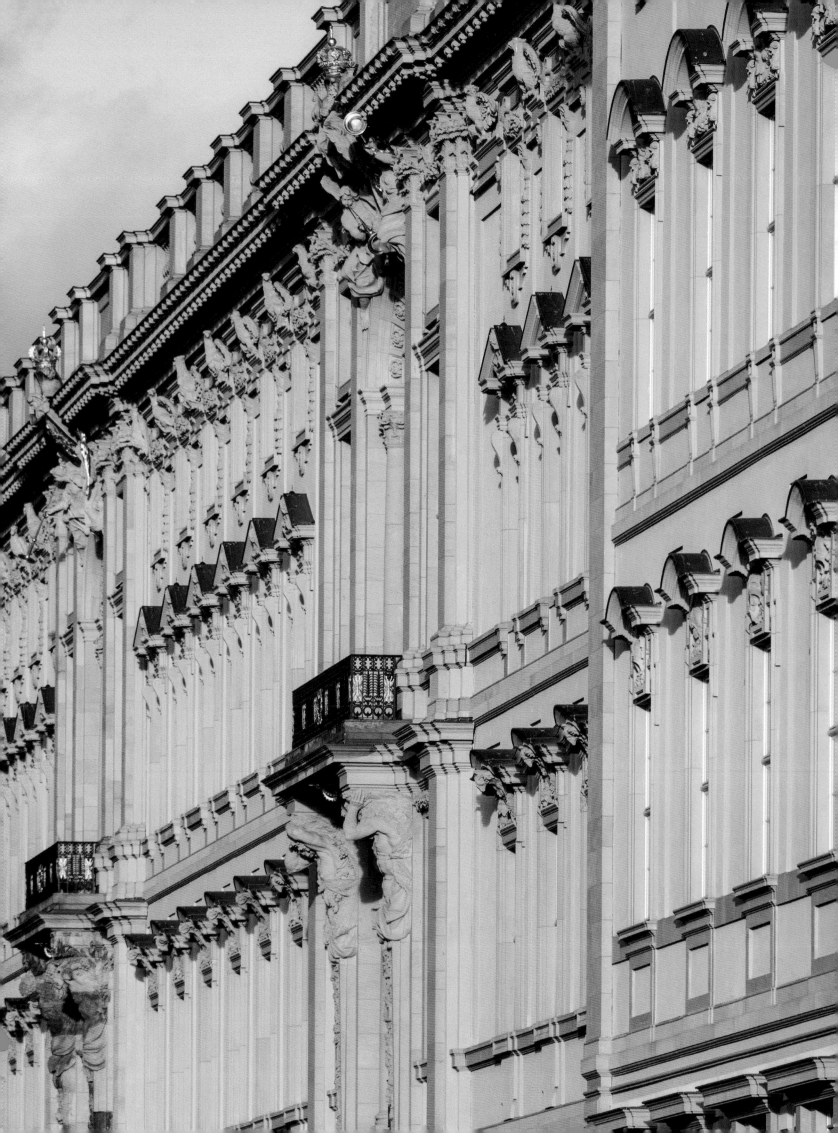

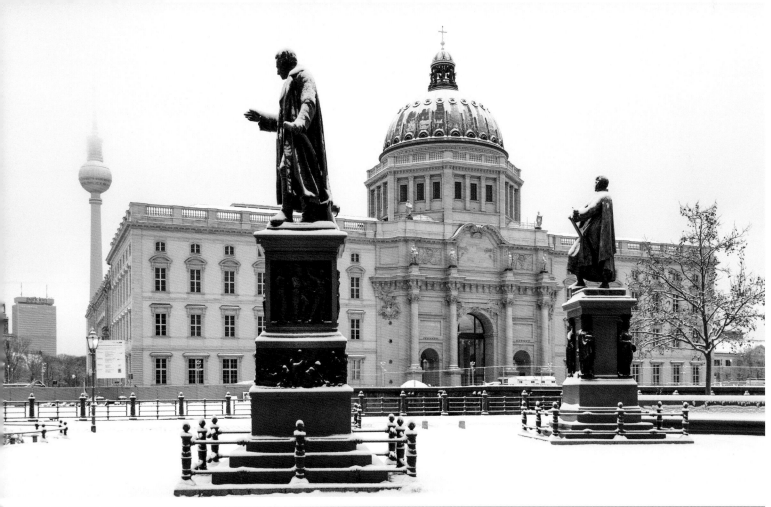

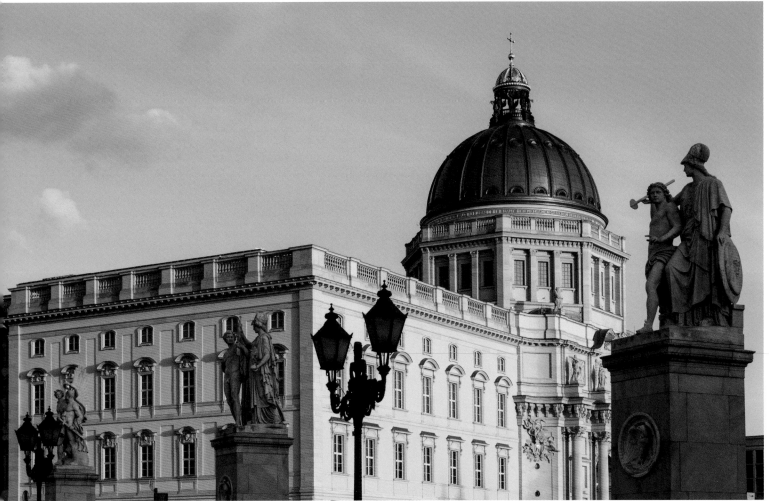

Top: The west façade with the Eosander Portal, seen from Schinkelplatz
Bottom: View from the Palace Bridge onto the north-west corner and the dome

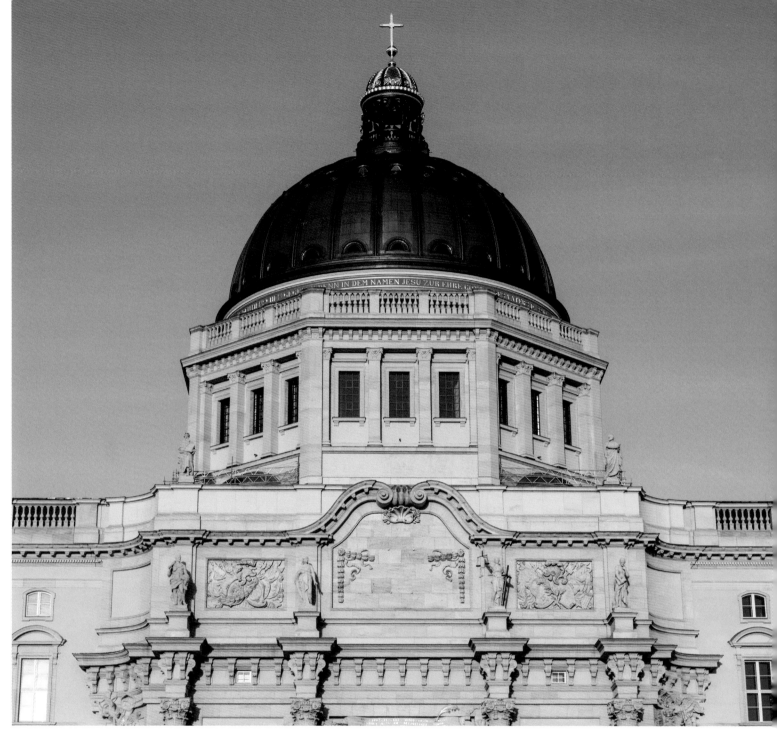

Upper section of the Eosander Portal with the dome, colossal figures, and reliefs with symbols of triumph and war

houses on the Schlossfreiheit facing the Spree Canal, which partially concealed Portal 3 until it was demolished in 1894, the triumphal arch provided a strong urban accent, especially since it was located in the alignment of Brüderstrasse, which extended from Petrikirchplatz as the former centre of Cölln, an independent city on the Spree Island until 1709 (today this connection is cut off by the former State Council Building of the GDR).

When Frederick I died in 1713, his son and successor Frederick William I dismissed most of the court, including the cavalier architect Eosander. Now it was up to Schlüter's disciple Martin Heinrich Böhme to complete the right section

of the façade and then to close the remaining gap on the south side by building Portal 2. As the gilded inscription under the entablature of the giant order informs us, the work was completed in 1716. Whereas Eosander had conceived Portal 4 facing the Lustgarten as a wider version of Portal 5, Böhme created a wider copy of Portal 1, taking care to place it in the axis of Portal 4. Eosander had already had this axis in mind, as it lies in the extension of Breite Strasse, the former Cöllner Hauptstrasse. This street began at the Cölln town hall. Portal 2 thus became another urban *point de vue* and a link between the southern and northern ends of the Spree Island. Furthermore, Breite Strasse intersects directly

Bottom: Detail of Portal 2 on the south façade with the dating 1716

Top and right page: Details of the west façade →

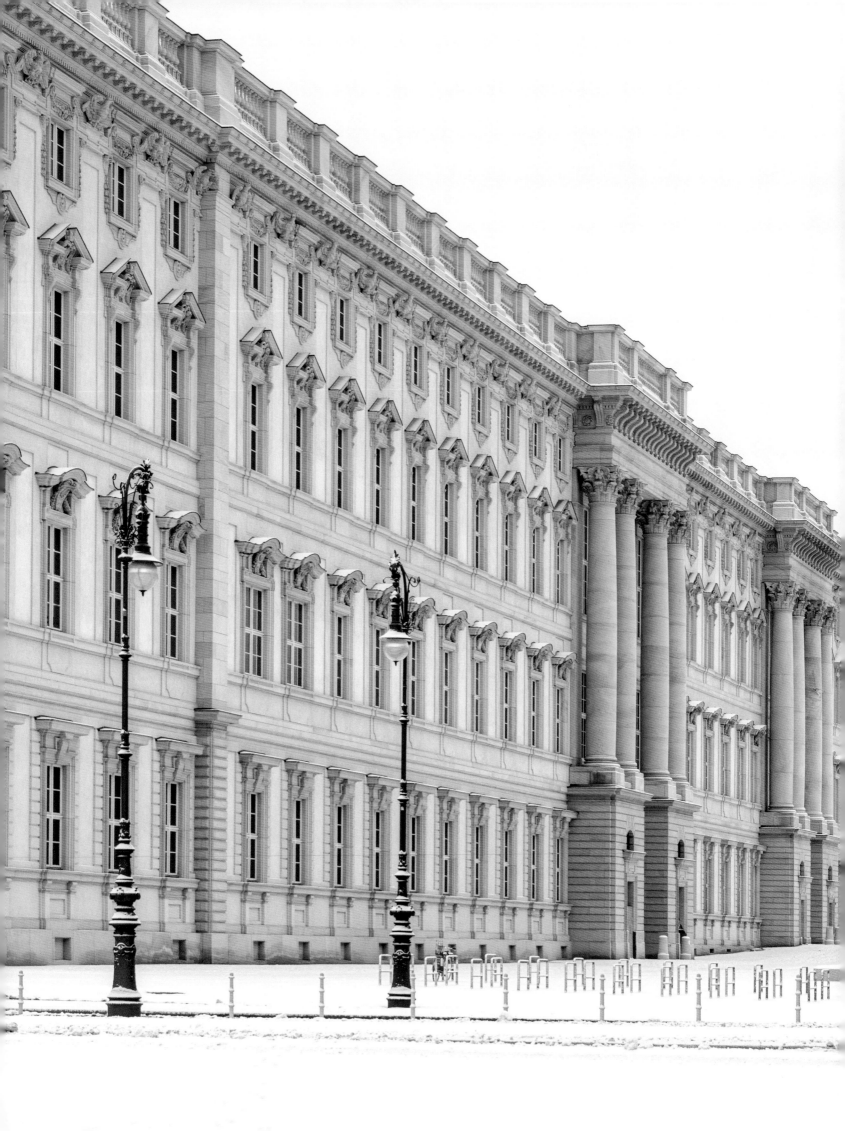

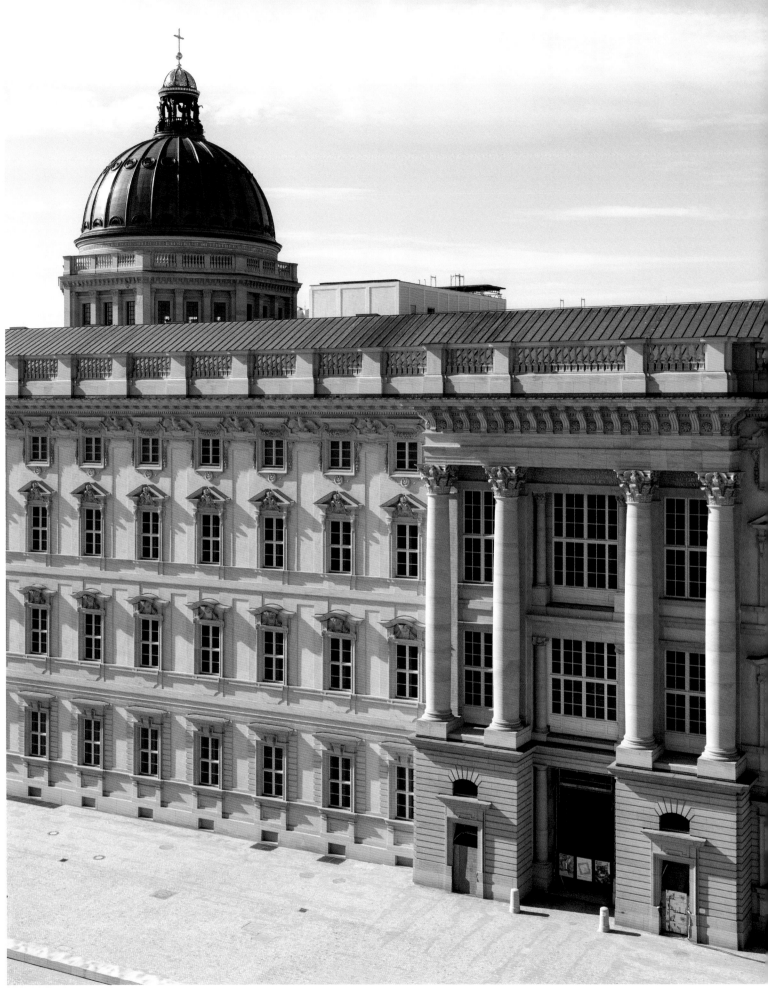

← The south façade with Portal 2 (left) and Portal 1 (right)

The south façade facing west with Portal 2, crowned by the dome

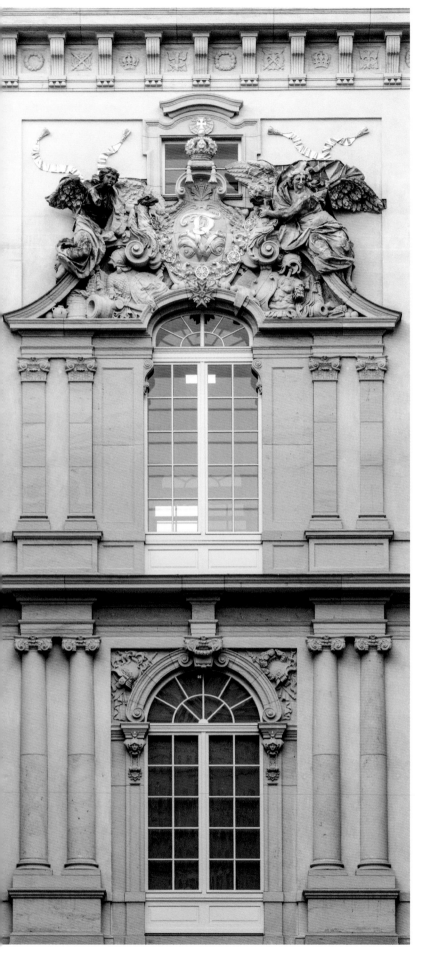

The courtyard side of Portal 2 with columns on the first floor, pilasters on the second floor, and heraldic cartouche

in front of it with the axial extension of Alt-Berliner Rathausstrasse (Schlossplatz). This intersection of two major routes also formed the zero point for the mileage counting of the Brandenburg-Prussian road system.

We continue our tour by passing through Portal 2. Whereas, in the past, one entered the Eosander courtyard here, today one enters a narrow passage created by Franco Stella, which connects the backs of Portal 2 and 4 and thus reinforces the axis coming from Breite Strasse in the direction of the Lustgarten. Since Stella understood all five portal *risaliti* in the sense of Schlüter and Eosander as gate buildings with spatial depth and not only as facade applications, he reconstructed not only the passages but also the backs of Portals 2 to 4, and in doing so went beyond the original specifications of the competition for the reconstruction.

Like Portal 3, the portal passages 2 and 4 show an architectural conception that deviates from Schlüter. They were designed as three-aisled halls, the columns of which are significantly lower than in portal passages 1 and 5. In addition, Böhme interrupted the rows of columns in portal passage 2 with massive pillars.

However, Eosander and Böhme abandoned not only the principle of a one storey structure running through the entire building. Schlüter's dialectic of two-dimensional wall construction and three-dimensional articulated construction meant nothing to them either. This is even more evident on the backs of Portals 2 and 4 than on the Atlas herms on the Lustgarten side or on the triumphal arch motif of Portal 3. The division of the lower storeys with Doric columns neither extends into the depth of the passage nor does it continue up the façade. Rather, it flattens out there into a purely decorative wall architecture: On the first floor, the Corinthian pilasters no longer even reach up to the eaves cornice but end prematurely at the height of the adjacent window lintels. The remaining area is concealed by a coat-of-arms cartouche and an ornamental gable that lacks any tectonic logic with its forced-open central field.

We now turn west from the middle of the passage and end our tour in the foyer, which takes up most of the former Eosanderhof courtyard. Stella has surrounded it on three sides with four-storey galleries that face the back of Portal 3 as if it were the back wall of an ancient Roman theatre stage (*scenae frons*). The theatricality of the Schlüterhof courtyard has been taken up here. The (neo) Latin inscription on the banner unrolled by two genii above the round arch of the triumphal arch deserves our final attention. It states that Frederick founded and extended his "royal residence" (REGIA) "for the grandeur of his kingship" (PRO DIGNITATE REGNI) and in this way contributed to the "eternal adornment of the city and his time" (AETERNO VRBIS ET SAECVLI SVI ORNAMENTO).

The inscription thus alludes to the eminent importance of the palace for the development of Berlin. With its five portal *risaliti* and the two courtyards used as transit halls, it had a

Passage with a view through courtyard Portal 4
onto the portico of the Altes Museum →

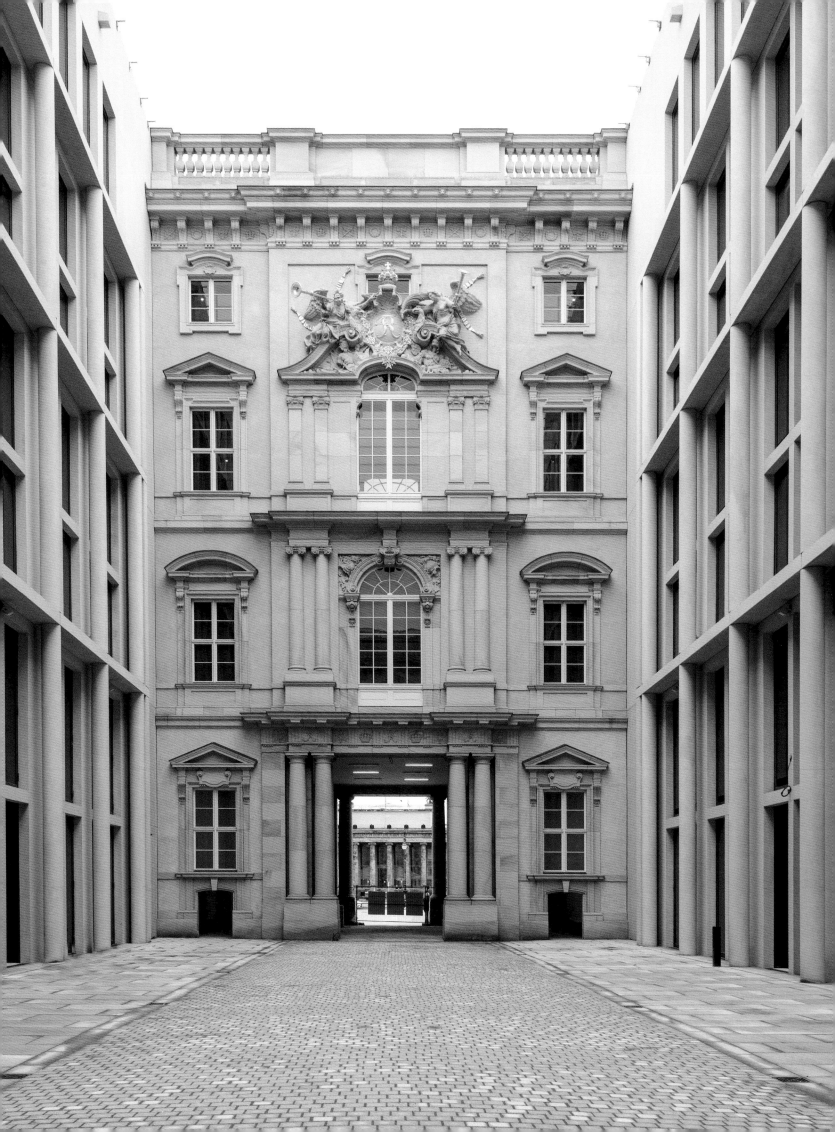

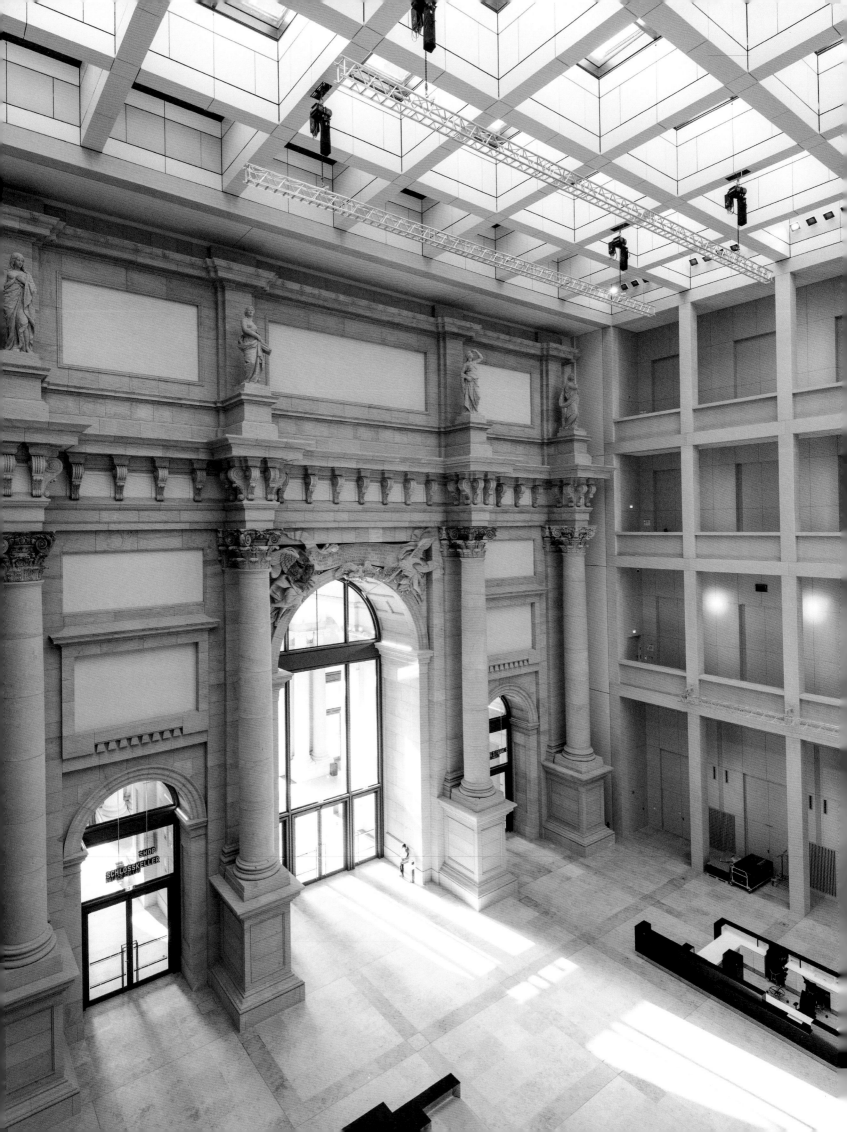

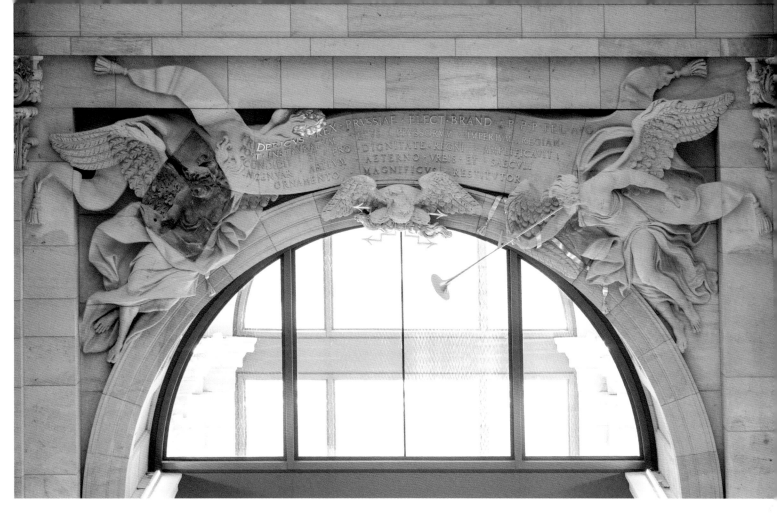

Genii above the round arch of the triumphal arc with banderole in the foyer

joint function that contributed significantly to structurally and ideally connecting the districts of Old Berlin, Cölln, Friedrichswerder, Dorotheenstadt, and Friedrichstadt, which had been autonomous towns until 1709, to the "royal residential city of Berlin", which then also advanced to become a Prussian metropolis in 1772. In turn, the development of the city was oriented on the palace, more precisely on the scale, the structure, and the figural decoration of the façades – and this continued until the First World War: With regard to the planning for the Forum Fridericianum, in the redesign of the avenue Unter den Linden, and in the development of the Spree Island with the Marstall (the royal stables, today the Hanns Eisler Academy of Music), the Berlin Cathedral, and the museums.

In addition, the palace proved to be a cultural crystallisation point. With its library, its cabinets of rarities and curiosities, and its collection of antiquities and paintings, as well as with its artistic furnishings and its façades, it was Berlin's first cultural forum. With the reconstruction of the façades that now sheath a new cultural forum, the cosmopolitan city of Berlin has reconnected with itself once again.

Peter Stephan is professor of Architectural Theory at the University of Applied Sciences Potsdam, and professor of Art History at the University of Freiburg.

← The foyer with the courtyard side of the Eosander Portal

Sculptures on the courtyard side of the Eosander Portal, from left to bottom right: Love, Faith, Hope, Prayer →
Vaults above the passage through the Eosander Portal →

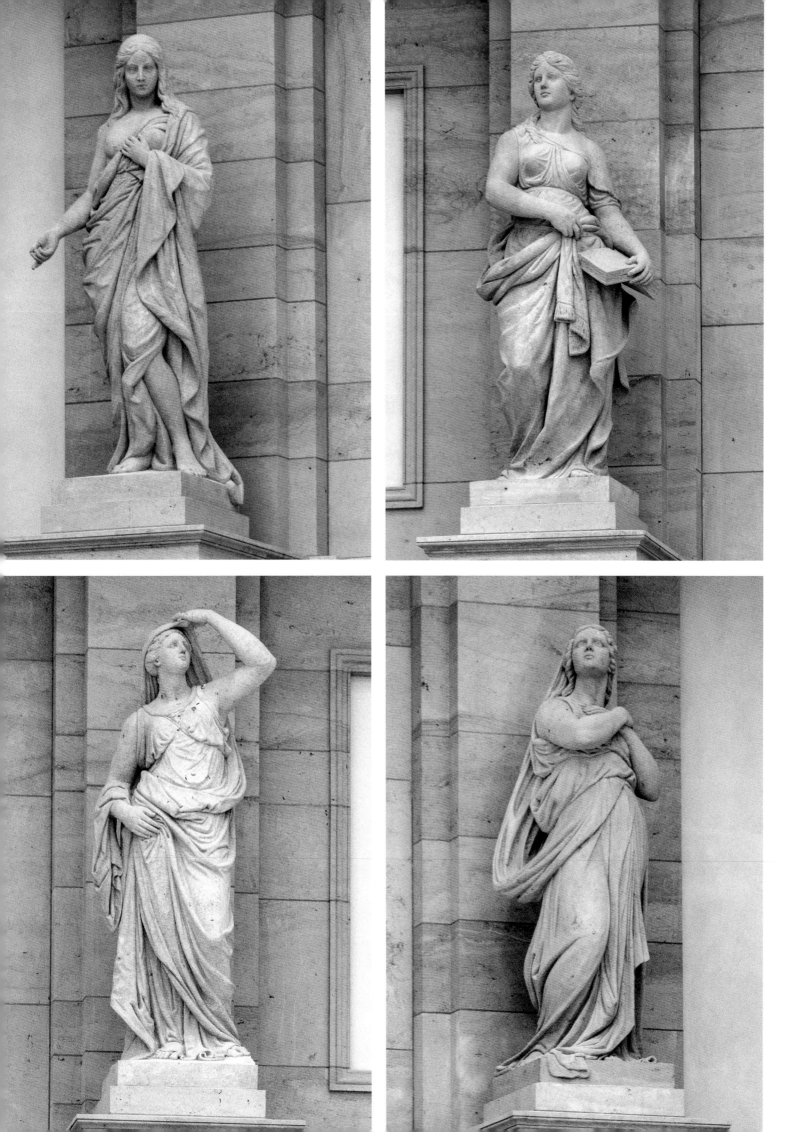

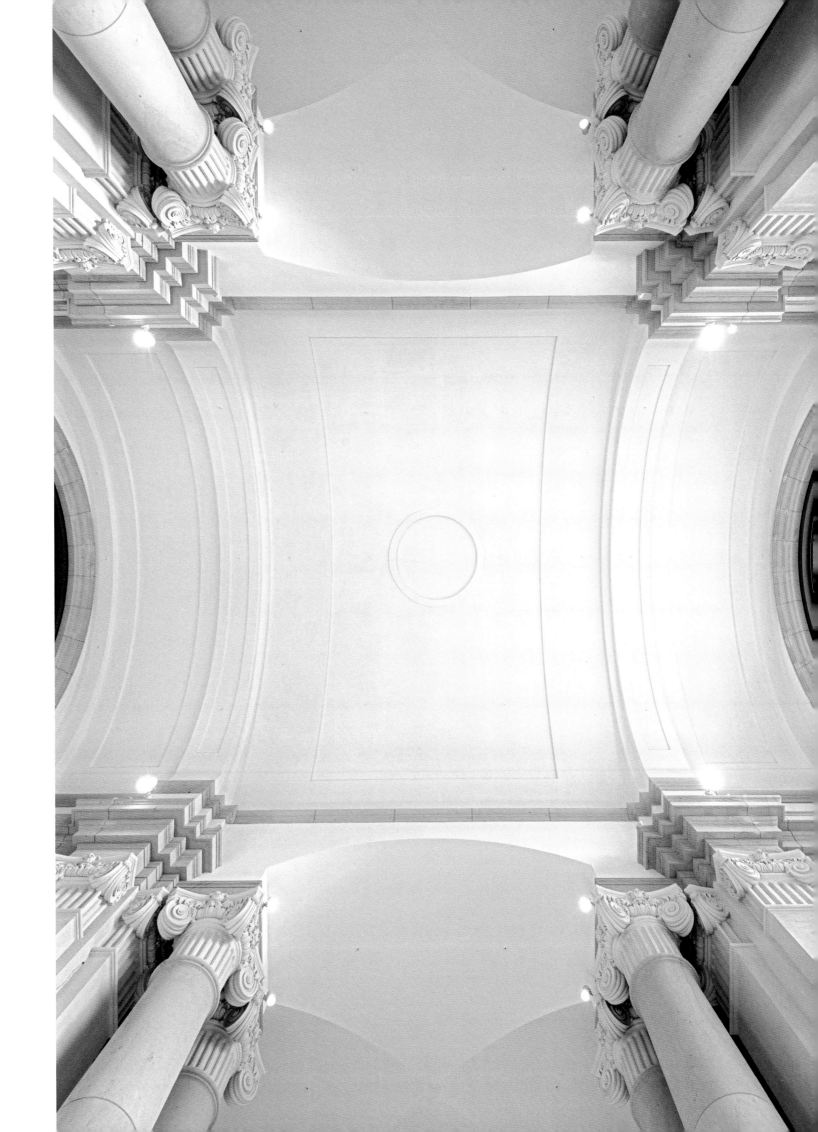

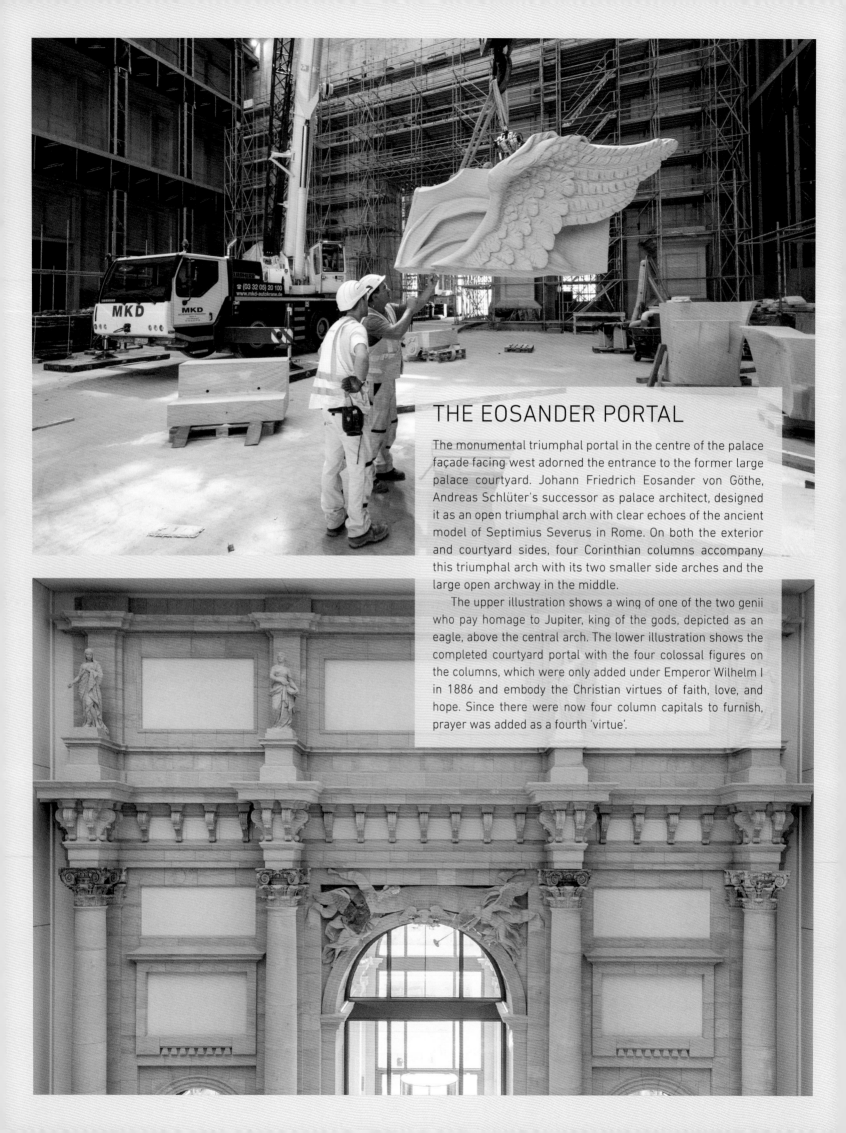

THE EOSANDER PORTAL

The monumental triumphal portal in the centre of the palace façade facing west adorned the entrance to the former large palace courtyard. Johann Friedrich Eosander von Göthe, Andreas Schlüter's successor as palace architect, designed it as an open triumphal arch with clear echoes of the ancient model of Septimius Severus in Rome. On both the exterior and courtyard sides, four Corinthian columns accompany this triumphal arch with its two smaller side arches and the large open archway in the middle.

The upper illustration shows a wing of one of the two genii who pay homage to Jupiter, king of the gods, depicted as an eagle, above the central arch. The lower illustration shows the completed courtyard portal with the four colossal figures on the columns, which were only added under Emperor Wilhelm I in 1886 and embody the Christian virtues of faith, love, and hope. Since there were now four column capitals to furnish, prayer was added as a fourth 'virtue'.

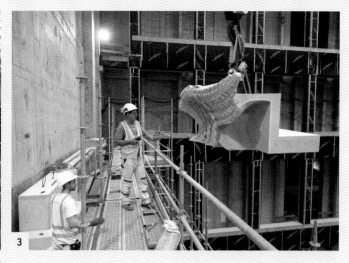

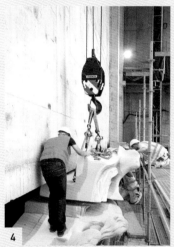

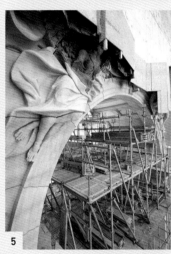

1–4 The three to four tonne stone blocks of the self-supporting natural stone façade of the Eosander Portal are 'shifted', i.e. mounted, with heavy equipment in front of the reinforced concrete wall of the shell.

5 The dark-patinated stone surface shows the preserved original sculptural element of the genie, which was mounted into the decorative portal.

6–9 So as not to overload the still original capitals of the Corinthian column, with the sandstone slabs on top, they were drilled through, and the load was dispersed onto steel cores.

10 The areas between the columns were lined with bricks in the historical format and covered with light-coloured plaster. In the foreground of the illustration is the construction site during the expansion phase, where decoratively packed aluminium elements of ventilation ducts can be seen.

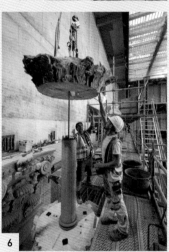

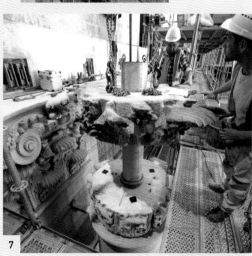

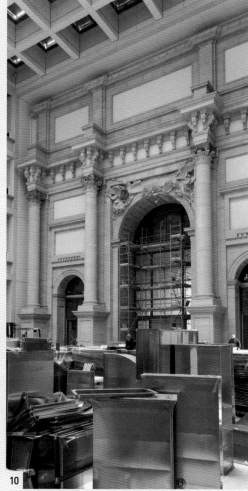

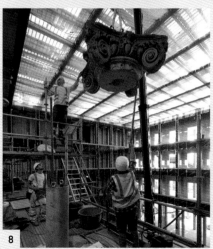

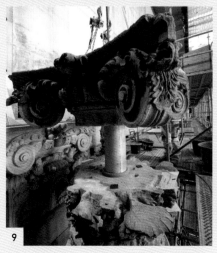

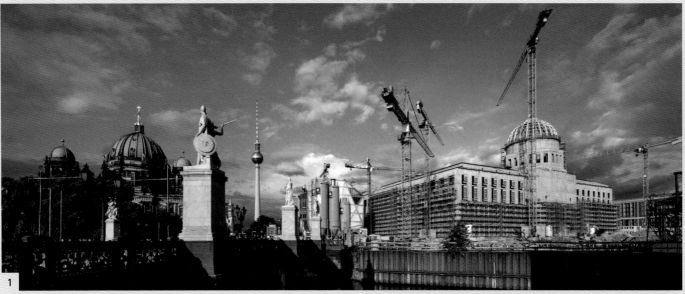

1

1 Visible from afar, the shell of the west façade with the portal by Johann Friedrich Eosander von Göthe (1717) and the dome by Friedrich August Stüler (1847) is under construction.

2 A template created with wood for the construction of the central round arch portal made of profiled sandstone elements. Only with the insertion of the central keystone does the arch achieve stability.

3 + 4 On the round arch, as on the courtyard side of the portal, lie the genii with their fanfare horns. Blocks weighing tonnes are 'threaded' into the shell.

5 Laurel tendrils and ribbons form the frame for a mighty heraldic cartouche made of bronze. The sculptors have skilfully carved the lightness and movement of the details into the hard sandstone.

6 Above the round arch, the architecture continues with heavily protruding cornices up to the balustrade. The individual blocks stand on top of each other with a setback depth of 65 centimetres.

7 To ensure that the pictorial forms appear unbroken and as one unit, as here on the relief with weapons, the sculpturing of the areas around the block joints are finished on the scaffolding.

8 The shell of the west side and the dome; in the foreground, one of the sculptures of the Palace Bridge

2

3

4

5

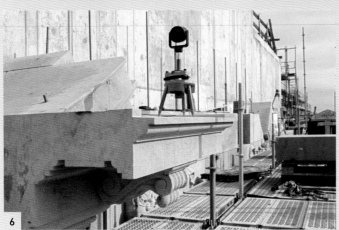

6

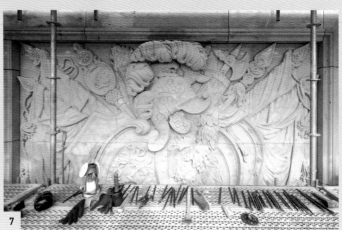

7

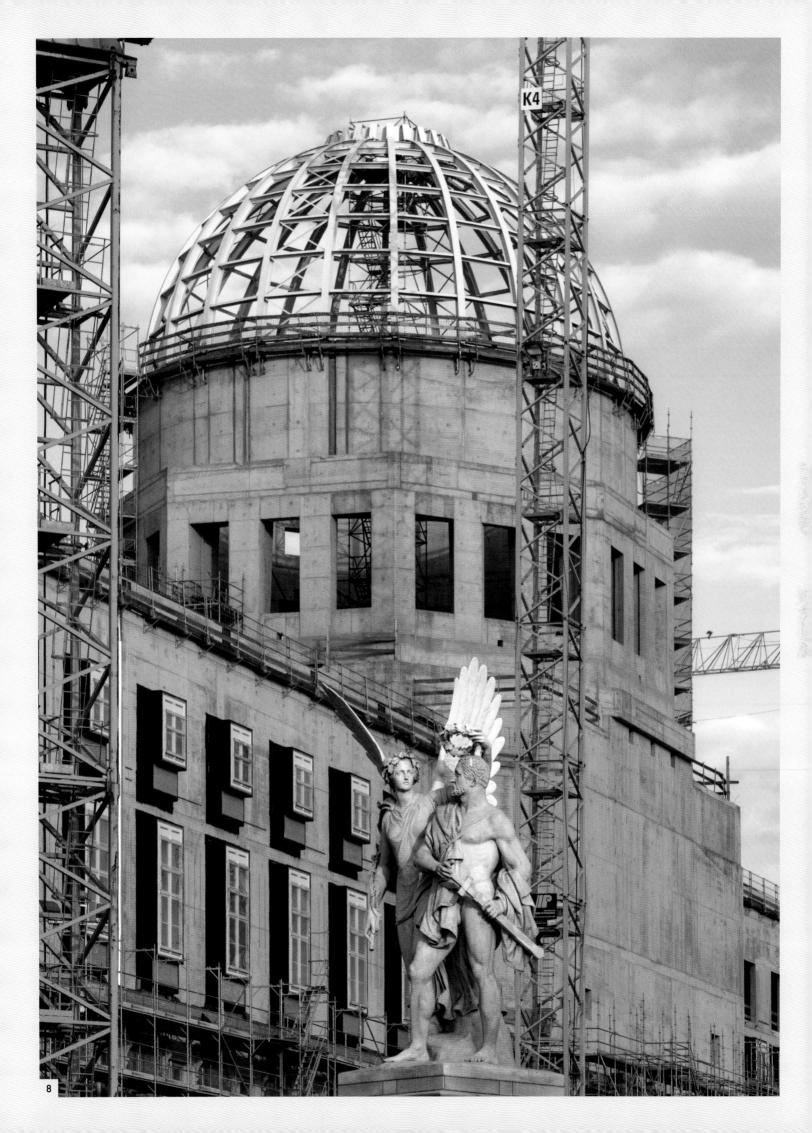

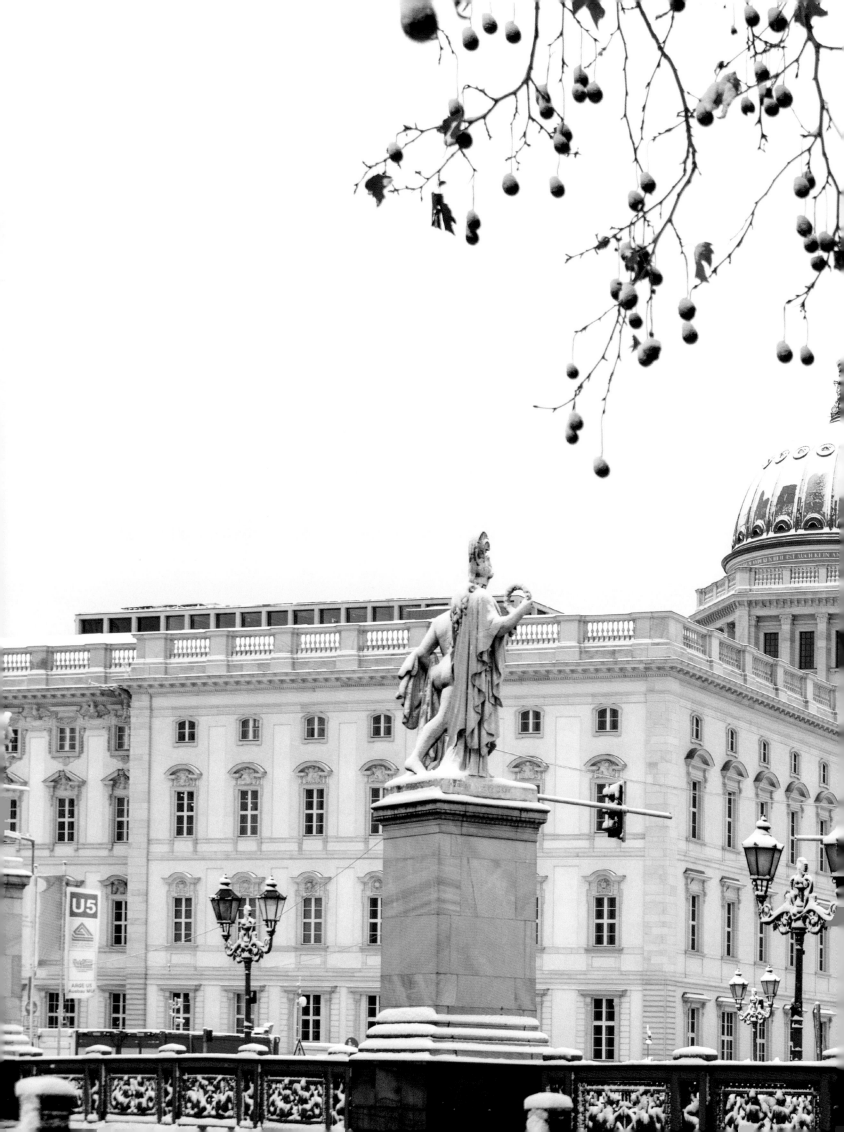

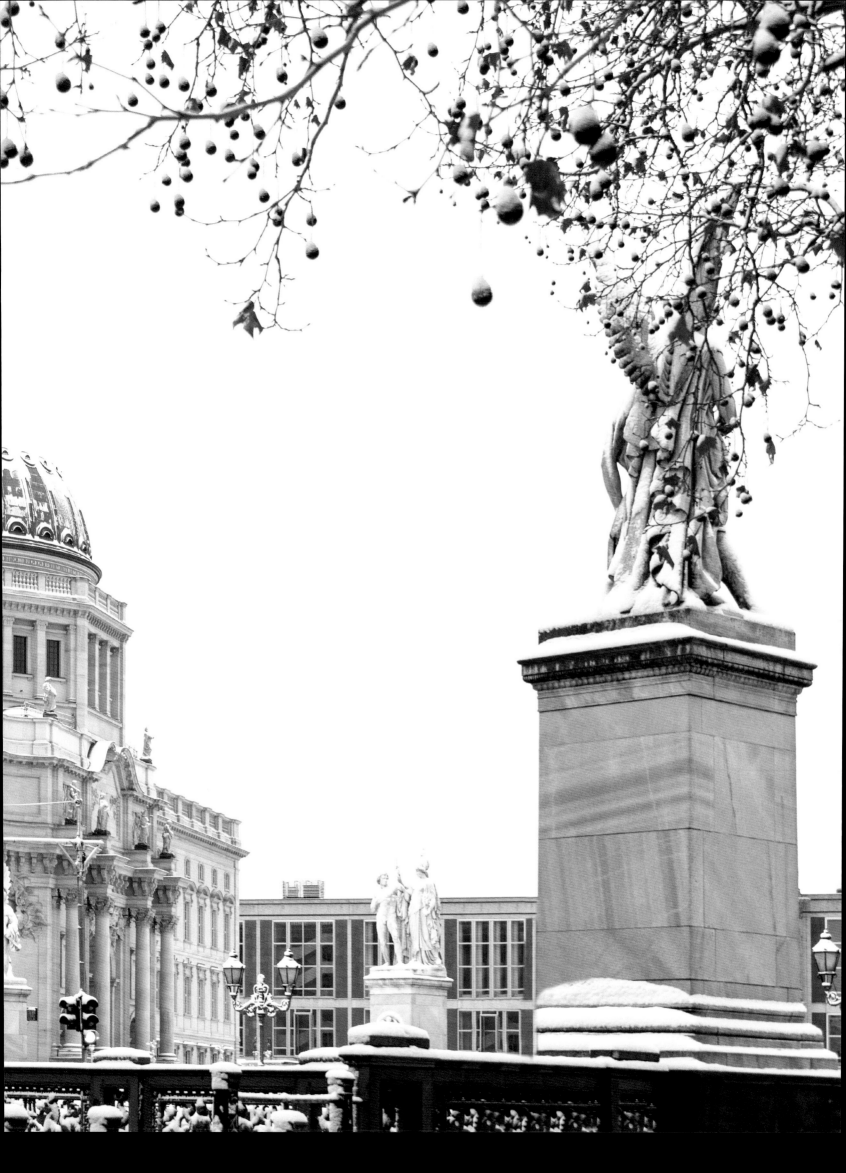

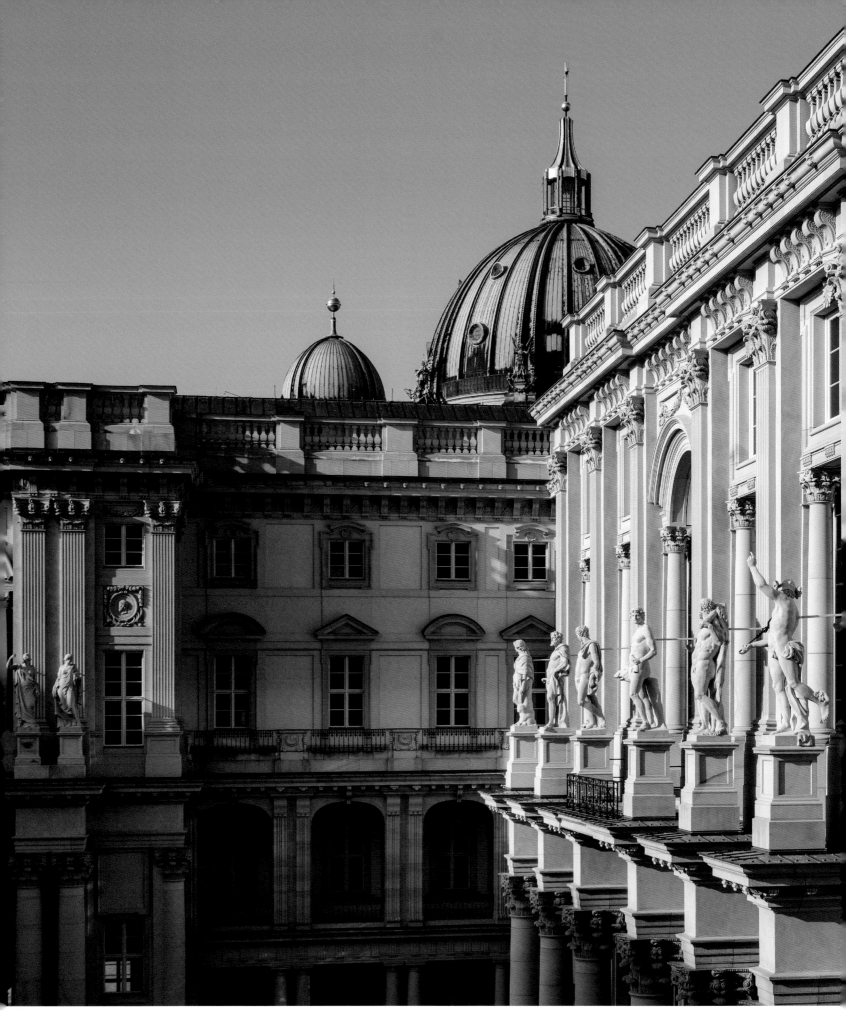

The Schlüterhof, view in northeasterly direction with Portal 6 and the courtyard side of Portal 5

← The west façade with the Eosander Portal and the dome, seen from the Palace Bridge

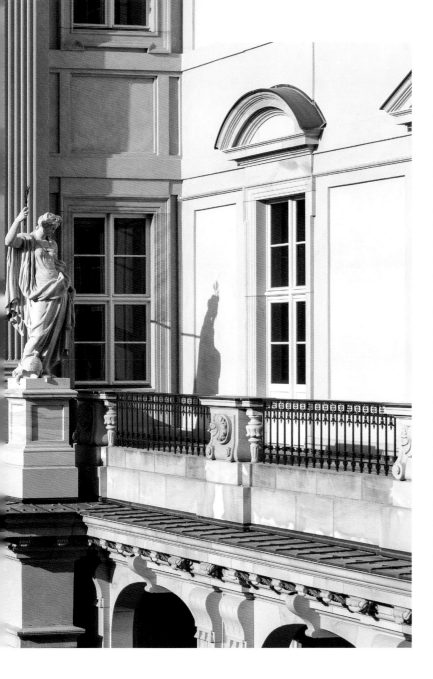

Bernd Wolfgang Lindemann

UNDER THE BANNER OF THE BAROQUE

ON THE ICONOGRAPHY OF THE BERLIN PALACE

The baroque Berlin Palace was an ambitious project, built from 1698 onwards by two historical figures: Frederick III, Elector of Brandenburg, who was King Frederick I of Prussia from 1701 to 1713, and Andreas Schlüter, his court sculptor. There was no residence building in the German states or in Austria that could equal the one that was being built in Berlin at that time. Schlüter was bold enough to submit his own designs when the Berlin court began to cast around for concepts concerning an extension to the palace, which was to provide an appropriate setting for the sought-after regality. The medieval period, the Renaissance, and the early baroque had left a charming conglomeration of constructional elements behind that now had to be redesigned and enlarged according to the notions of contemporary architecture and modern royal representation.

Not everything that Andreas Schlüter planned was carried out – and furthermore, his concept, which he had already modified several times, was changed by the enormous extension for which Johann Friedrich Eosander von Göthe had been commissioned in 1707, and yet it continued to be adhered to at the same time, although not entirely in the way Schlüter had originally envisaged. In addition, further changes were made in the mid and late nineteenth century, due, above all, to the new domed chapel. The entire area of the balustrades which round off the façades is particularly complicated: What the original sculptural decoration looked like here can hardly be ascertained with absolute certainty. At the time of the destruction of the palace in 1950, sculptural works from the nineteenth century stood there. And even the monumental figures in the Schlüterhof did not survive the passage of time unchanged: The attributes with which they

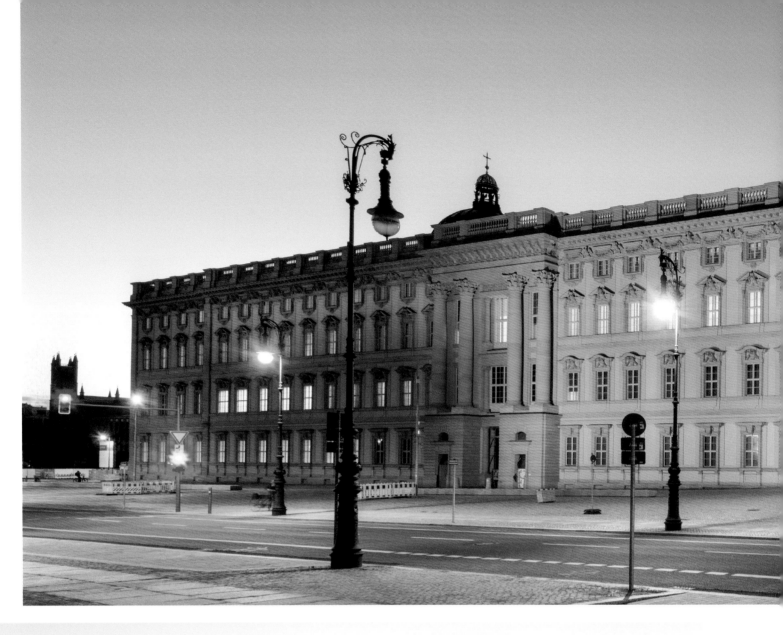

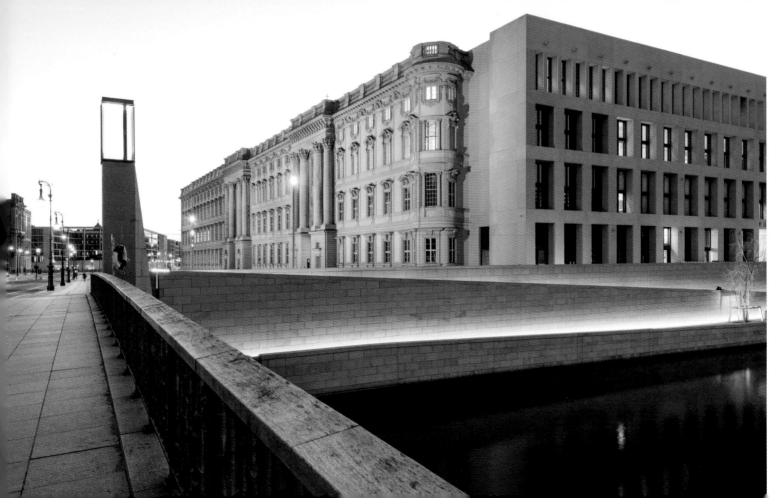

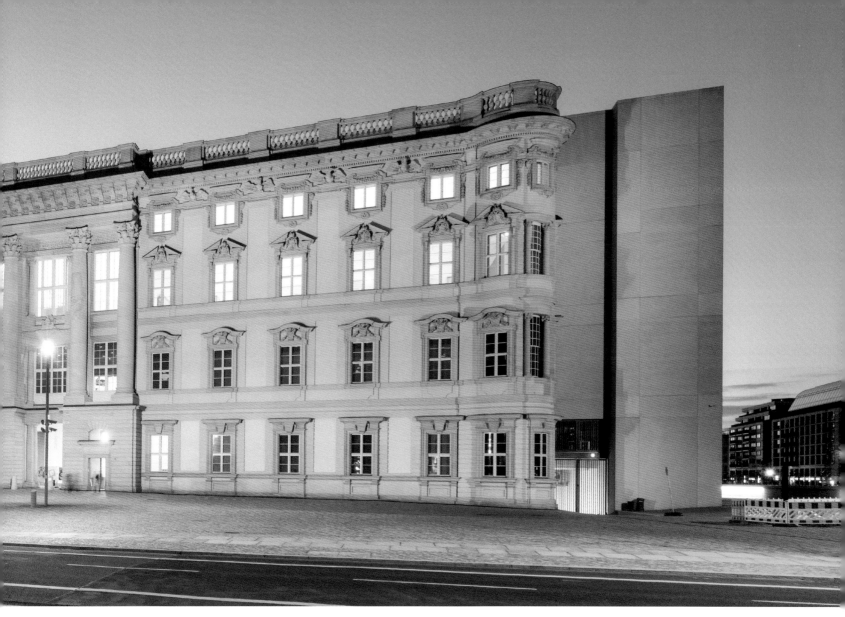

The south façade at dusk

were most recently endowed were not the original ones but were in all likelihood freely conceived additions from the nineteenth century.

The reconstruction of the palace carried out in recent years is not an entirely faithful reconstruction of what was damaged in the Second World War and demolished at the behest of Walter Ulbricht, later Chairman of the State Council of the GDR; it was decided not to rebuild the wing on the Spree side, which, until its demolition, had retained that picturesque appearance defined by medieval, Renaissance and early baroque components – Franco Stella's new wing now stands in its place (for a site plan, see pages 28/29). The restoration of modifications was also abandoned which dated back to interventions by Ernst von Ihne during his enlargement of the White Hall which was completed in 1895 and which resulted in serious changes in the inner façade of Portal 3. – Instead the original architecture of Eosander was reconstructed here.

ON THE OUTER APPEARANCE OF THE FAÇADES

When we consider the iconography of the baroque palace, it is important to bear in mind that the current reconstructed state is not able to match the original concept completely – however this may have appeared in detail.

Before the invention of dynamite, demolition was as costly as rebuilding – it is therefore understandable that Andreas Schlüter had to preserve as much of the existing parts of the Berlin Palace as possible when he began his grand project. And so it happened that when he redesigned the Renaissance wing on Schlossplatz, he had to retain its irregular window spacing. This deprived him of the opportunity to divide up his new façade with pilasters. Instead, the window axes became the main vertical structure, inspired and aesthetically legitimised by the Palazzo Madama in Rome, which was given a baroque touch in the mid-seventeenth century. Portal 1, the outer appearance of which was marked by colossal Corinthian columns and is now being restored, was all the more powerful for this.

← The southeast corner of the building, seen from the Rathaus Bridge

The southwest corner of the south façade and view towards Werderscher Markt with simulation of a corner of the façade of the destroyed Bauakademie (Building Academy), the Friedrichswerder Church, and the dome of St. Hedwig's Cathedral →

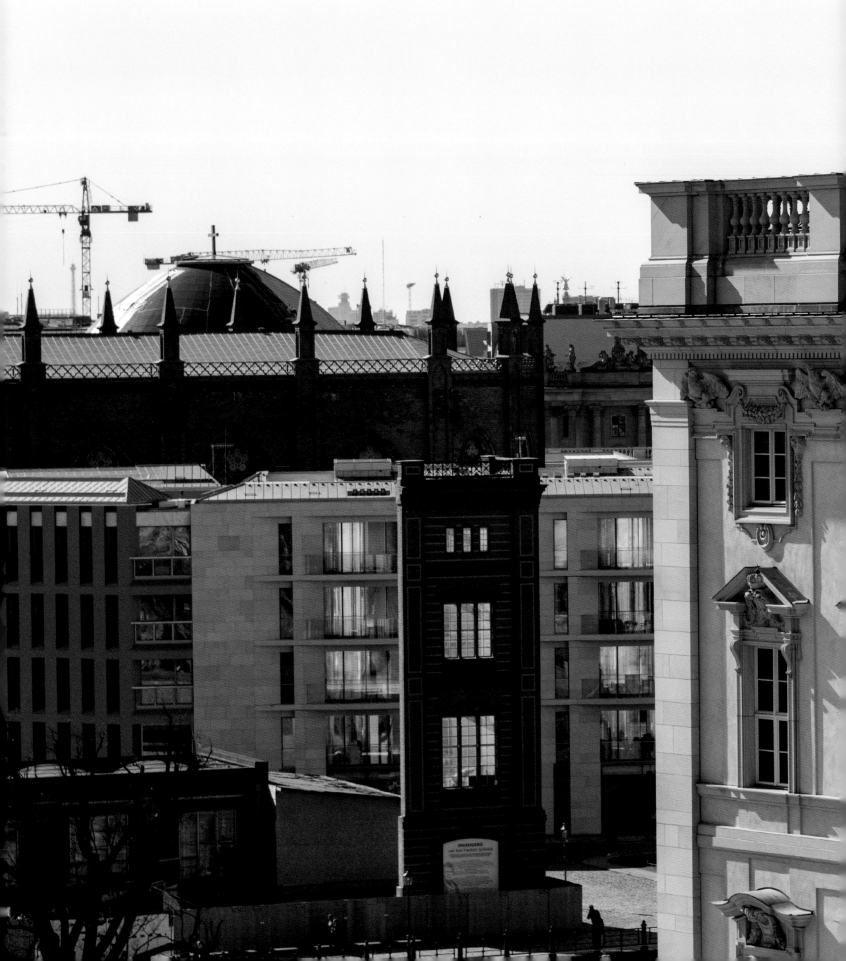

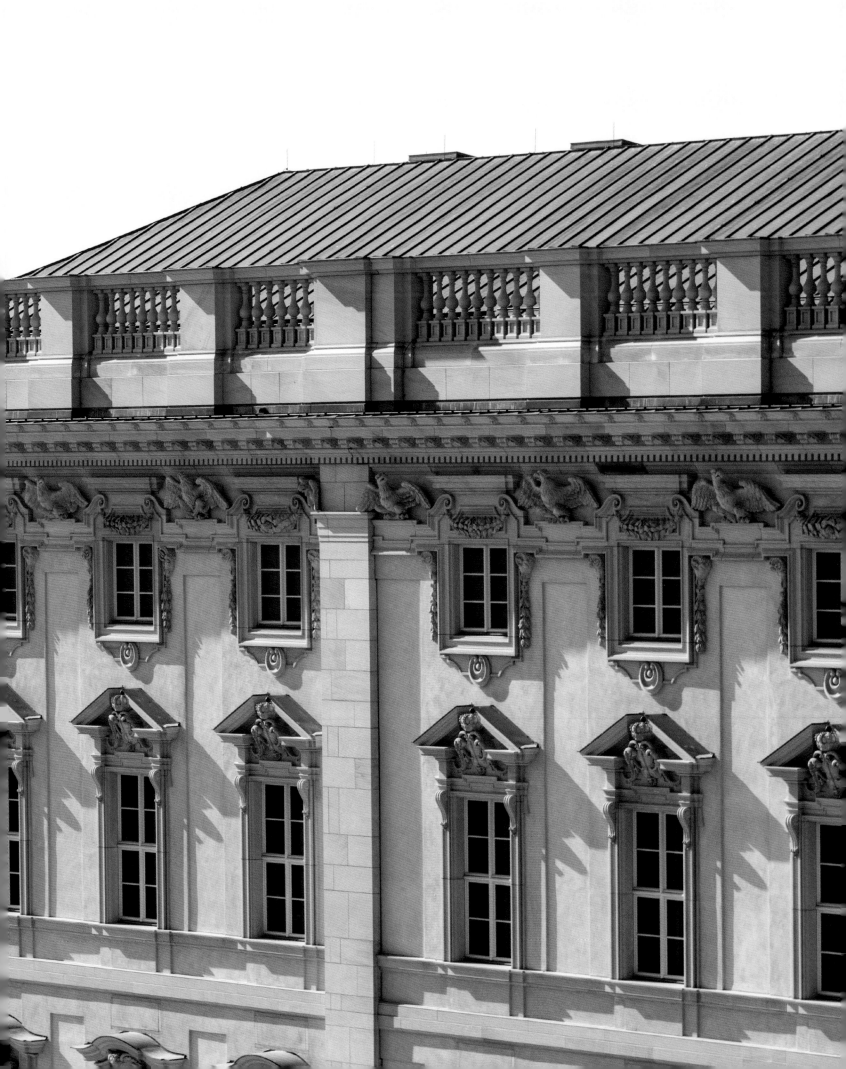

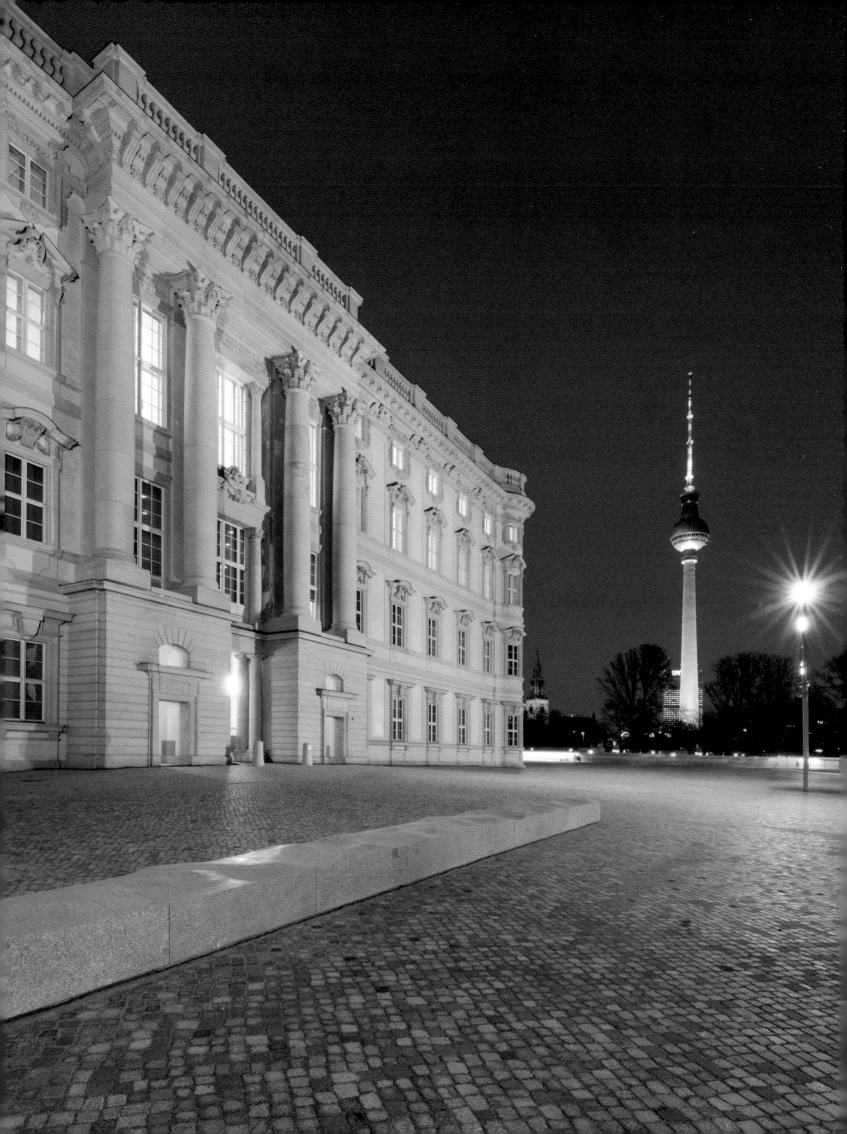

The Lustgarten façade, seen from the east bank of the Spree; on the right, a detail of the Berlin Cathedral

On the Lustgarten façade the window axes equally became the main vertical accents; for Portal 5, however, no columns were foreseen from the outset, even in Schlüter's plans; in the course of further construction, for which Eosander was then responsible, it was furnished with herm pilasters on the first floor – and together with Portal 4, for which, in turn, Eosander was solely responsible, a sequence of the four seasons was achieved and executed – according to the conviction of scholars involved in the study of the palace – no longer by Schlüter and his assistants, but rather by the workshop of Balthasar Permoser.

This intervention by Eosander was consistent in that it complemented the outer appearance of the Lustgarten façade, which Schlüter had already designed in terms of architectural iconology, in a way that was thematically coherent: While the abandonment of full columns in favour of pilasters already marked a hierarchical gradient from the Schlossplatz façade to that of the Lustgarten, the herms now also established a direct contextual reference to the adjacent garden, which is subject to the changing seasons – a solution that, incidentally, was to be repeated decades later at the Sanssouci Palace in Potsdam with the contrast between

← The south façade with Portal 1 and view of the television tower

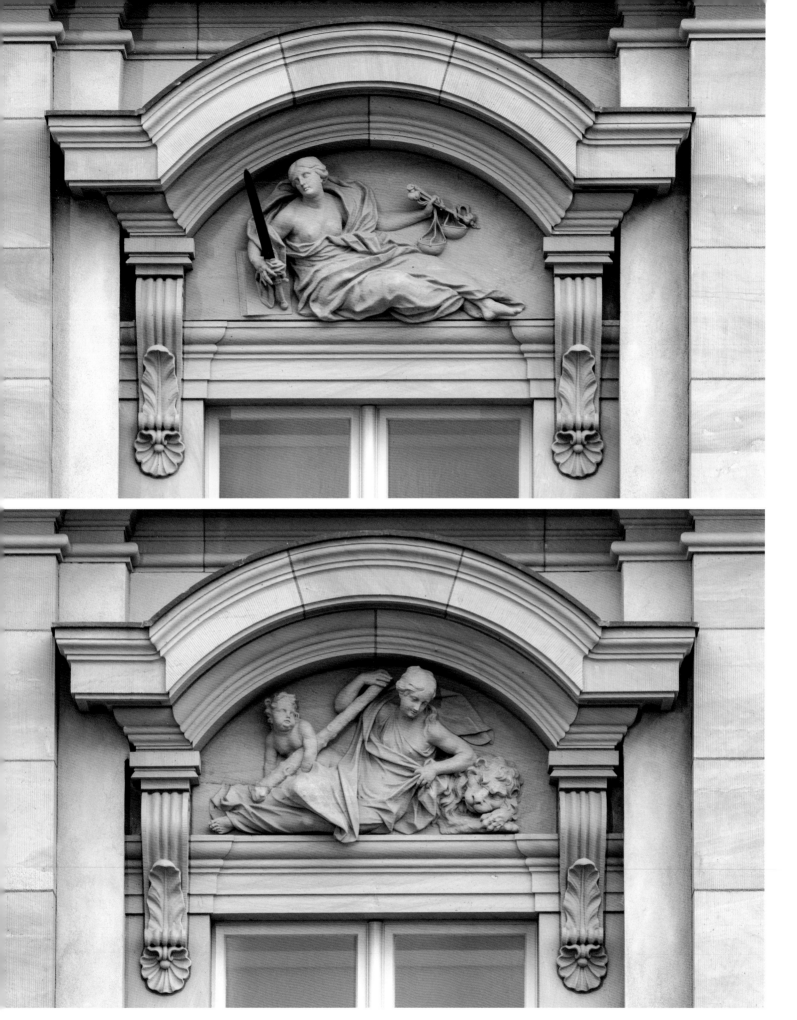

Lunette reliefs with the allegories of Justice (top) and Strength (bottom) on Portal 5

Portal 4 of the palace, originally integrated to a great extent into the façade of the former GDR State Council Building on Schlossplatz

colonnades and herm pilasters. The lunette reliefs with the allegorical personifications of strength and justice placed on the first floor of Portal 5 on the side of the entrance still originate from Schlüter's original concept; iconographically, for all the charm of their depictions, they strike a more serious note than the herm pilasters that were only inserted there as a result of Eosander's plans, despite the heavy burden that the latter have to bear.

If we regard the window axes in Schlüter's façade as the essential vertical accents – only in a second step did the architect add the recessed fields in the intervening wall

sections – it is not surprising that he devoted particular attention and imagination to these axes and the framing of the wall openings. On the first floor, the windows are crowned by an upward-swinging entablature, under each of which is a cartouche. In turn the upper end, projecting into the space, has the shape of a skeletal animal skull – somewhat stylised, but clearly recognisable. At the top, on the sides of the square mezzanine windows, there are applied rams' heads on the left and right, with laurel garlands hanging from their mouths.

Both – the animal skulls and the rams' heads – are surprising in view of the period in which our palace was built:

Portal 4 on the Lustgarten façade; in front of this, sculptures on the Palace Bridge representing warriors and goddesses of victory based on Greek mythology, 19th century →

They do not belong to the regular decorative repertoire of the High baroque they are more frequently encountered on buildings of earlier periods, such as the sixteenth century. The question arises as to what Andreas Schlüter might have intended by using them on his façades of the Berlin Palace. If we consider the fact that Elector Frederick III was promoted to king precisely during the construction of the palace, and that the enormous undertaking of building the residence was directly connected with this elevation in status, then one explanation could be feasible: With Frederick I, Prussia became a new kingdom – in contrast to other, traditional European monarchies – and he himself was, in a sense, an upstart, a *parvenu*. The use of antique decorative elements on the façades of the palace was able to cover up this mar in an elegant way, if not to make it magically disappear, so to speak – it reflected an ancestry that *de facto* did not exist. We will encounter something similar in details of the Schlüterhof. Incidentally, Schlüter may have found inspiration for the rams' heads in the tomb of Otto Christoph von Sparr in the nearby St. Mary's Church, which was executed around 1663 by the Dutch sculptor Artus Quellinus the Elder; there, however, they are found – correctly in terms of iconography – on an altar stone with an antique design.

At the very top of the façade, directly below the entablature and on the side of the mezzanine windows, Schlüter placed the Prussian heraldic animal in multitude: eagles that alternately turn their heads to the right or left. They spread their wings, sometimes more, sometimes less, depending on the space available to them.

Eosander retained Schlüter's façade structure for the extension of the residence building, as well as its decorative elements; only for its 'shoulder', the west-facing component with the triumphal arch of Portal 3, did he change the concept in favour of a purist style.

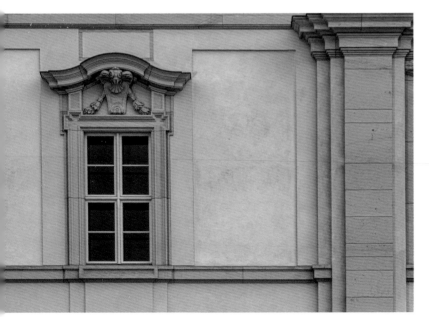

Window on the first floor of the Lustgarten façade with stylised animal skull in the cartouche of the entablature

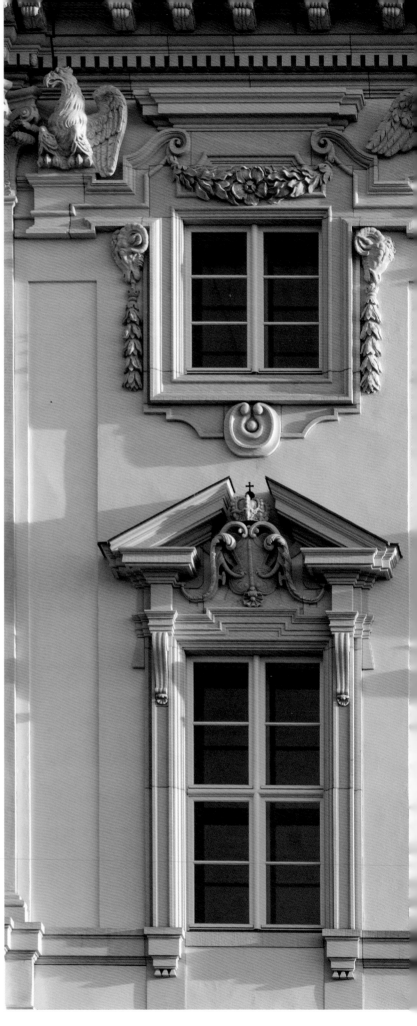

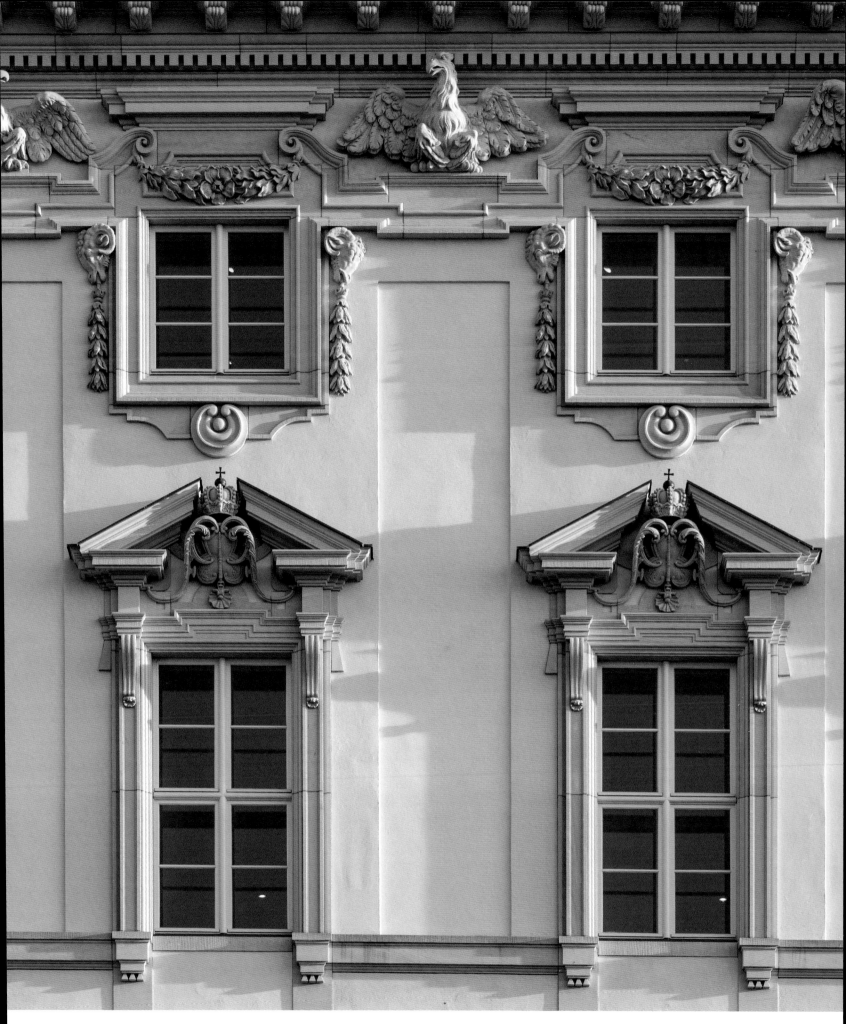

Windows of the second storey of the Lustgarten façade and of the mezzanine storey with rams' heads; above these, eagles: the Prussian heraldic animal

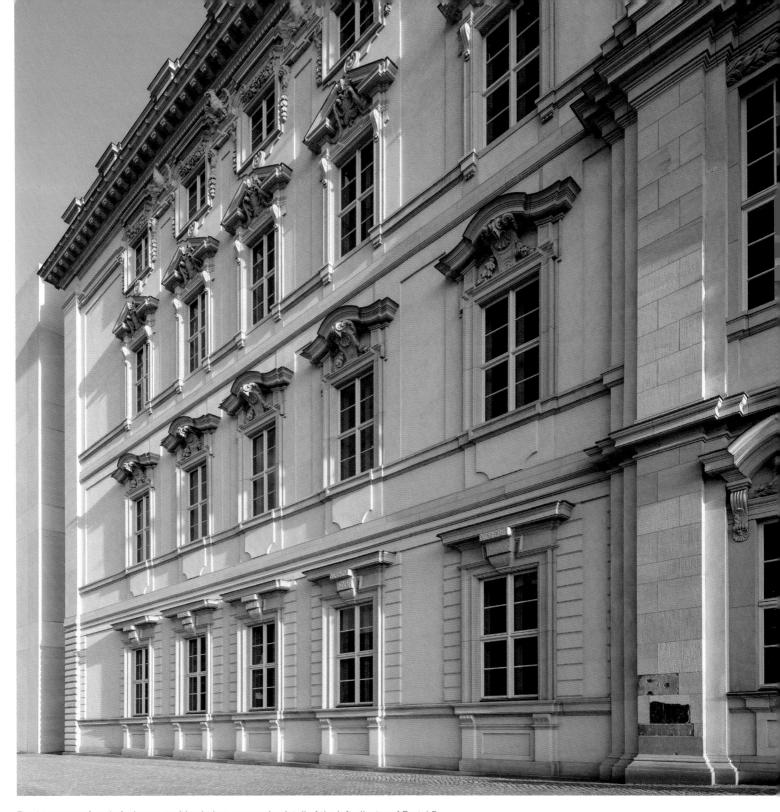

The Lustgarten façade facing east with window axes and a detail of the left pilaster of Portal 5

In the central axis of Portal 1, on the cornice between the first and second storeys, Andreas Schlüter placed an armature consisting of a shield with a relief of a battle scene, crowned by a richly decorated helmet and quivers filled with arrows. Below the shield, a lion's skin hangs over the cornice, spread wide, with the paws on the left and right at the outer ends. This skin, that of the Nemean lion, is reminiscent of the virtuous hero of ancient mythology *par excellence*:

Hercules, who in the Christian-influenced modern era even outranked the Old Testament Samson. Unlike the latter, Hercules was not only a strongman who was victorious in a variety of tasks – he also resisted, it was said, the 'wiles of women', unlike Samson, who was shamefully inferior to his Delilah. The hanging of the trophies – and according to the myth, the skin is also a trophy – above the main entrance made it more or less a representational palace, the residence

← Detail of the right pilaster of Portal 5

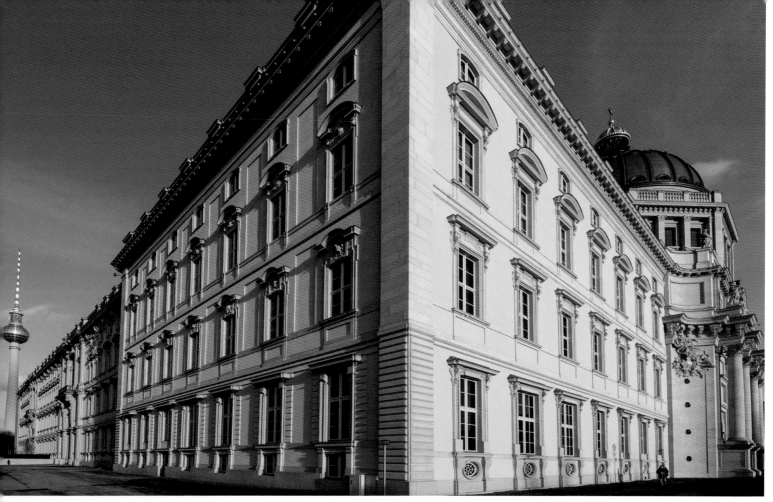

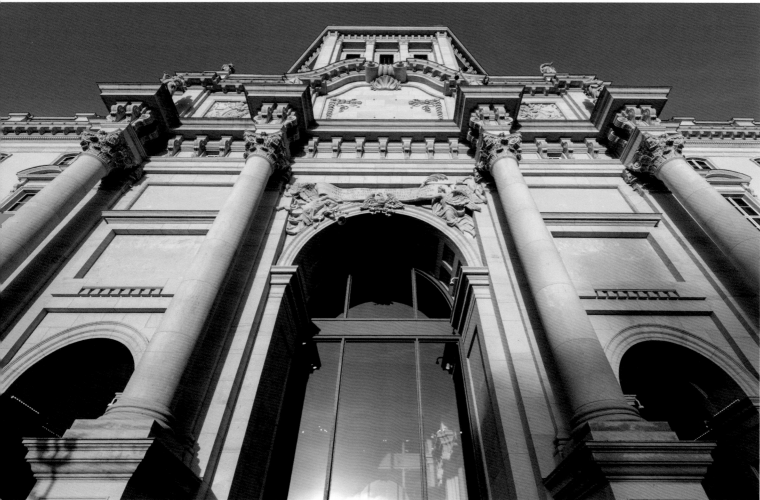

Top: The north-west corner of the palace building, extension by Eosander
Bottom: The triumphal arch of the Eosander Portal

Detail of the Eosander Portal with the figures of Moses and Elijah (above)
and the Virtues; below right: monogram cartouche of Frederick I →

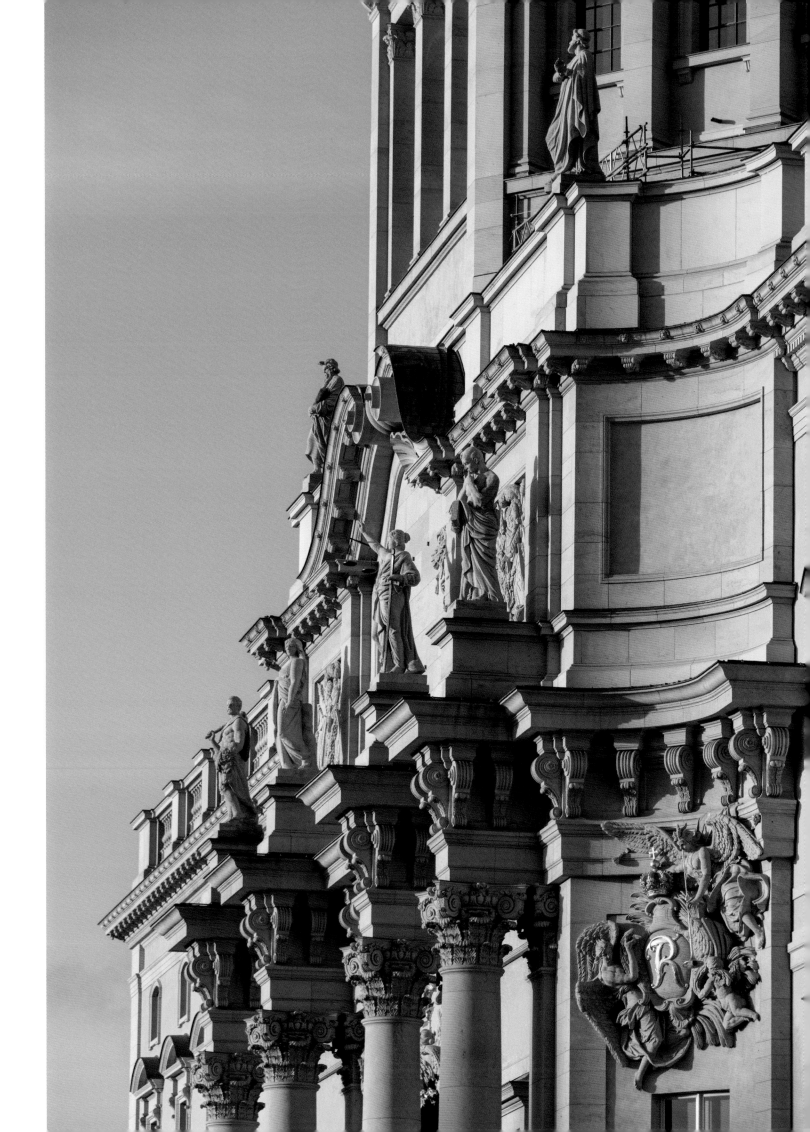

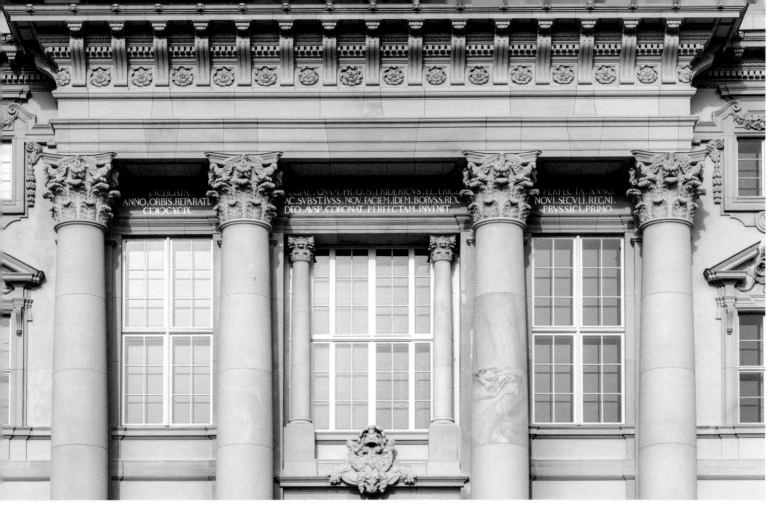

The second storey of Portal 1 on the south façade

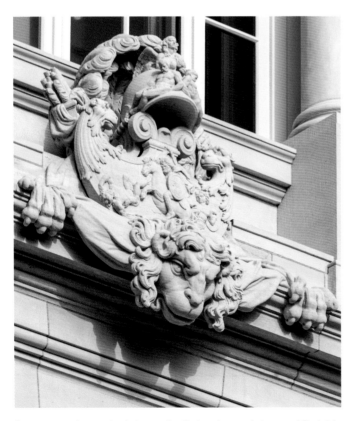

Armature on the cornice between the first and second storeys of Portal 1 with the pelt of the Nemean lion

of the virtuous hero. And for his part, the actual occupant of the building, Frederick I, committed himself to the principles of the ancient demigod.

ON THE SIGNIFICATION OF THE SCULPTURAL DECORATION

Passing through this portal, we reach the inner courtyard: the Schlüterhof. Here, for the first time, we see free-standing large-scale figures, originally created from Andreas Schlüter's models by assistants in his workshop and now reconstructed by the sculptors of the palace workshop.

The Schlüterhof has three *risalti*: two with three axes at the portals to Schlossplatz and the Lustgarten (1 and 5), one with five axes, originally in front of the main entrance to the representative rooms, the Giant Staircase, now the Lapidarium (Portal 6). Full columns span the two lower storeys; the figures stand in their vertical extension – four females on each of the narrower *risalti*, six males on the wider one, flanked by two more females.

Much and intensive thought has been given to how a possible iconographic programme of these sculptures could be reconstructed today. This is all the more understandable given that baroque art did indeed attach the greatest importance to the *concetto*, the astutely conceived conceptual

Sculpture of Antinous on Portal 6 in the Schlüterhof →

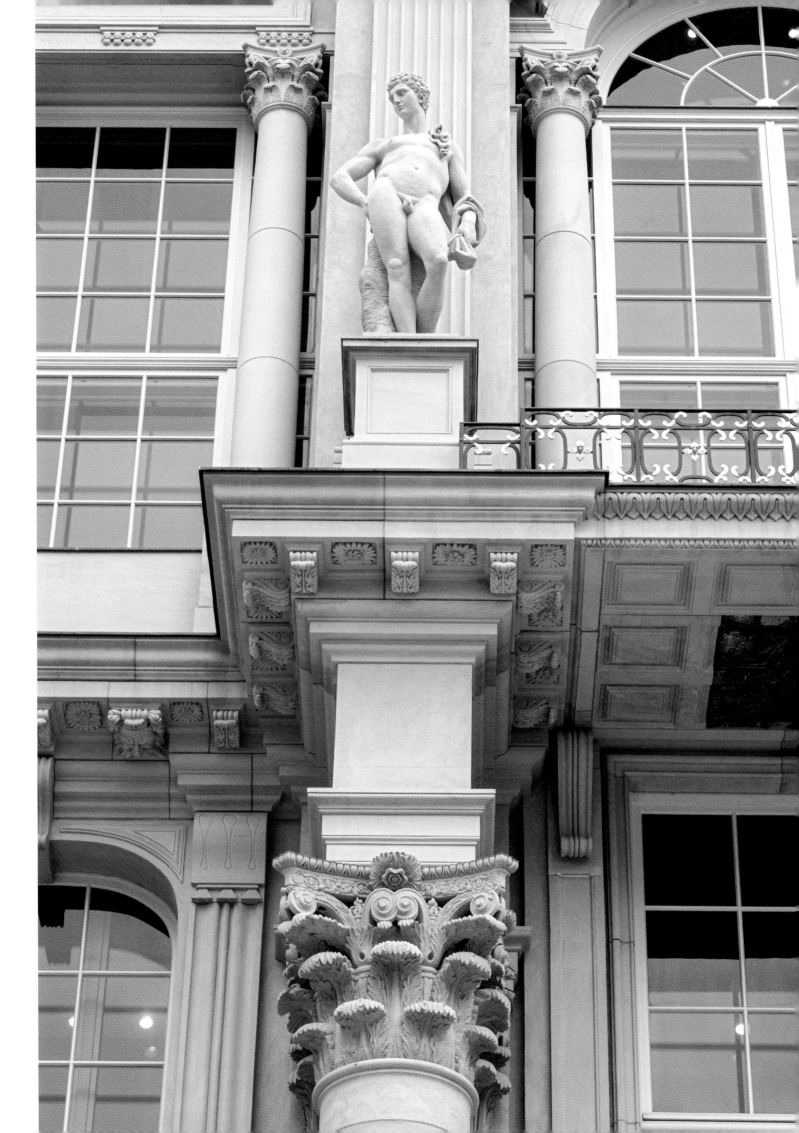

framework of figurative creations. Furthermore, in other places, such as the Giant Staircase and the representative rooms on the second floor, the Berlin Palace revealed the iconological precision with which Schlüter and his colleagues had gone about their work. However, none of the proposals for the figures in the Schlüterhof is convincing. The designations of the female figures as personifications, mostly due to the freely invented attributes added in the nineteenth century, are just as misguided as the suggestion to regard them as muses: There are eight figures on the narrow *risalti*, not nine, as is canonical for the patron goddesses of the arts. And the male figures in front of Portal 6 also fail to fit into a coherent iconographic programme: Gathered here are three gods (Apollo, Neptune, and Mercury), a demigod raised to immortality (Hercules), a mortal (Meleager), and a personality who was only declared a god in imperial Roman times: Antinous, the favourite of Emperor Hadrian.

When we detach ourselves from the compulsion to give all the figures names and thus ostensibly meaning, it becomes worthwhile to draw attention to individual formal solutions. It is striking how intensively Schlüter made use of famous models here – and did not paraphrase them, but rather copied them directly. On the *risalit* of Portal 5, we encounter a replica of St. Susanna by François Duquesnoy in Santa Maria di Loreto in Rome, created around 1630, as well as a copy of the ancient Flora Farnese, the original of which is now in the Museo Archeologico Nazionale in Naples. The figure in Portal 6, always identified as Borussia, is a copy of Giovanni Lorenzo Bernini's *Mathilde of Tuscia* (1634–1644) in St. Peter's Basilica in Rome; the figure of Antinous standing at the same portal is in turn a replica of an ancient prototype or one of its numerous modern derivatives.

In 1699, shortly before the construction of the residential palace began, the Akademie der Künste (Academy of Arts) was founded in Berlin. The French counterpart, installed in 1648, served as a role model. At that time, art academies were considered the guardians of the canons for the arts that were recognised as eternally correct – and it is no coincidence that they were successful above all where a strong central power determined politics. That is why it was precisely the Parisian institution that provided the guiding principles for an entire epoch – incidentally until well into the nineteenth century, when such rules and regulations were increasingly regarded as enemies by artists and, subsequently, by art history.

It is obvious that, in view of his regality, Frederick III also wanted such an institution, and Andreas Schlüter was to play a leading role in it, even becoming its director for two years. His prerequisites for this were excellent: He had travelled extensively, had seen Rome, the Netherlands, and presumably also Paris. He had brought plaster casts of exemplary antiquities from Italy to Berlin on behalf of the sovereign.

With this in mind, let us venture another interpretation of the figures in the small palace courtyard, the Schlüterhof.

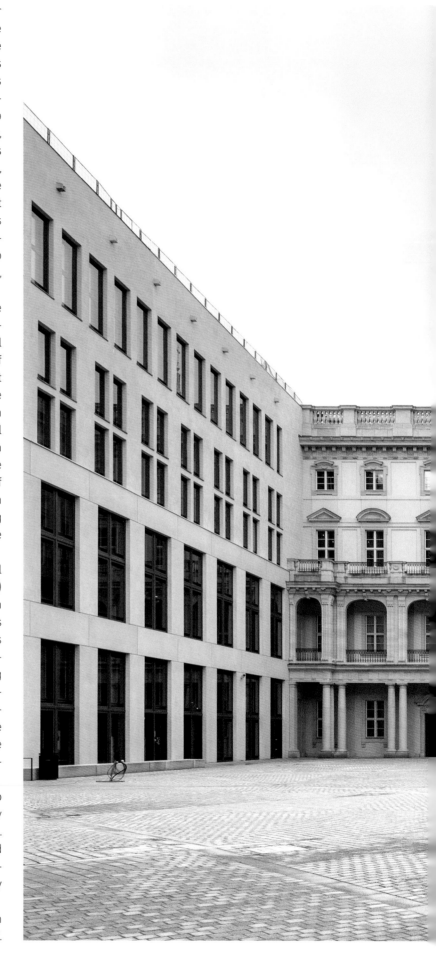

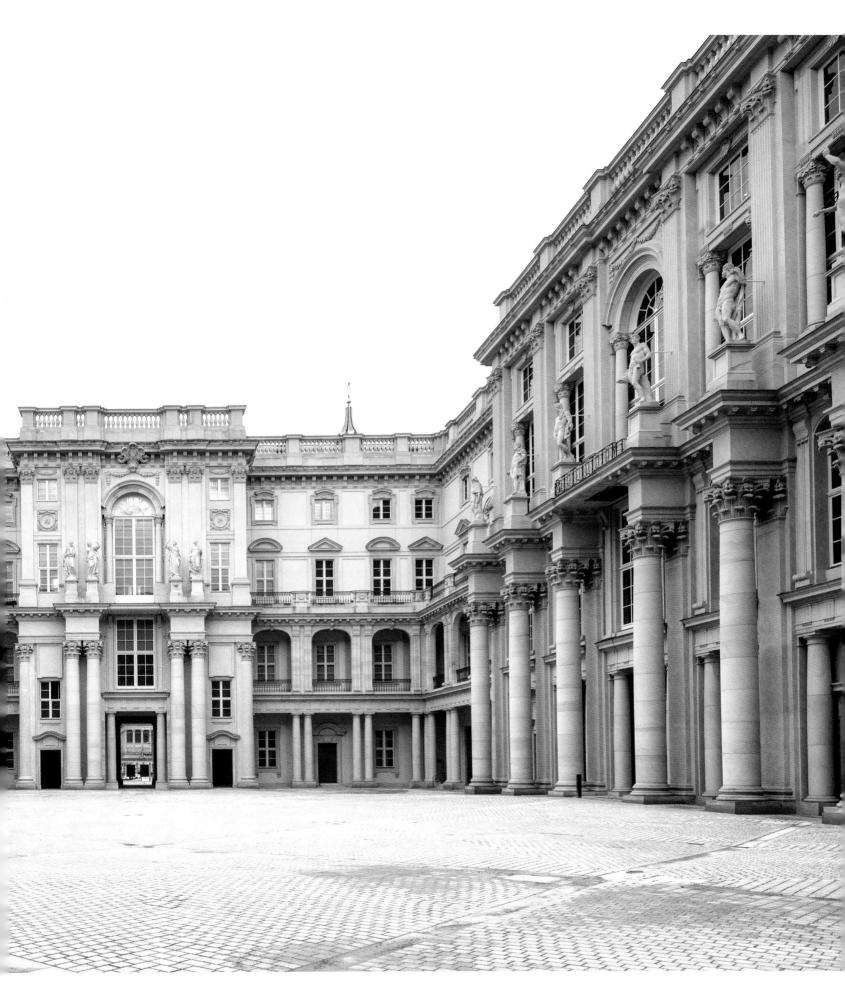

The Schlüterhof with the modern west façade and the reconstructed north and east façades

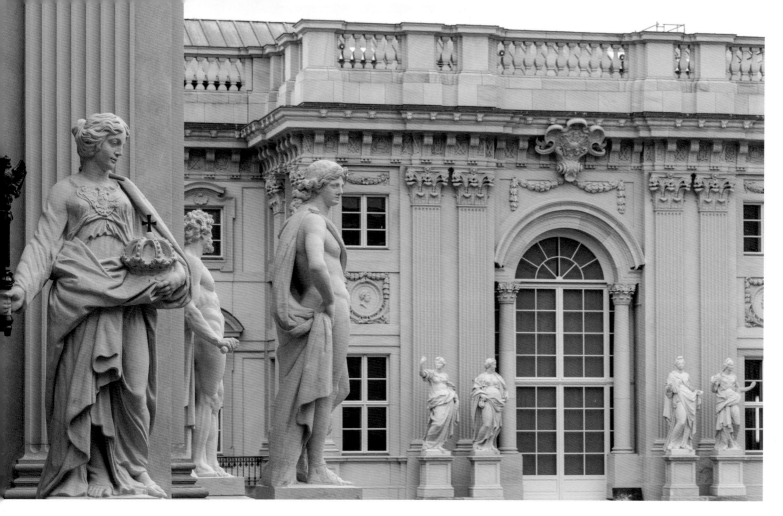

Portal 6 with 'Borussia', Apollo, and Neptune, as well as the courtyard side of Portal 1 with four robed female figures in the Schlüterhof

In front of us and around us are six nude male and ten robed female figures, some of them recognisably copies of famous models, exemplary of the adherence to academic canons. Let us see in this – abandoning the obviously hopeless search for a conventional iconological programme – what these works are in fact: ideal models, prime examples of contemporary sculpture. The programme would therefore not be, as usual, a line of orientation from the point of view of princely education and monarchical virtues and qualities, but rather instructions in stone for new generations of sculptors, exhibited in the most distinguished place in the city – the courtyard of the newly designed residential palace.

The sculptures are highly suitable for this task as exemplary models; although they were created in one and the same workshop, they show an enormous range of artistic design. The nudes represent men of different ages and physiques, mature athletes as well as ephebic youth. On the female figures, we encounter garments that closely follow the contours of the body, structured by long, often parallel folds; others have draperies that project into the space in front of and next to the figure, structured by a multitude of differently spherically curved surfaces.

One figure deserves special attention: that of Apollo. If one looks closely, it is not a single figure, but rather the group of Apollo and Daphne, the nymph whom Apollo lovingly

pursued and who was saved from his grasp by being transformed into a laurel tree. The tree trunk at the god's side has two recognisable rootstocks – the transformed legs of Daphne – and on close perusal, one can even make out her navel. Perhaps this observation explains Apollo's facial expression, which clearly shows signs of disappointment.

The ornamentation of the Schlüterhof does not entirely dispense with conventional princely allegory: Eight reliefs were planned for the flanks of the narrow *risaliti* that recede towards the façades, but only four were executed. Two of them have survived and were copied for the reconstruction. They are the female tamer of a steed and another female personification accompanied by a lion. Regardless of the names proposed thus far, the common denominator for these is that the creatures of nature are tamed by human ability, an idea that also determined the contemporary ideals of princely education – only he who knows how to tame his own affects and temperaments is also able to rule a nation.

And finally, below the mezzanine windows, four portraits designed after ancient coins decorate the two narrow *risaliti* in this courtyard. As already suggested above, we can also read this representation as an indication of an asserted ancestry: Kings, the sculptures tell us, existed long before an empire was established, and Elector Frederick III was

The northwest corner of the Schlüterhof, the courtyard side of Portal 5 with four robed female figures →

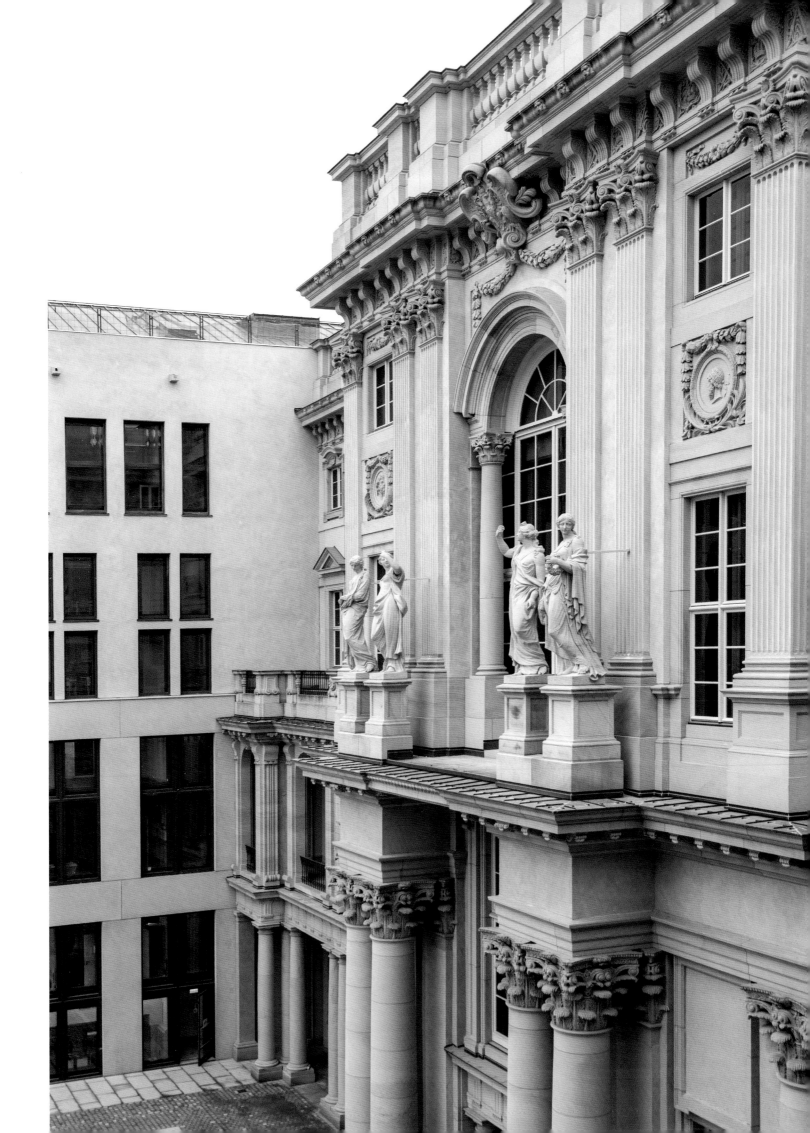

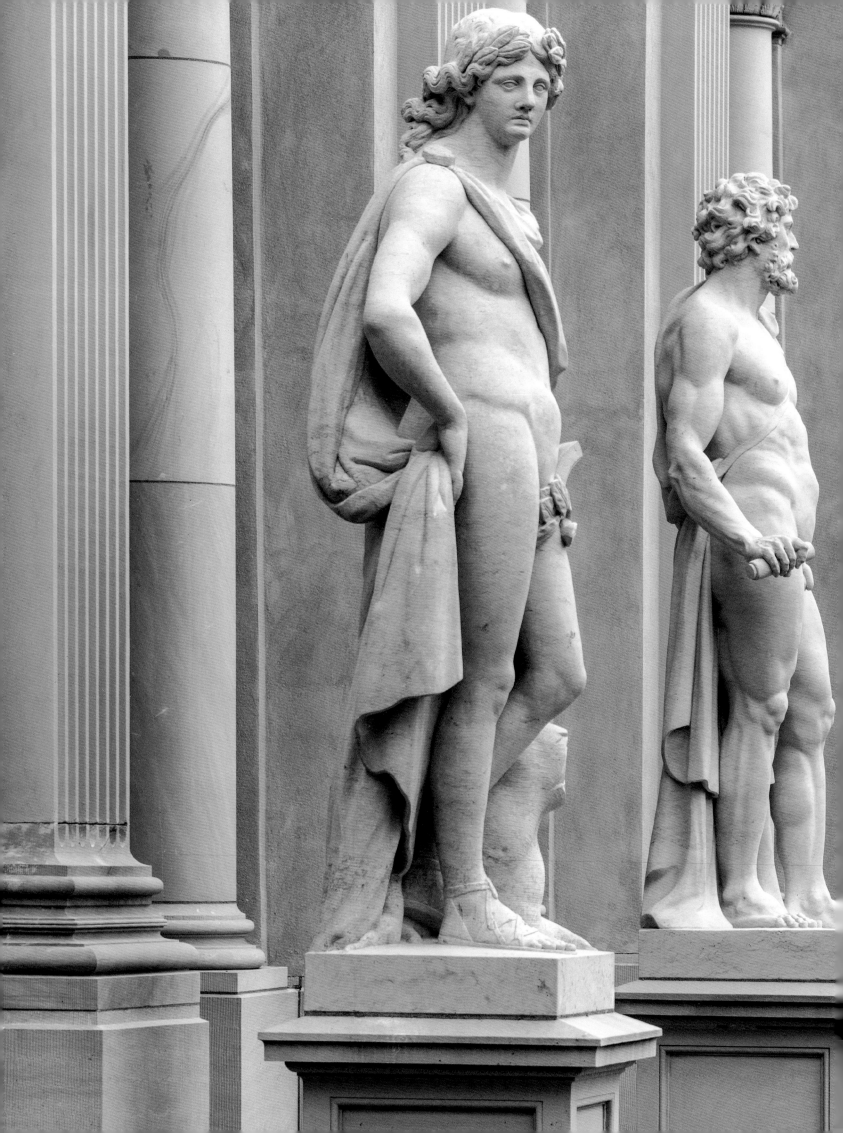

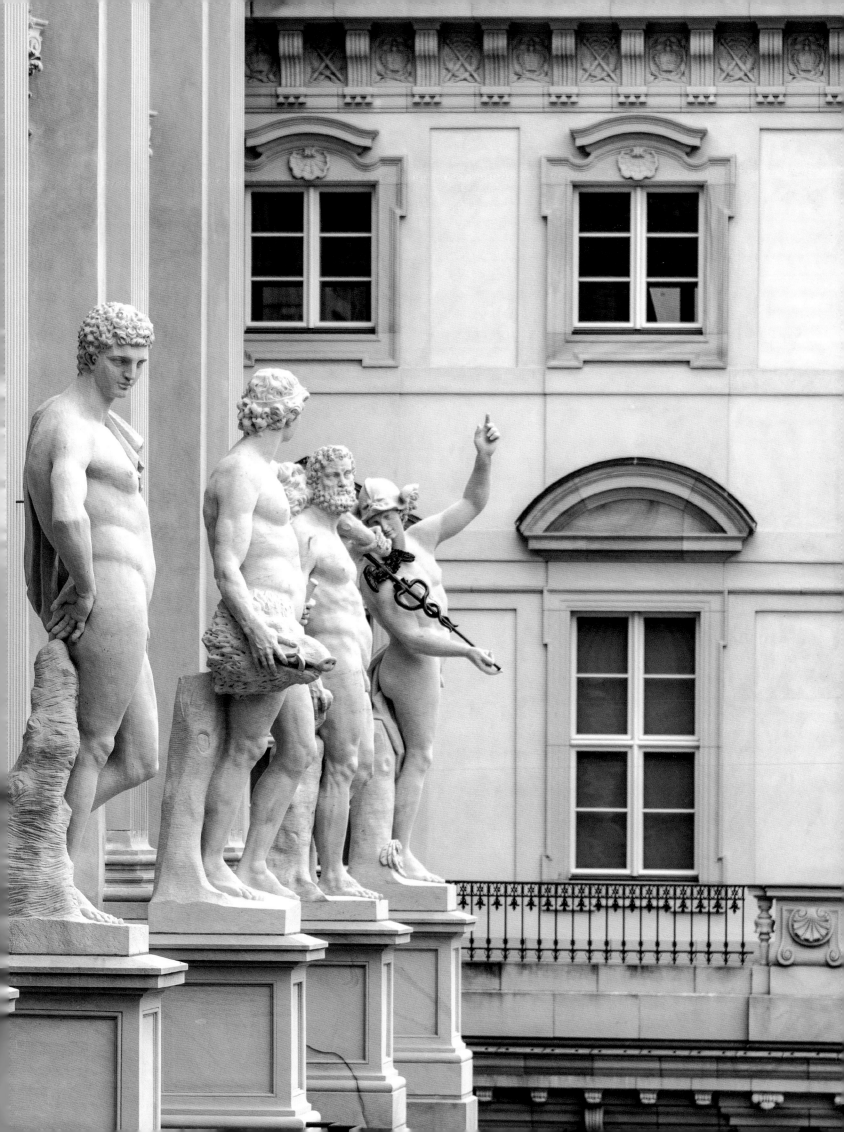

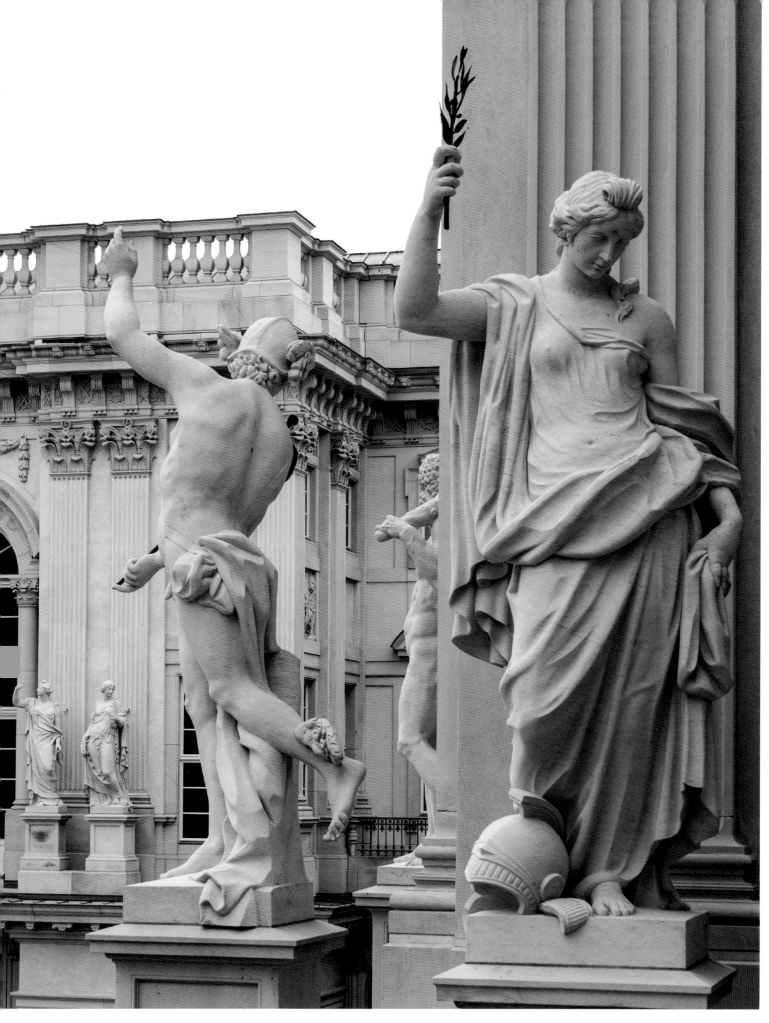

← Apollo, Neptune, Antinous, Meleager,
Hercules, and Mercury on Portal 6

Robed female figure, Mercury, and Hercules on Portal 6 and two robed
female figures on the courtyard side of Portal 5

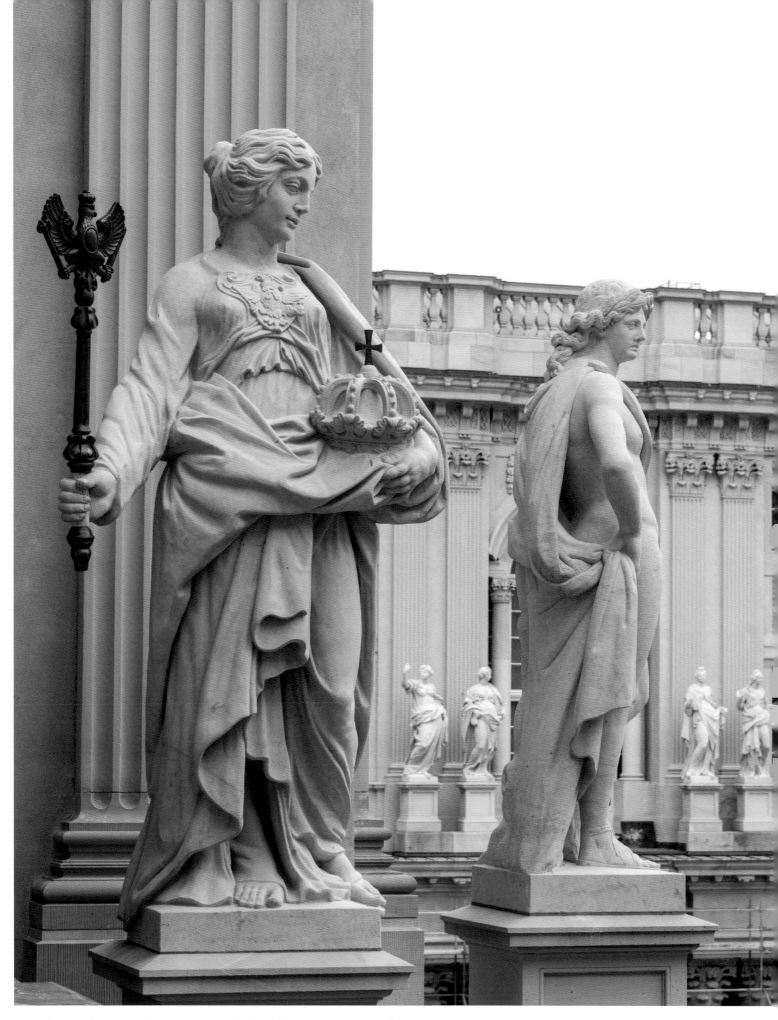

'Borussia', copy after Giovanni Lorenzo Bernini's *Mathilde of Tuscia*, and Apollo; in the background, four robed female figures on the courtyard side of Portal 1 in the Schlüterhof

Original sandstone figures from the Schlüterhof in the Sculpture Hall behind Portal 6: Apollo, Jupiter, Antinous, Hercules, Mercury, and a robed female figure →

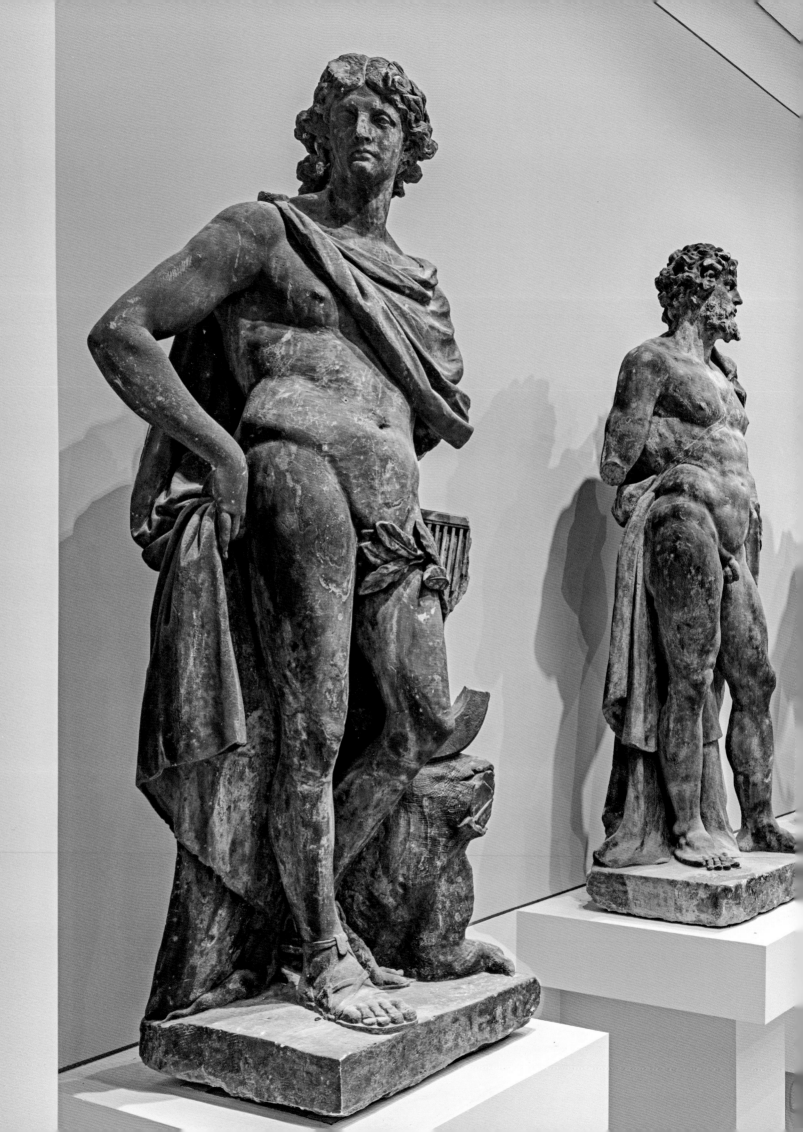

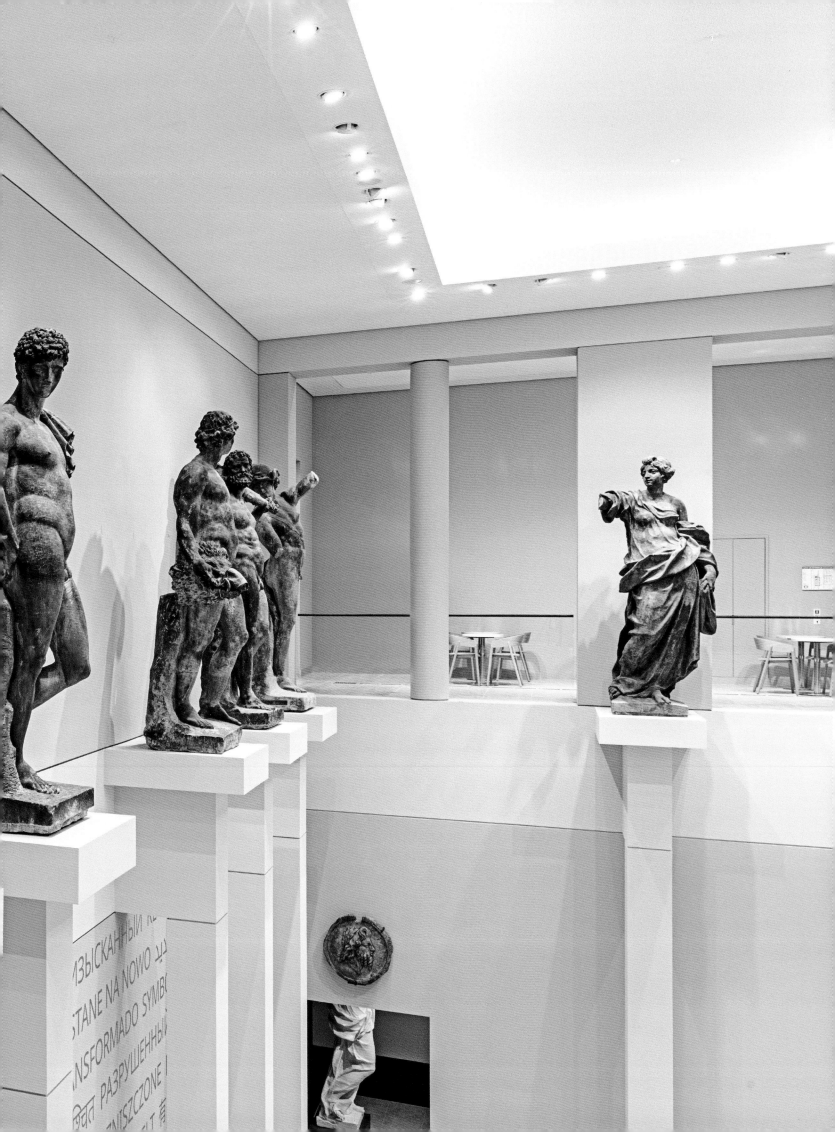

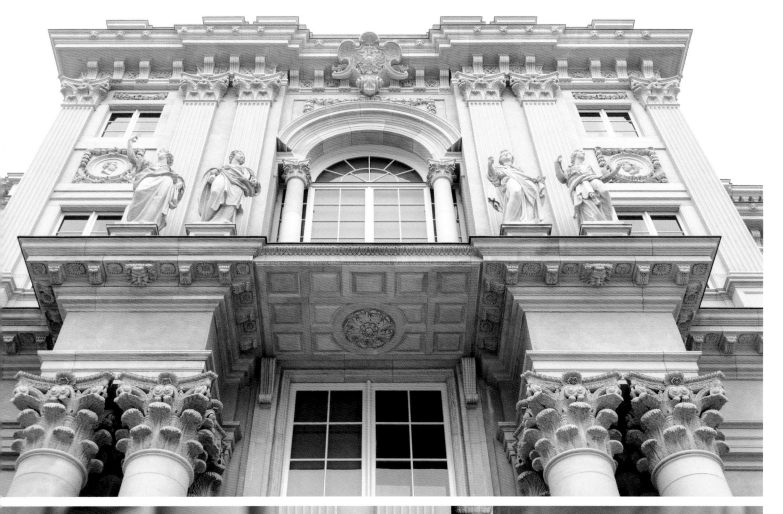

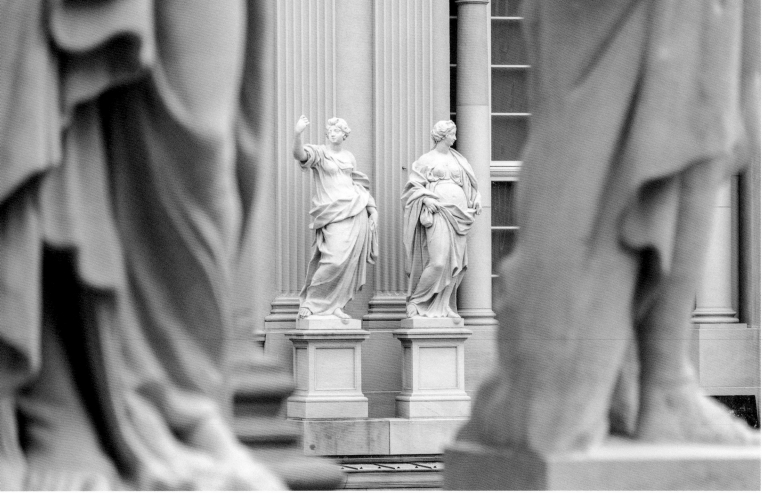

Top: Courtyard side of Portal 1 with robed female figures
Bottom: Two robed female figures on the courtyard side of Portal 1

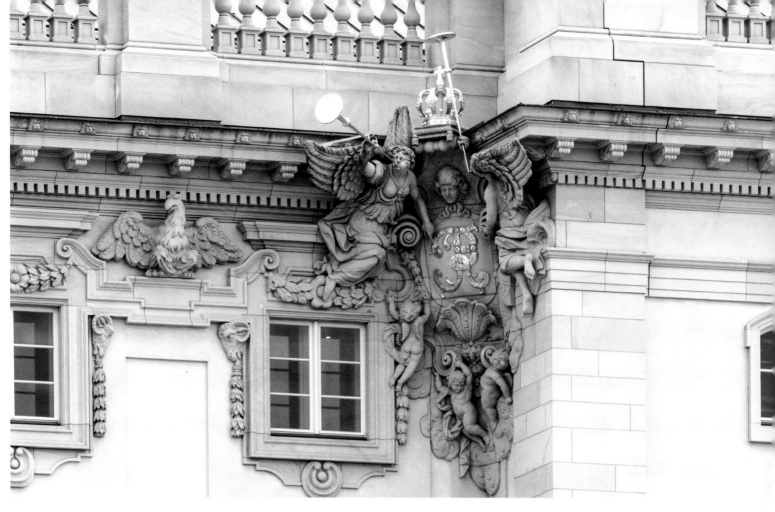

Monogram cartouche of Frederick I with genii at the transition from the Schlüter façade to the Eosander façade in the direction of the Lustgarten

only able to achieve his longed-for elevation in status after extended negotiations with the imperial court in Vienna.

If the Giant Staircase (once located behind Portal 6) once again existed, it would be possible at this point to write admirably about the victorious battle of Jupiter against the rebellious giants depicted there, who would now be condemned to serve the elaborate architectural order of Schlüter's staircase instead of the chaos they had wrought.

Not to be forgotten, finally, are the genii encountered in several places on the palace façades, which make use of fanfare horns to proclaim the glory of the commissioning sovereigns, Frederick I and Frederick William I, who were often enough surrounded by abundant weapons and other war material. As noted in one of the inscriptions on the building, the palace was built, as it were, in the shadow of belligerent threats. We do not have to interpret this ornamentation in Walter Ulbricht's sense that Prussia had always been devoted to the military; rather, let us try to read them in the spirit of their first creation: '*Si vis pacem, para bellum*' – if you want peace, prepare (yourself) for war. Incidentally, one of these decorative elements – the one on the Lustgarten side, in the angle between the Schlüter façade and the Eosander shoulder – has a primarily aesthetic function: There, it covers up the harsh clash of two different, even absolutely opposing architectural structures.

So much for the work of Schlüter and Eosander, the extensive reconstruction of which now once again stands before us. Perhaps in the near future it will be possible to add sculptures on the balustrades rounding off the façades that match the style of the original architecture and are based on the few surviving originals.

Bernd Wolfgang Lindemann was Director of the Gemäldegalerie in Berlin from 2004 until 2016.

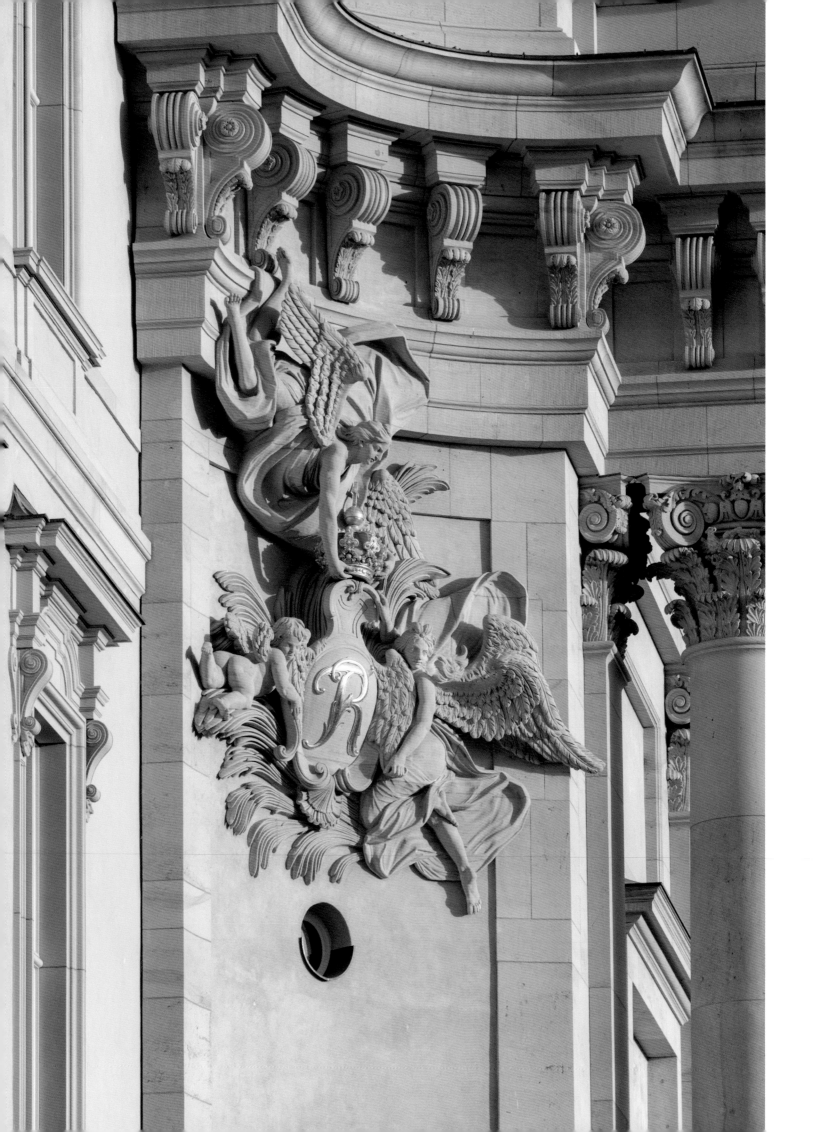

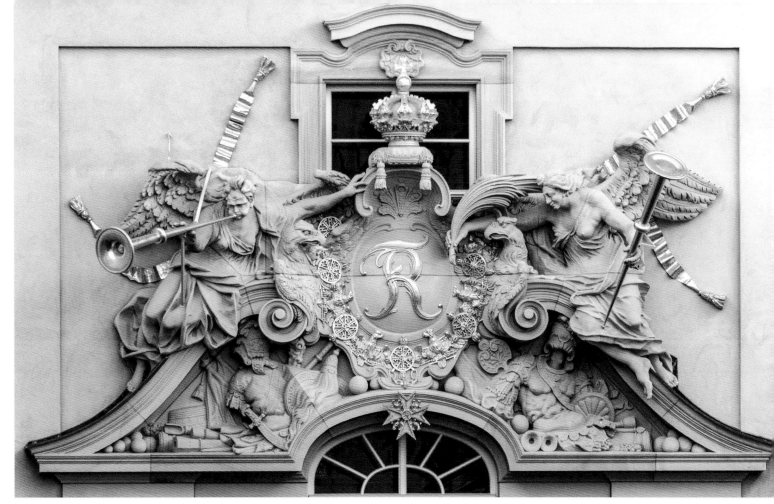

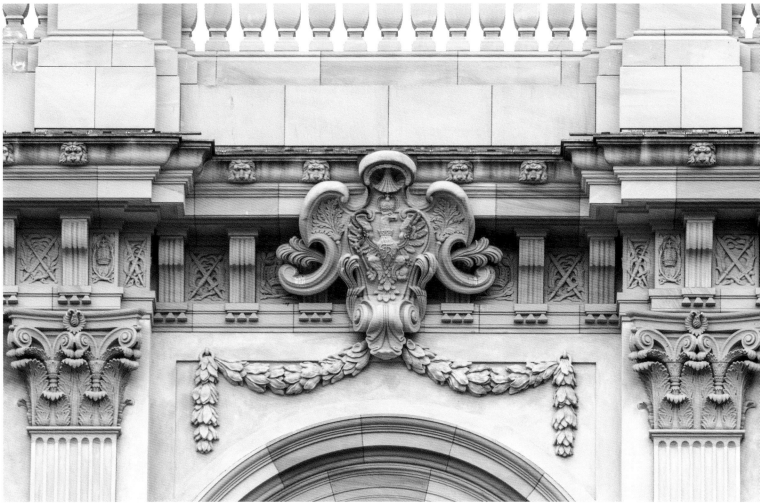

← Monogram cartouche of Frederick I with genii to the left of the Eosander Portal

Top: Monogram cartouche of Frederick I on courtyard Portal 4 in the passage between the Lustgarten and Breite Strasse
Bottom: Cartouche with the Prussian eagle in the Schlüterhof

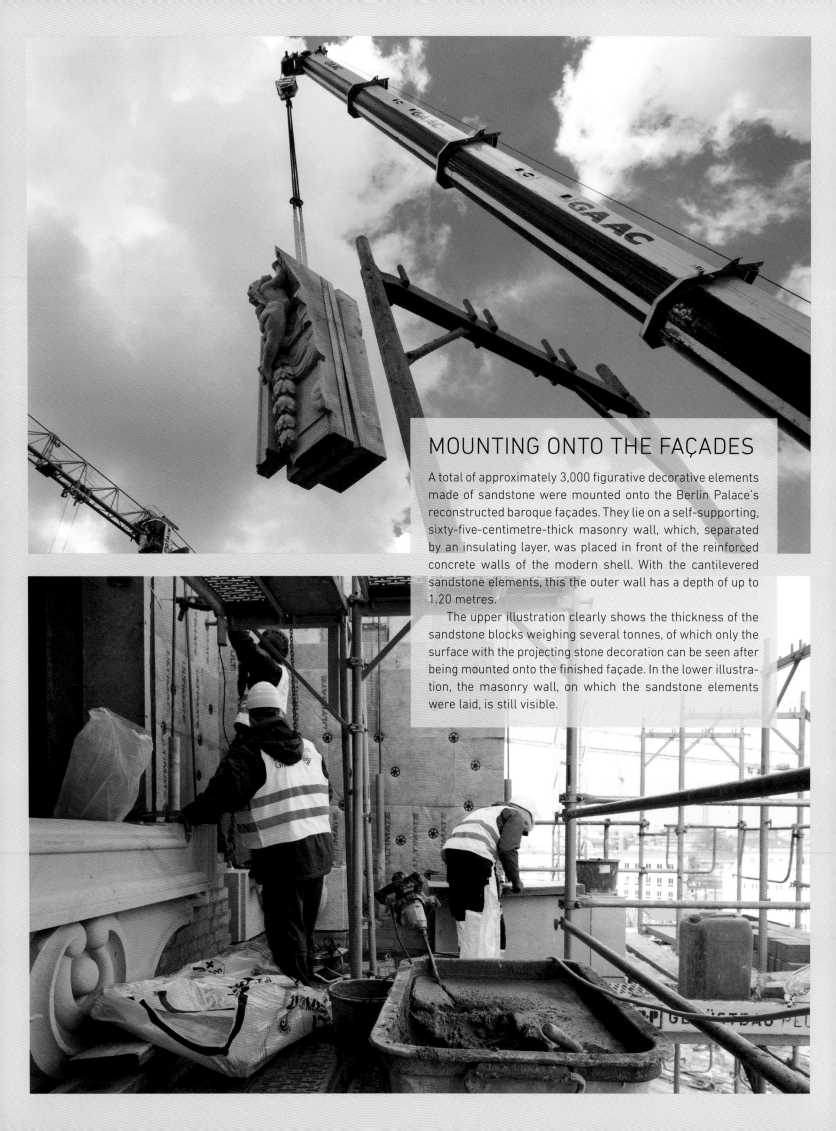

MOUNTING ONTO THE FAÇADES

A total of approximately 3,000 figurative decorative elements made of sandstone were mounted onto the Berlin Palace's reconstructed baroque façades. They lie on a self-supporting, sixty-five-centimetre-thick masonry wall, which, separated by an insulating layer, was placed in front of the reinforced concrete walls of the modern shell. With the cantilevered sandstone elements, this the outer wall has a depth of up to 1.20 metres.

The upper illustration clearly shows the thickness of the sandstone blocks weighing several tonnes, of which only the surface with the projecting stone decoration can be seen after being mounted onto the finished façade. In the lower illustration, the masonry wall, on which the sandstone elements were laid, is still visible.

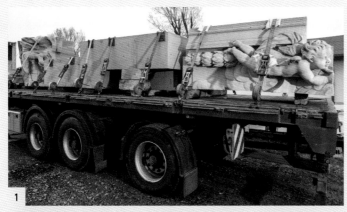

1–3 The heavy stone blocks for the large corner cartouche on the Lustgarten façade are transported by low-loaders and hoisted by heavy lifting cranes to the mounting site at a height of thirty metres. This decorative element alone, the assembly of which is shown in the following illustrations, consists of nineteen extremely heavy individual parts. Together, they add up to a height of up to 7.3 metres and weigh fifty-six tonnes.

4–8 On site the individual blocks are aligned precisely down to the centimetre and, when necessary, processed further. Great attention to detail was given to the sculptural decoration, despite the height at which it was mounted.

9 Detail view of the putti under the escutcheon of the finished corner cartouche

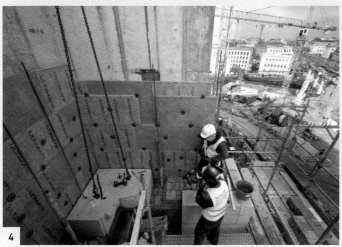

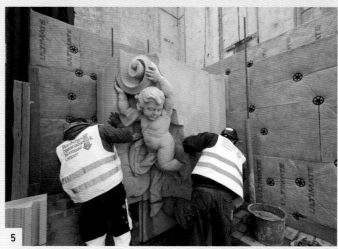

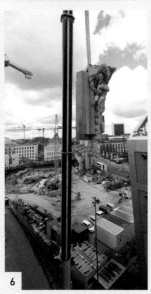

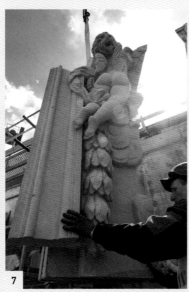

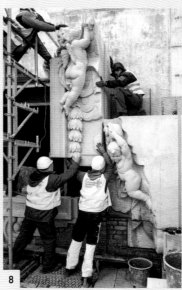

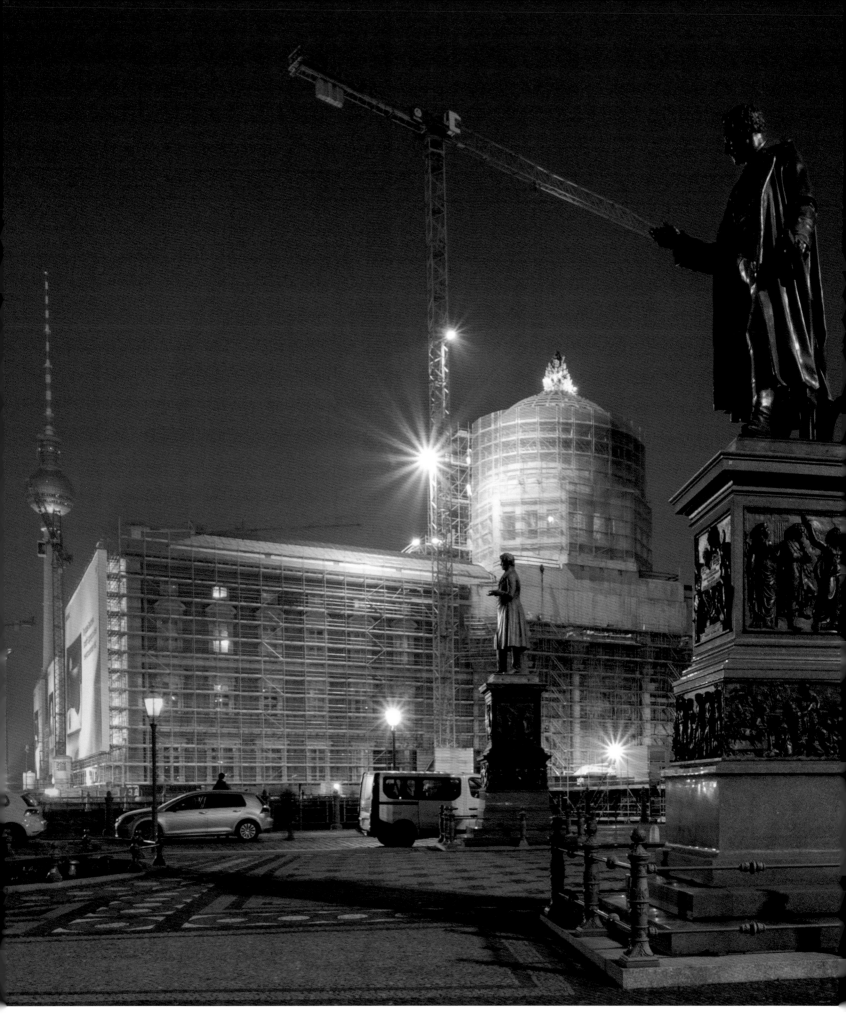

The reconstruction of the west façade of the Berlin Palace, view from Schinkelplatz; on the left, the television tower

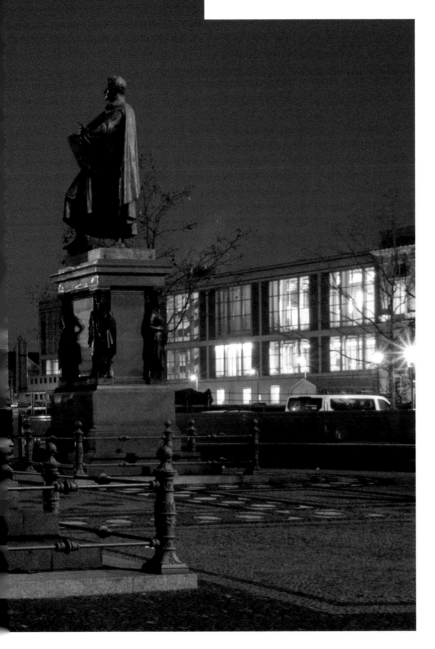

Franco Stella with Peter Westermann

THE RECONSTRUCTED FAÇADES OF THE BERLIN PALACE

THE SIGNIFICANCE OF CONSTRUCTION

THE CIVIL-URBAN IMPORTANCE OF THE HISTORICAL FAÇADES

The reconstruction of the baroque façades of the Berlin Palace and its dome which was erected in the nineteenth century takes place within the context of a completely new building that meets the design and modern technical requirements of the Humboldt Forum cultural complex. As the residence of the Brandenburg electors, Prussian kings, and German emperors, the palace was Berlin's most important building in both socio-political and urban-architectural terms during the five centuries of its existence until it was demolished in 1950.

Beyond the principles of 'critical reconstruction' that have characterised Berlin's urban development in recent decades, the reconstruction of a lost architectural monument beyond its mere volume also means a faithful restoration of the façade. In the case of the Berlin Palace, the façades have an indispensable significance for collective memory, as well as for the architectural identity of the city centre. They remind us of the building's construction period and enable us to understand that the most important buildings and squares of Berlin's historic centre were related to the royal palace.

The resolution on the partial reconstruction of the Berlin Palace – that is to say, the baroque building from the early 18th century and the dome added 150 years later – passed in 2002 by the German Parliament with a large suprafractional majority, underscores the special importance of the façades. Apart from the urban planning recommendation that "a development of the Schlossplatz should be oriented towards the stereometry of the former Berlin Palace", the

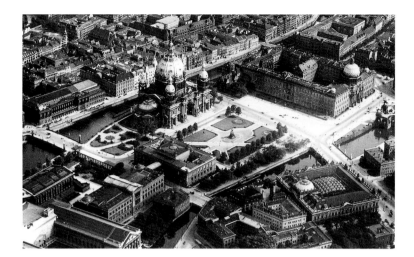

Aerial view of the historic palace; in front of this, the Spree Island with the Berlin Cathedral and the Lustgarten (left) and the Armory (right), 1925

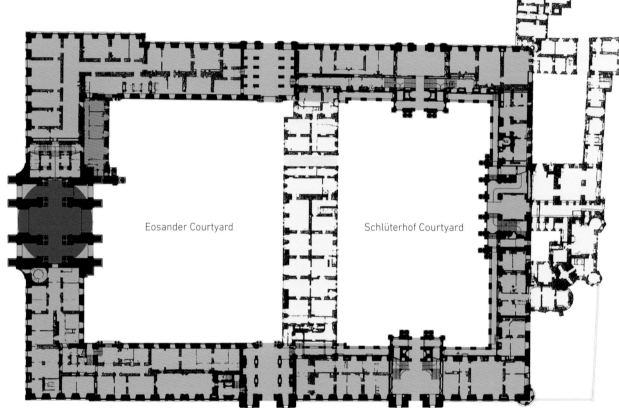

Eosander Courtyard

Schlüterhof Courtyard

The Old Palace

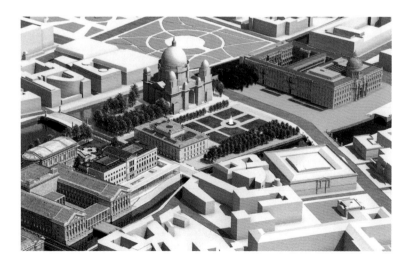

Model of the rebuilt palace and its surroundings

Pre-Baroque Buildings

Baroque Buildings

19th Century Dome

Later Addition

New Modern Buildings

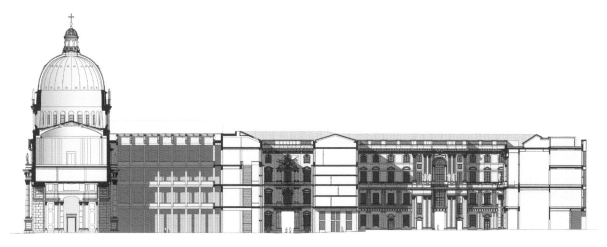

The New Palace: west-east section through the transverse wings

Portal 4 Portal 5

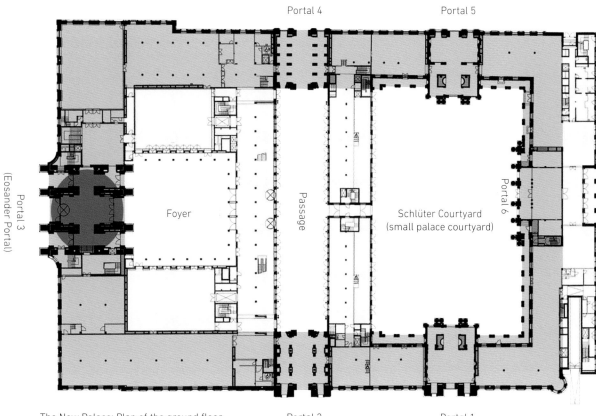

Portal 3
(Eosander Portal)

Foyer

Passage

Portal 6

Schlüter Courtyard
(small palace courtyard)

The New Palace: Plan of the ground floor Portal 2 Portal 1

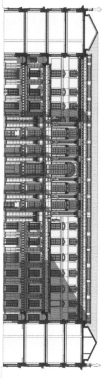

The New Palace:
The north-south
section through the
Schlüterhof, east
façade with Portal 6

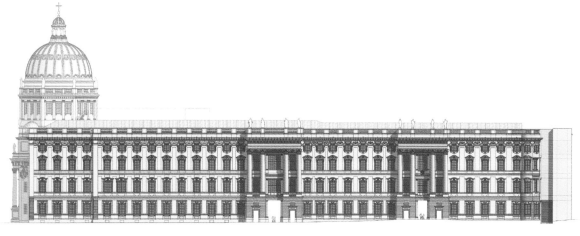

The New Palace: The south façade

only architecturally binding requirement, as stated in the Parliament resolution was "'the reconstruction of the baroque façades on the north, west, and south sides, as well as the Schlüterhof courtyard of the former Berlin Palace". This was taken on board by the international architectural competition held in 2007.

Beyond the competition specifications, the courtyard sides and the passages of Portals 2 and 4, which provide access to the new Passage were also reconstructed true to the original. The same applies to the Eosander Portal (Portal 3) under the dome, which serves as a powerful access portal to the new large reception and event hall. The reconstruction of all courtyard portals and their passageways reconnects the inner and outer squares to form a great public space in the heart of Berlin.

The Schlüterhof, once the place of court ceremonial and now future venue for a wide range of events, will regain the character of a theatre square through the reconstruction of its three baroque wings with their portals and surrounding loggias. The newly designed fourth wing is intended to be its completion. In the large Foyer where a glass-covered lobby and event hall are enclosed on three sides by new galleries, the reconstructed 'triumphal arch'- portal designed by Johann Friedrich Eosander von Göthe now looks like a fixed scene's front of an ancient theatre. In the Passage, a new column-lined pathway between the Schlossplatz and the Lustgarten, the reconstructed Portals 2 and 4 regain their original significance as the entrance and exit gates of the palace. With the reconstruction of the historic dome with lantern and cross, a landmark of the palace's identity returns.

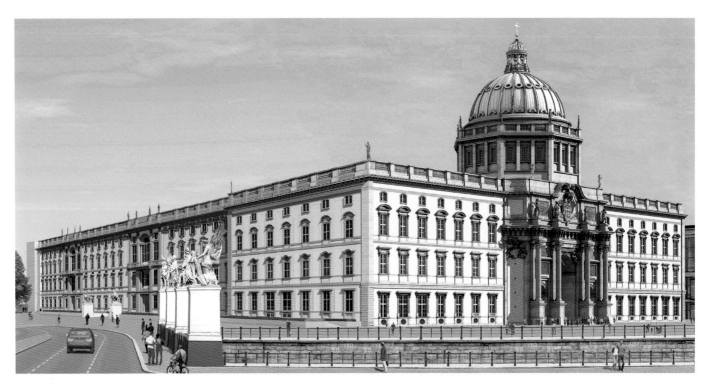

Rendering of the north and west façades of the palace

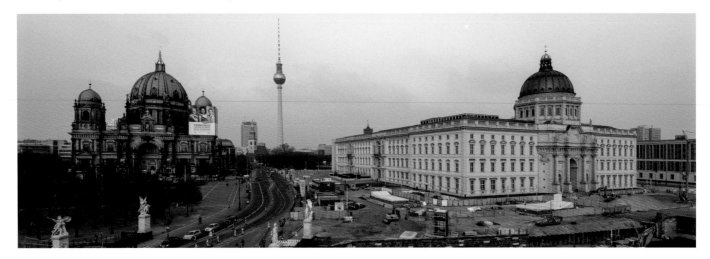

View of the palace construction site with the north and west façades; on the left, the Berlin Cathedral

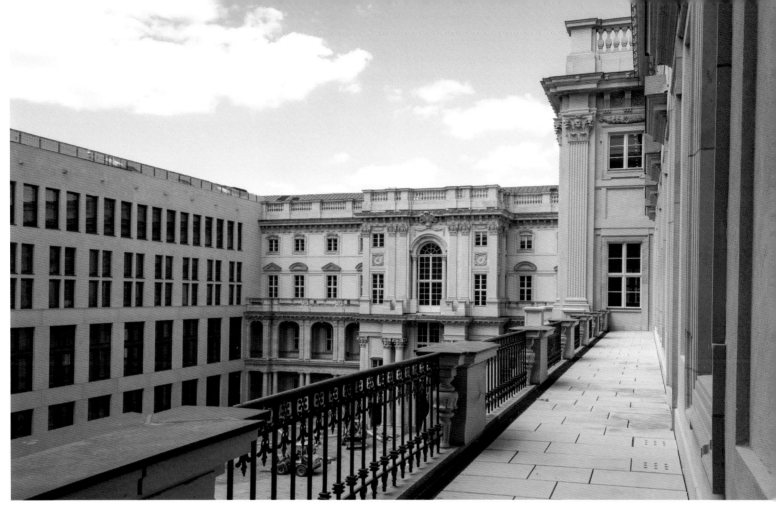

The Schlüterhof during the construction phase, still without sculptural decoration

The exhibition rooms, with ceilings up to seven metres high, fit into the storey heights of the baroque palace building without conflicting with its façades.

THE CONSTRUCTION OF THE HISTORICAL FAÇADES

The façades of the new Berlin Palace are part of a mighty three-layer wall system, the depth of which is comparable to that of the historic palace. A massive, 65-centimetre-thick brick wall with integrated natural stone elements is connected to the inner, 30 to 50-centimetre-thick reinforced concrete wall of the building's supporting structure via double-hinged anchors, which allows for thermal movements. The inner, 12-centimetre-thick mineral core insulation is accompanied by a slender, non-ventilating air layer. It serves to compensate for tolerances and as hygric decoupling.

The dense, energy-optimised wall construction has values that are thirty per cent better than those required by the current Energy Saving Ordinance. Flank-insulated metal frames form window openings in the inner reinforced concrete wall and project into the historical position within the outer brick wall. Clad in wood, they form accessible window niches within the air-conditioned exhibition rooms and ensure the necessary, high-level impermeability against wind and damp. As precise installation frames, they support the massive European oak-window boxes and at the same time served as millimetre-precise gages for the construction of the historic outer wall. They enabled the prolonged standing times within the complex construction process and now guarantee detailed connections as well as necessary margins for temperature-related movements between the window and the brick wall.

With over 3.5 million bricks, the reconstructed palace façades are built as massive and structurally independent walls, laid by hand from the base to the balustrade. Embedded in this construction are the large and, in some cases, widely protruding sandstone elements made by stonemasons and sculptors using traditional setting and anchoring techniques. On the outer wall the historically irregular joints can be seen, which are documented by excellent sources, and the traditional craft techniques of the time when it was built. The mineral-based exterior plaster with a thickness of 26 millimetres was also applied by hand, created with a lath wrap and rubbed down with a wooden board. It is finished with a multi-layered silicate glaze in light ochre. In keeping with the historic state, the exterior walls form large, expansion-joint-free façade sections 30 metres high and over 50 metres long. Temperature-induced movements and tensions within the enormous dimensions are relieved by a

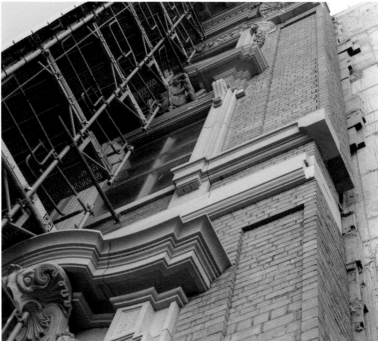

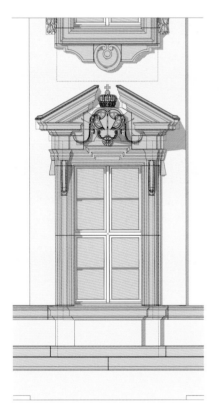
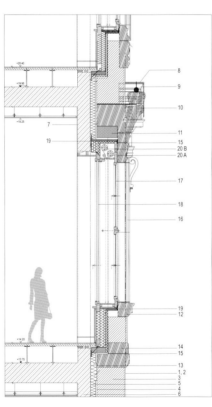
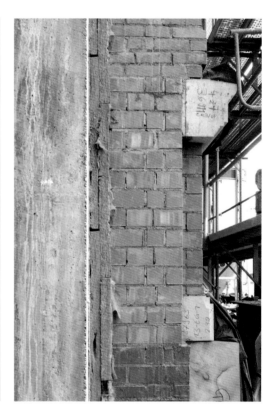

Wall structure of the palace façades

1 Glaze: silicate paint, shade: light ocher
2 Mineral exterior plaster,
 rubbed down, 26 mm
3 Brick masonry or sandstone
 elements, 650 mm
4 Standing air space, 30 mm
5 Mineral insulation, 120 mm
6 Reinforced concrete wall, 300–500 mm
7 Interior plaster: gypsum, 15 mm
8 Sheet metal covering: copper
9 Window roofing: sandstone
10 Cartouche: sandstone
11 Window lintel: prefabricated
 reinforced concrete, 500 mm
12 Window cornice: sandstone
13 Fire barrier: mineral wool, 150 mm
14 Storey cornice, two parts
15 Horizontal joint with soft mortar
16 Window jambs: sandstone

Windows of the palace façades

Box-type windows: oak, consisting of:
17 Exterior windows, historic, with
 glazing bars: nineteenth century,
 single glazing, partly in grey glass
18 Interior windows, modern, no glazing
 bars: thermal insulation/safety
 glazing, joint tightness class IV,
 parapet area, mineral insulation
Window colour: tinted white

19 Steel installation frame, hot-dip
 galvanised with laminated insulation,
 glass foam 40 mm
20 Motorised sun-protection blinds
 A Textile blind, transparent
 B Textile blind, translucent

Wall construction and windows of the palace façades

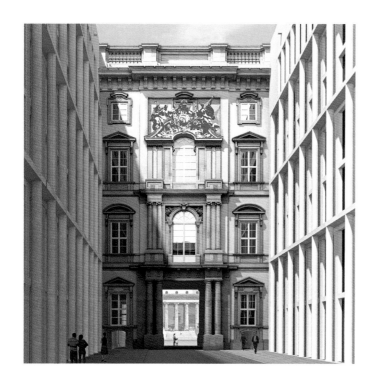

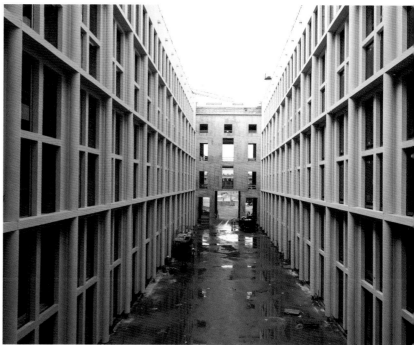

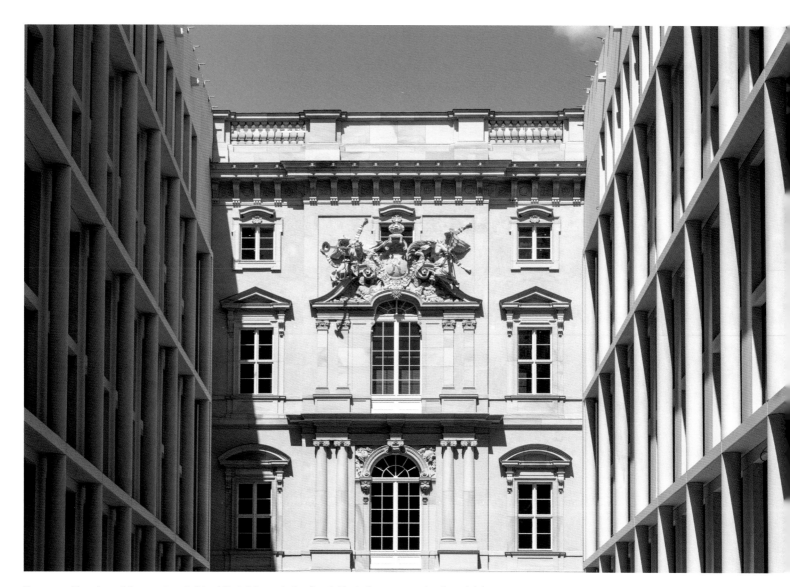

Passage with a view of the courtyard side of Portal 4: rendering (top left); during construction (top right);
completed façade of the first, second, and mezzanine storeys (bottom)

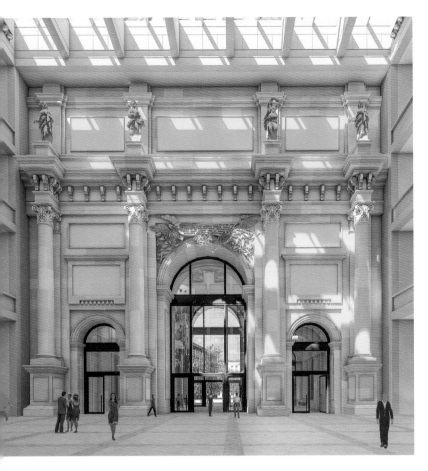

Courtyard side of the Eosander Portal: rendering

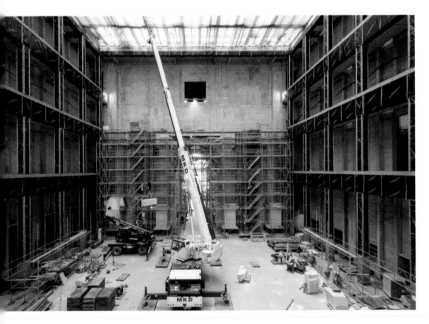

Courtyard side of the Eosander Portal under construction

The portals stand out clearly against the façades. As entrances, or city gates, to the inner palace squares, they are richly decorated. They were built stone by stone true to the original in their respective form as city, garden, or courtyard portals, as well as true to their original architectural arrangement in form and material. These include pilasters with arches, the herms supporting the balconies, and colossal columns crowned by large sandstone figures.

The reconstructed exterior façades deliberately have no load-bearing function for the interior building so that they can be faithfully reproduced. Both the roof structures and the wide-spanning floor slabs rest on the inner reinforced concrete wall. This is due to the fact that the requirements for load-bearing capacity and fire protection and the energy-technical specifications of a modern museum far exceed the possibilities of historical wooden beam ceilings as they once existed in the Berlin Palace. The inner load-bearing structure was financed by public funds, while the reconstructed outer walls were funded by private donations. With the separation of the façade within the construction, it was possible to have the shell and the core of the building erected and sealed quickly and to press ahead with the interior furnishing of the museum, independently of the palace façades, which were being crafted by hand over a longer period of time.

The now visible building impressively demonstrates that neither the use of new building materials within the described wall system nor the loss of the load-bearing function diminishes the credibility of the reconstructed baroque façades. The assumption that the material homogeneity of an exterior wall in its full and invisible depth is an indispensable requirement for the constructive truth is also refuted by numerous examples from the architectural history of every building epoch. It is safe to say that a self-supporting masonry façade of this dimension, or a 30-metre-high brick wall built in more recent times, can hardly be found anywhere else in Europe.

The reconstruction of the palace façades includes over thirty door-systems and more than 500 windows of exceptional dimensions. Two transparent textile hangings with different shading densities are integrated into each of the double-hung windows, allowing a wide variety of daylight scenarios for the exhibitions. The muntin pattern, profiling, and colour tone of the windows refer to the time around 1850, when the sandstone of the palace was no longer coloured and when the palace received its final form with Friedrich August Stüler's dome.

system of mortar joints of varying softness, through vertical tie rods integrated into the wall, horizontal reinforcement layers, and a sliding bearing arranged below ground level. These measures limit the risk of visible cracks forming in the exterior plaster.

Franco Stella is the architect of the rebuilt Berlin Palace as the Humboldt Forum.
Peter Westermann is the project manager responsible for the historic and new façades within the 'Franco Stella Humboldt Forum Projektgemeinschaft'.

Completed foyer with triumphal arch →

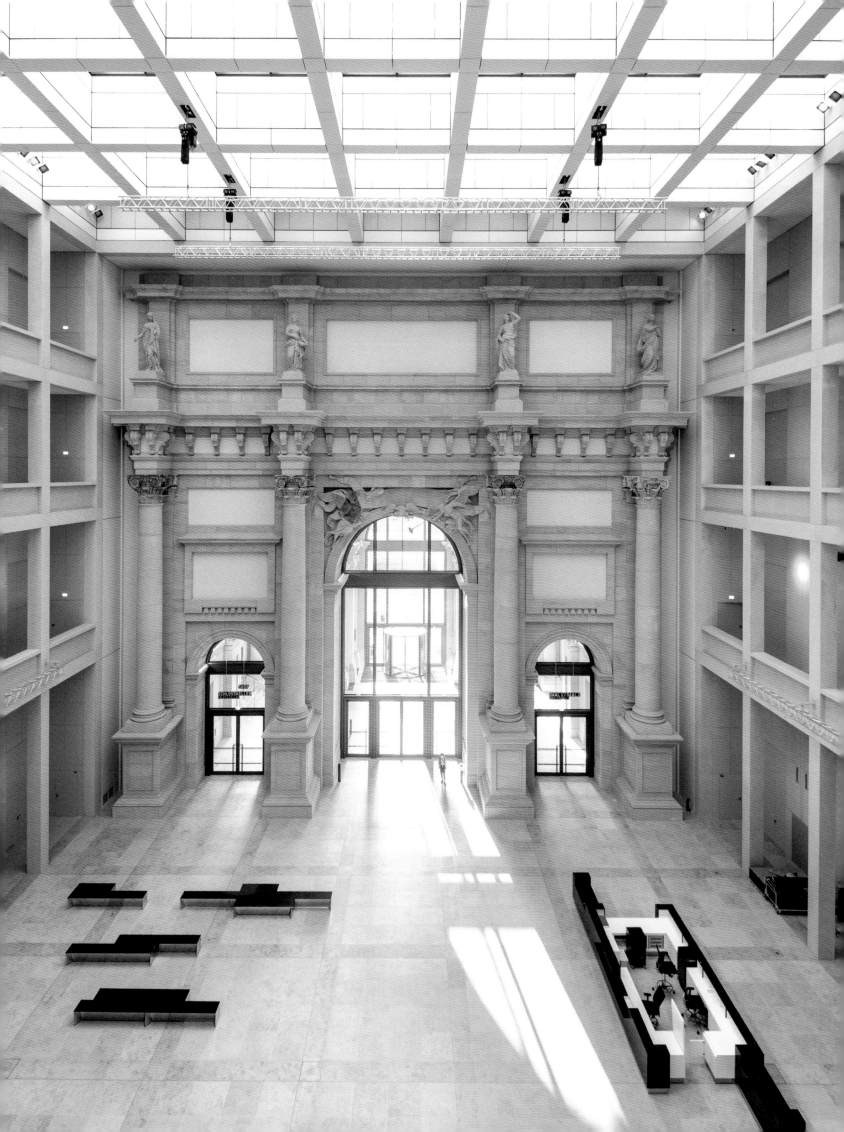

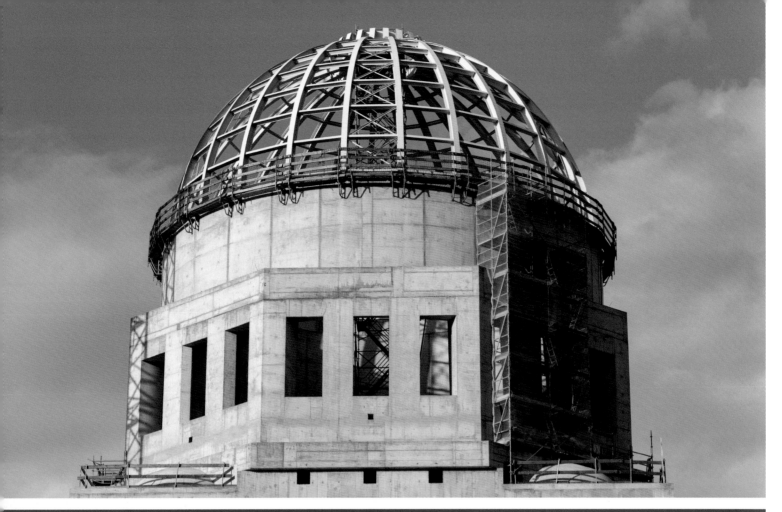

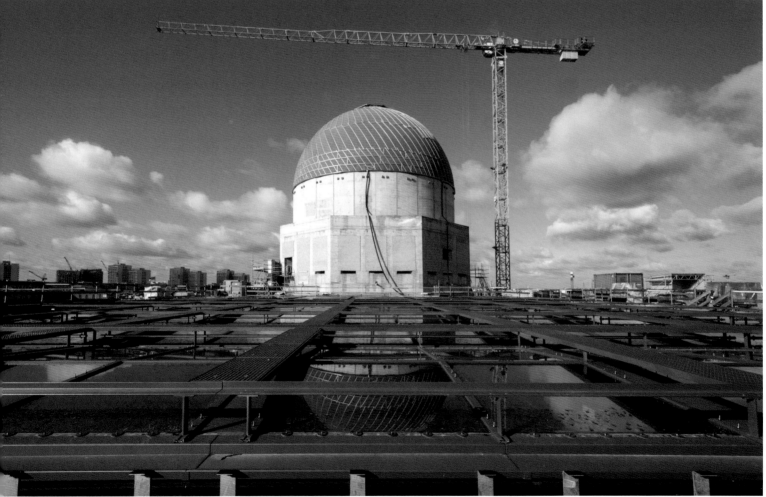

Top/bottom: Shell construction stages of the dome

Dome after completion →

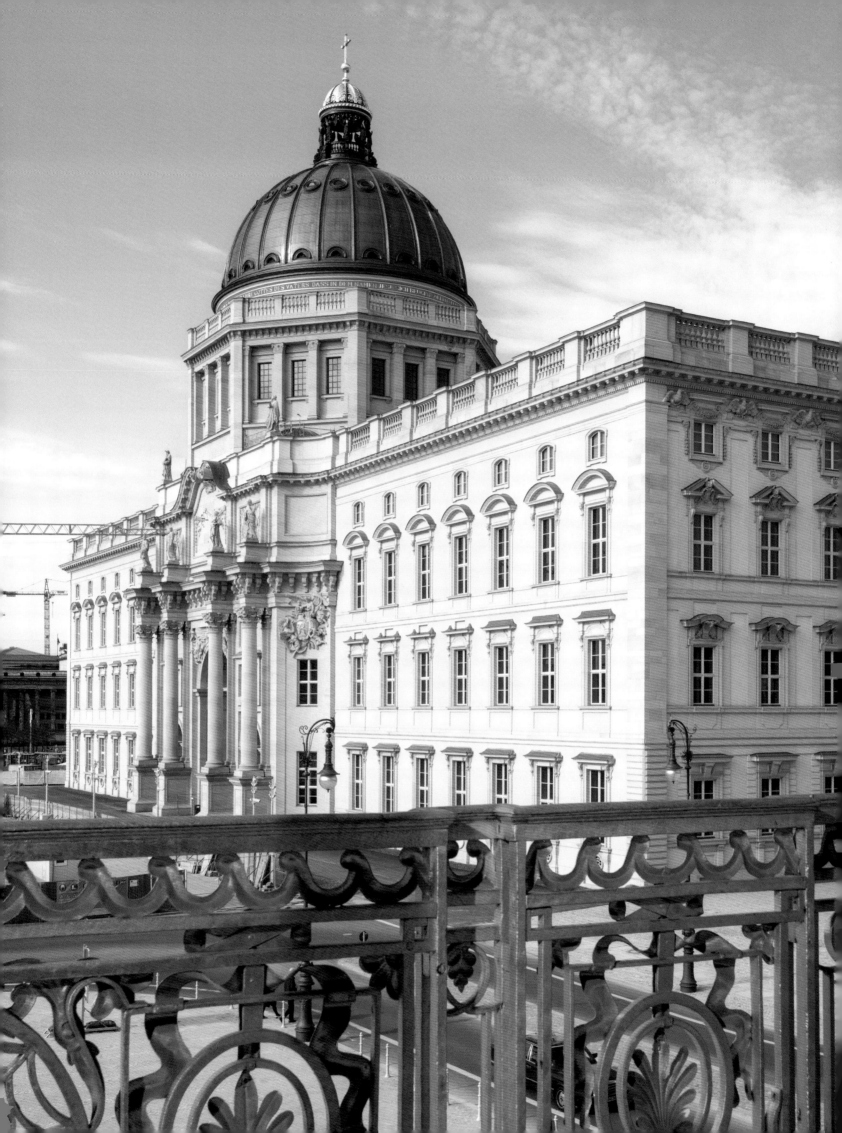

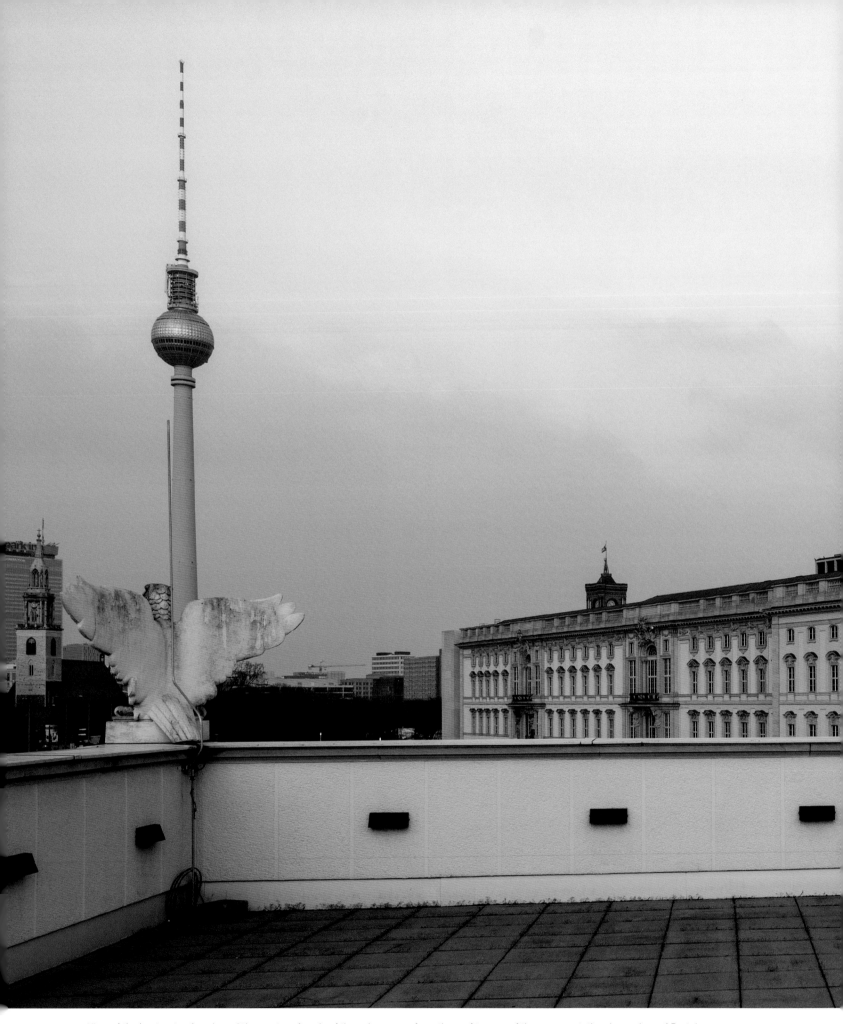

View of the Lustgarten façade and the western façade of the palace, seen from the roof terrace of the representational premises of Bertelsmann at Unter den Linden 1, with St. Mary's Church, the television tower, and the Rotes Rathaus in the background

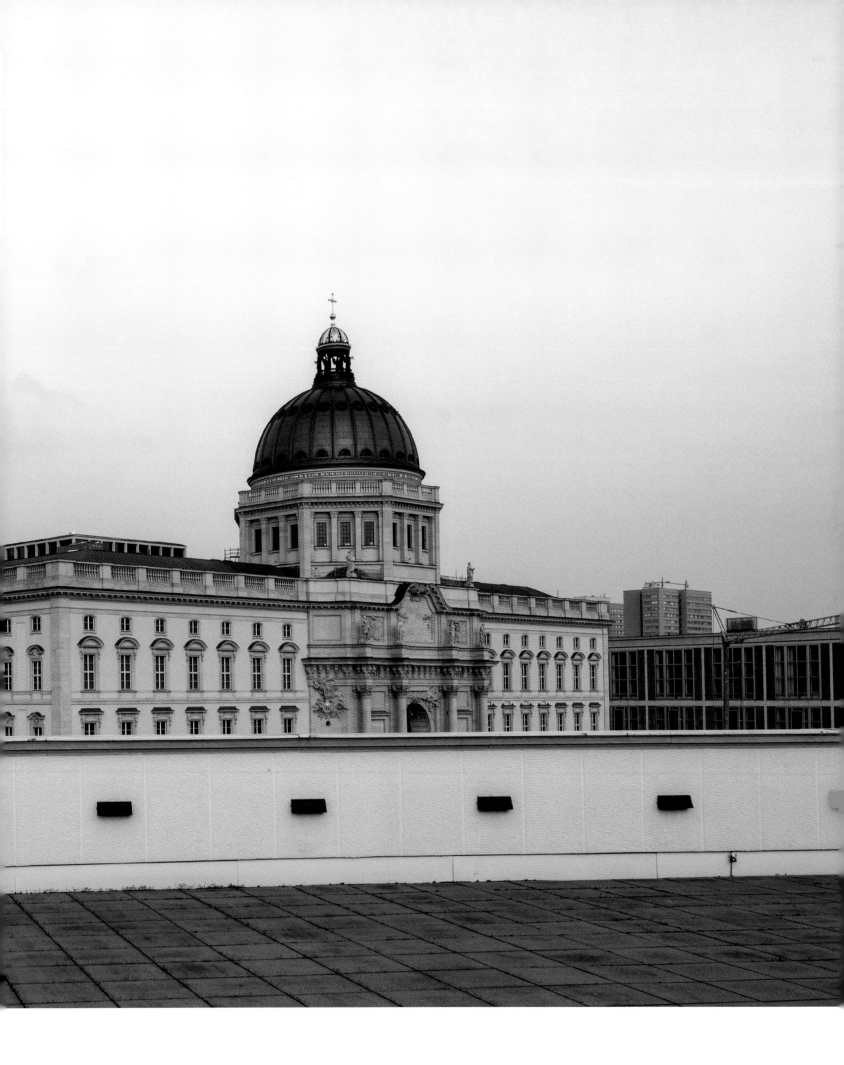

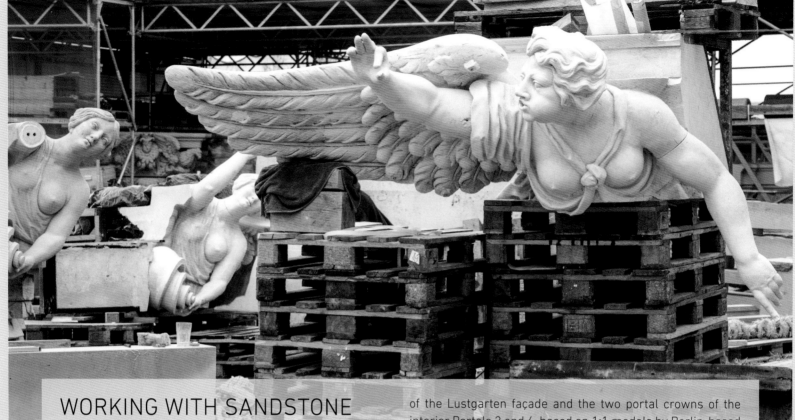

WORKING WITH SANDSTONE

In Sven Schubert's stonemasonry and stone sculpture work-shop near Dresden, heavy stone saws are in use, as well as the latest computer-controlled milling machines. With these, the surface of the decorative element or figure can be milled out of the sandstone down to a one-centimetre top layer. This last layer is then worked off by hand with cudgels and carving tools. The three-dimensional scan serves as an electronic template for the milling machine's work. This is taken from the sculptors' life-size plaster model or scanned without contact, as in the case of the herm pilasters on the exterior of the still existent historic Portal 4 of the former State Council. In Schubert's workshop, numerous sculptural works were created, including the large corner cartouche of the Lustgarten façade and the two portal crowns of the interior Portals 2 and 4, based on 1:1 models by Berlin-based sculptors.

The work on the Berlin Palace's reconstruction of the façades' sandstone decorative elements thus combines state-of-the-art computer and robot technology with centuries-old craft techniques and devices such as the pointing machine. The latter involves using the simplest of means to transfer specific, three-dimensionally defined points one after the other from the plaster model to the sandstone block, thus gradually creating the sandstone replica. In the illustration above you can see a genie on the passage (still without the fanfare horn) from the courtyard side of Portal 4. Below, the large sandstone blocks lie in the open, awaiting further processing.

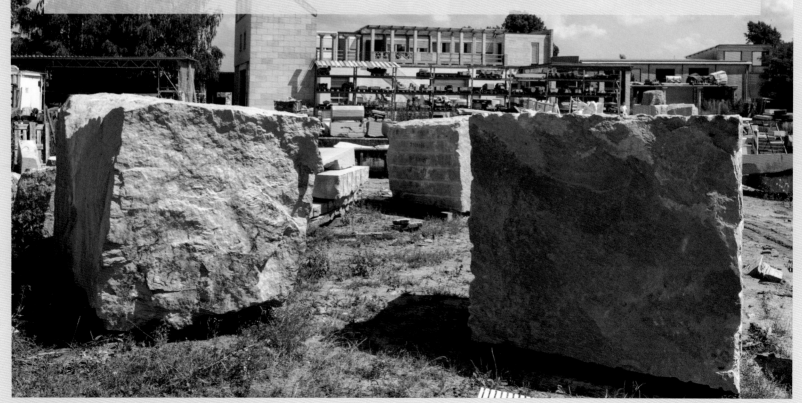

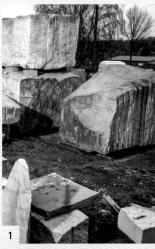

1 Raw blocks of stone before processing
2 + 3 The stone blocks are cut to size by the huge
 stone saw.
4 + 5 With the pointing machine, a mechanical
 construction of brass rods, joints, and a needle
 attached to a wooden cross, the sculptor takes
 the position of, for example, a toe from the
 model for the execution in stone.
6 With the help of compressed air, the milled
 surface is reworked and finished by hand.
7 The pre-milled decorative elements still reveal
 machine-produced traces on the stone surfaces,
 which are now carefully worked by hand.
8 Finished sections of the mighty Portal 4 herm
 pilasters 4
9+10 Preliminary work with the stone cutter on the
 lower shaft of one of the herm pilasters

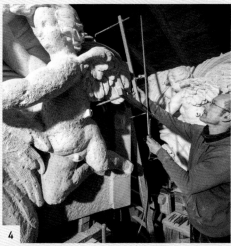

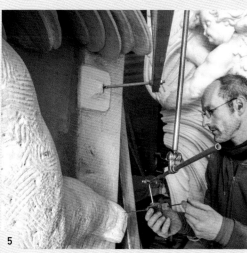

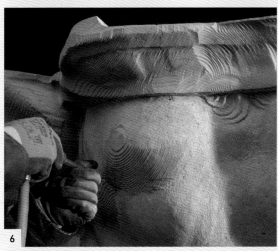

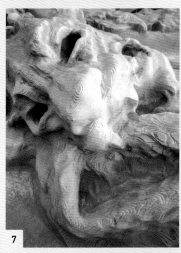

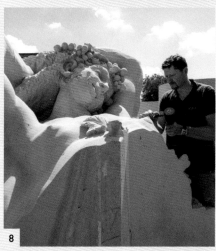

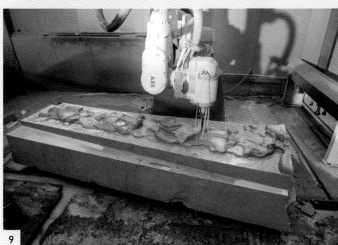

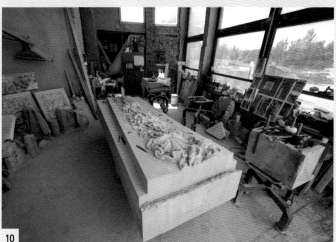

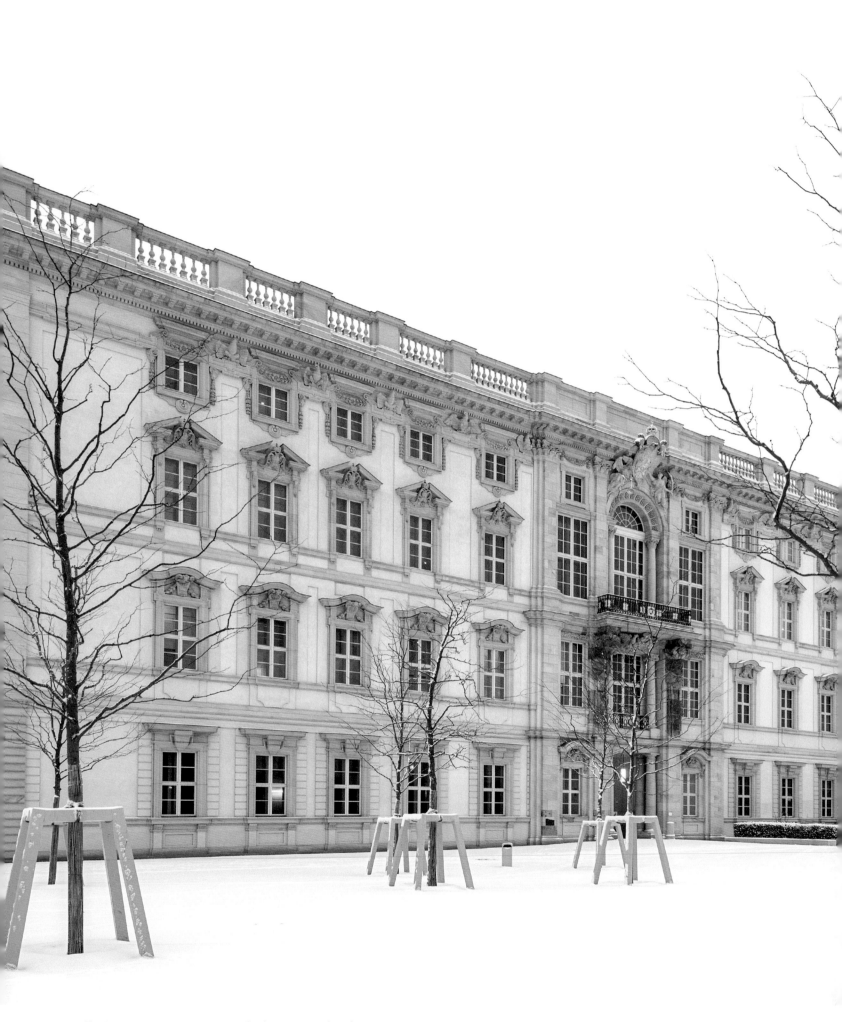

The Lustgarten façade with Portal 5 (left) and Portal 4 (right)

Kathrin Lange and Bertold Just*

RESTORE – RECONSTRUCT – REPLICATE

ON THE RECREATION OF THE SCULPTURAL FAÇADE DECORATION

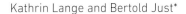

With the Altes Museum behind them, visitors coming from the Lustgarten can see a reconstructed baroque façade with two large portals. The ornamentation made of sculptures and sculpturally designed architectural elements is particularly opulent here. Powerful herms grow out of the architecture; the balconies are carried by allegories of Spring and Summer on the left, eastern portal, and by Autumn and Winter on the right, western portal. Between them is a cartouche flanked by eagles with the initials F(ridericus) R(ex). On the top floor, two genii each rise above the round arch. Blowing their golden fanfare horns, they hold the four-metre-high heraldic cartouches which bear royal crowns. On the ground floor of the eastern portal, the allegorical reliefs of Strength and Justice make reference to the political system. Flower festoons, laurel bouquets, and capitals complete the architectural decoration.

With a view to their re-building, the portals impressively unite the diverse possibilities and different approaches which are conceivable when reconstructing a façade. Architectural elements of the historic façade were rescued, restored, and reused as authentically as possible. These include the Spring and Summer herms on Portal 5, which have been largely preserved in their original form. Also preserved is the original Portal 4 with Autumn and Winter. Since 1962, however, it was permanently integrated into the then newly built GDR State Council Building. For the reconstruction of the façade, both sculptures were scanned, plotted, reworked, and replicated in sandstone. The two valuable Allegories reliefs (c. 1704) by Andreas Schlüter mentioned above are now on display in the Bode Museum. In view of their art-historical value and the condition of the surfaces and stone

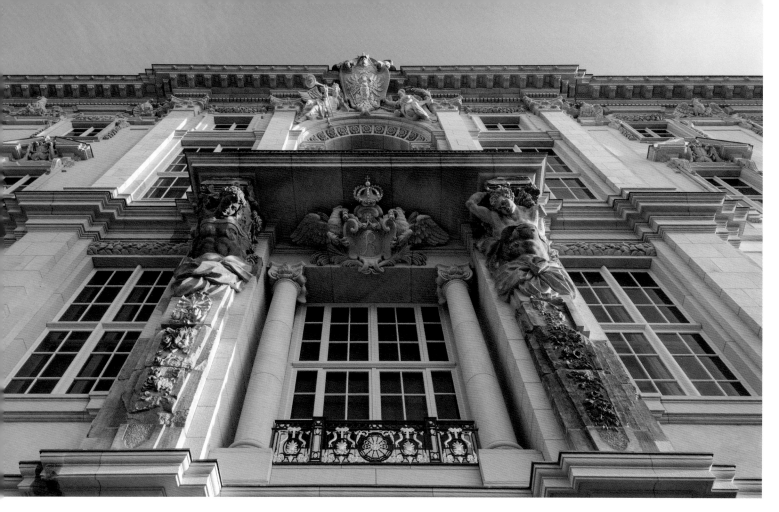

Atlas herms and heraldic cartouches on Portal 5

substance, the decision was made not to reinstall them, since the risk of gradual weathering in the open air was deemed too high. Both reliefs could, however, be directly moulded and replicated. For all other sculptured elements of the façades, plaster models were created on the basis of preserved fragments, historical photos, and baroque design principles. The models were then executed in sandstone.

Using the example of the ornamentation on the two portals facing the Lustgarten, the tasks, procedures, and challenges involved in the production of the sculptural decoration shall be outlined.

THE RESTORATION OF THE ORIGINALS

"The preserved fragments and archaeological finds, as well as essential parts of the palace building, should be reused in the Humboldt Forum, be it by reinstalling them at the 'historical site', or in a museum presentation or appropriate storage". With this proviso, experts at an international conference which took place at the Villa Vigoni on Lake Como supported efforts to pursue as many clues as possible regarding the whereabouts of original fragments, then to collect and check them for their reutilisation. Further stipulations laid down by an expert commission who were ap-

pointed by the Board of Directors of the Humboldt Forum in 2010 solely for the reconstruction of the façades called for the selection to be further differentiated. For example, the original parts to be installed should have a minimum size of sixty centimetres, and their state of preservation should permit exterior fitting; furthermore, they should be positioned in the original place or somewhere comparable and be easily perceptible. At Portal 5, fourteen preserved fragments were placed in the new façade, in addition to eight herms for Spring, and Summer with six original pieces.

Both portal herms had been salvaged before the demolition of the Berlin Palace in 1950 and survived in various storage locations in Berlin: in Heinersdorf, Ahrensfelde, Buch, and Friedrichsfelde. In 2011, the preserved sections were finally transported to the Palace Masonry Workshop in Berlin-Spandau and reassembled once again. With their powerful and dynamic demeanour, they are convincingly impressive examples of baroque sculpture. Preliminary examinations of their state of preservation provided information on the stone's strength, as well as the surface condition, which in turn led to the decision to reinstall the herms in the new façade. In close consultation with Norbert Heuler as representative of the State Monuments Office, the expert commission defined essential criteria for dealing with all

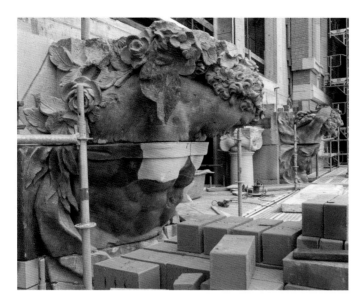

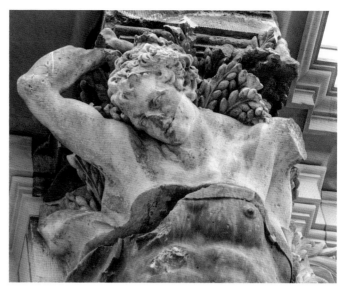

Installation of the original herm representing Spring on Portal 5; in front of this, bricks for the wall of the façade

The original herm representing Summer after installation

original objects. They agreed on the key point of visibly preserving the damage caused by the war and its aftermath, integrating the fragment as a constituent part of the façade, while making reference to the complete destruction of the historic building by depicting its damaged condition. Restorers specialised in baroque sandstone sculptures carried out the conservation and reconstruction. They cleaned the surfaces with micro-steam and micro-particle blasting,

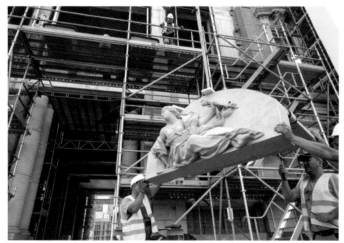

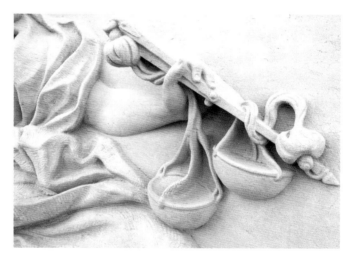

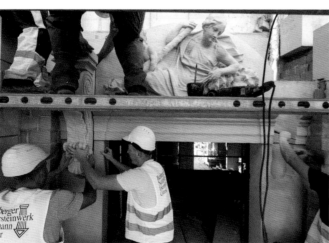

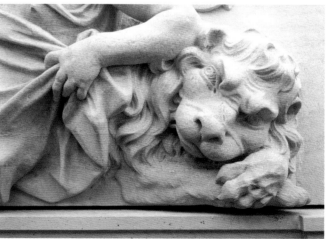

Copies of the lunette reliefs preserved in a museum being mounted on Portal 5

Details of the allegories of Justice and Strength in the lunette reliefs

THE HERM PORTAL 4

1 The original herms representing Autumn and Winter are installed in the former GDR State Council Building. They were scanned for the reconstruction of the façade and copied in sandstone.

2 + 3 The sculptors transfer the forms, details, and surface structures into the sandstone based on the scanned models.

4 + 5 The members of the expert commission accompany the process and give advice on details of the execution. Only when, as here, the herm representing Autumn has been given a mischievous smile comparable to the original, do they give the go-ahead to install the blocks.

6–8 With the help of powerful cranes and hoisting equipment, the blocks that were secured on load frames for transport, are inserted into the portal.

9 The Portal with copies of the herms

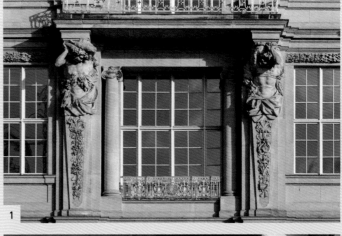

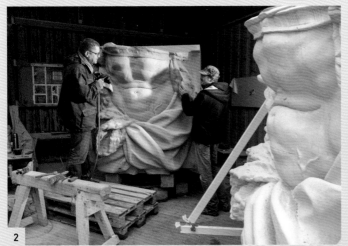

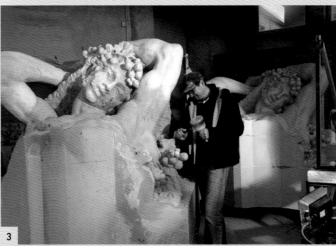

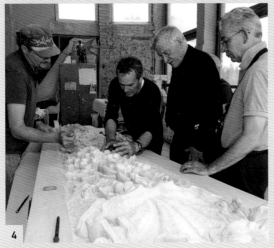

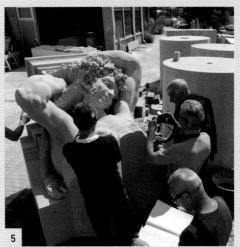

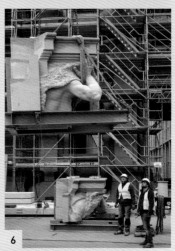

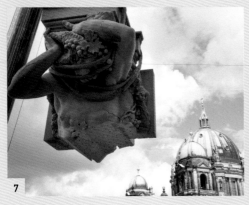

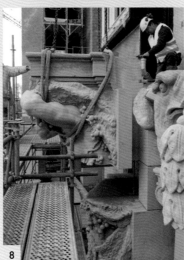

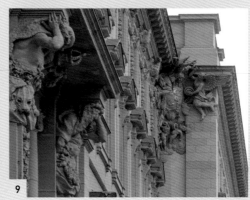

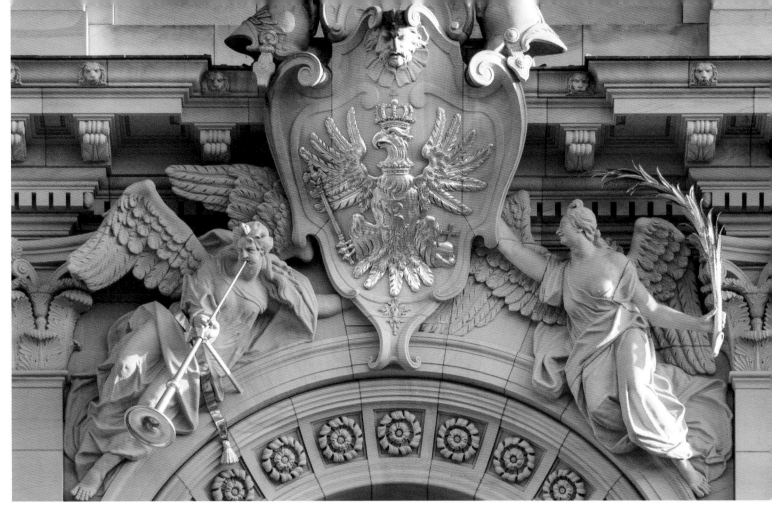

The Prussian coat of arms with eagle and the genii Fama and Pax on Portal 5

removed black pollution crusts and reduced damaging salts with the help of compresses. Morbid stone structures were strengthened, rusting old anchors and reinforcements were carefully removed or conserved. Largely intact additions to the sculptures from the time after their creation were to be left as historical testimonies and restored. Each herm was originally composed of seven blocks, five of which have been preserved. Additions were made in sandstone for the missing blocks, one each in the middle and on the lower part. The lost arms as well as a wealth of other damage were not included in the restoration process.

THE RECONSTRUCTION OF THE
ARCHITECTURAL SCULPTURE

Most of the Berlin Palace's original sculptural façade decoration was completely lost. What were the special challenges in reconstructing it? Was it the variety, the quantity, and the size of the sculptural elements? Or the high demands on quality, materials, technical implementation, and tendering procedures? Ultimately, the special nature of the task resulted from its complexity, since it was necessary to deal not only with the historical building in all its facets and aesthetics, but at the same time also with the construction

methods of the nascent twenty-first century, including corresponding laws, regulations, and technical requirements.

Replication and reconstruction demand "the greatest efforts with regard to the examination of the original conception and the technical-manual realisation [...]. It is a humble approach, a submission to the original intentions of the artist, the designer, as well as to the idea and its implementation". With this credo, the sculptors created over 300 individually designed models as templates for execution in sandstone. This was necessary in order to come anywhere near to reaching the historically documented variety of sculpturally designed façade elements. The detailed design of each individual element was carried out with equal care, be it the rosettes in the uppermost portal arches of the Lustgarten side, the capitals in the storeys below, or the sculptural decoration beside the windows.

In 2011, the preparations for a reconstruction of the two genii Pheme and Pax with the escutcheon above the round arch on Portal 5 were completed. Their dimensions with a total height of 5.3 metres and a total width of 5.6 metres could be derived from the proportions of the architecture. Careful research also brought photographic material from 1876 to 1950 to light. Among this material are pictures taken from the scaffolding in the immediate vicinity of the sculptures before demolition. They reveal impressive details such

as the flowing robes and the arrangement of the feathers on the wings, for example. Probably the most important find were the two original heads of the genii. They could be moulded and integrated as plaster casts into the life-size plaster model. For such complex representations, the sculptor first works out the overall composition in a reduced clay model (*bozzetto*) on a scale of 1:6. Both genii and the coat-of-arms cartouche were arranged spatially in alignment with the surrounding architectural elements. The genii appear to be moving: Pheme (reputation) welcomes the arrivals with the fanfare horn, while Pax (peace) refers to the Prussian eagle and thus to the location, with the palm branch. In the *bozzetto*, the first modelling examination of the content, form, and arrangement of what is to be depicted takes place. Subsequently the aforementioned model is created in a life-size scale. A steel substructure stabilised both the façade area which was built in wood and plaster as well as the expansive sculptural ornamentation, developed in modelling clay. Time and again, the sculptor checked and compared the work with historical photos. In order to examine it from a distance and see it from below, it was necessary to climb up and down the scaffolding countless times. Further original fragments of other palace sculptures served as comparative examples for questions of detail, such as a female torso or part of an eagle's wing. Before final approval was given, the expert commission inspected the model work many times in order to discuss, assess, and decide on it together. Only then did the sculptor, together with the stone technician, determine the block joints and dimensions for future installation in the façade. Such large works of art are always assembled in several sections in order to keep the weights and dimensions of the sandstone blocks within manageable limits. Stable plaster casts ultimately replaced the soft clay model in the correspondingly determined block dimensions, so that altogether sixteen independent sections were created as templates for the life-size realization in stone.

According to these models, a stone milling machine worked the sculptures out of the sandstone blocks with an oversize of roughly 0.5 to 1.5 centimetres using modern stone technology. This was done before the stone sculptor used the pointing process – a replication process in which individual points from the plaster model, for example on the knuckle of the hand, are measured into the sandstone block and set with the stone sculptor's tool – to create the sculptural surfaces in all their details. The stone sculptor responsible for the replicas also has to understand the aesthetic forms and know how to shape baroque hands and garment folds, as well as baroque female figures. The previous plaster models were created in a loose, modelling manner and left room for interpretation. The sculptor's carving tools create new edges and sharpness in the sandstone, thus producing other surface structures. Here, a well-founded knowledge of baroque working methods with sandstone was required in order to ultimately achieve the dynamics and power already mentioned with regard to the herms.

After completion, heavy-duty lorries transported the genii to the palace building site, where a team of stonemasonry, stone technology, and sculpture experts, as well as crane drivers, fitted the sections weighing several tonnes with millimetre precision into the façade. The central part of the coat of arms, for example, weighs roughly ten tonnes, and the block with the upper body of the right genie roughly six. There was a constant danger of the edges chipping or filigree parts hitting something and breaking off. The work was completed when the fanfare horn and the palm branch were in place. These gilded attributes were formed in sheet copper and eased into the hands of the genii.

How should a reconstructed façade look? Like the original façade, of course. With its appearance and radiance it should inspire contemplation and invite people to enjoy discovering the many forms and artistic representations. And it should contain as many original elements as possible, which, like 'Stolpersteine' (stumbling blocks), remind us of the place's history.

** Bertold Just died in November 2018. The content of this essay was jointly agreed upon, and the text is dedicated to his memory.*

Kathrin Lange is head of the Restoration Department of the Stiftung Preußische Schlösser und Gärten Berlin-Brandenburg (Prussian Palaces and Gardens Foundation Berlin-Brandenburg).
Bertold Just was Head of the Palace Masonry Workshop until November 2018 and, as a member of the expert commission, played a key role in the reconstruction of the façade.

Literary Sources
Alter Glanz in neuer Umgebung', in: *Von der Vision zur Wirklichkeit. Der neue Landtag in Potsdams Mitte*, Brandenburg Ministry of Finance (ed.), Potsdam 2014, vol. 2, here p.148 [translated].
Zehn Thesen der Villa Vigoni', in: Manfred Rettig (ed.), *Stiftung Berliner Schloss – Humboldtforum: Rekonstruktion am Beispiel Berliner Schloss aus kunsthistorischer Sicht. Ergebnisse der Fachtagung im April 2010, Essays und Thesen* [*Villa Vigoni im Gespräch*, vol. 2], Stuttgart 2011, here p.11 [translated].

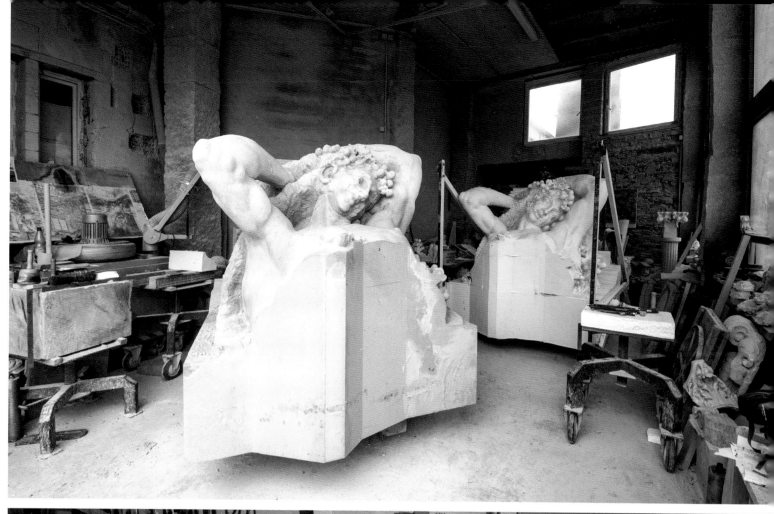

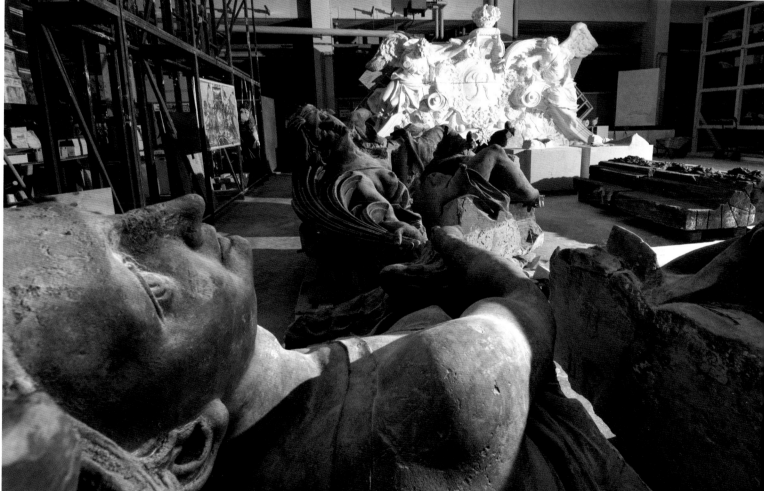

Top: The herm representing Autumn after processing by the stone milling machine and before manual sculpting; in the background, the model based on the scan of the original herm

Bottom: Original sculptures before restoration in the Palace Masonry Workshop; in the background, a reconstructed coat of arms cartouche with genii as a plaster model for execution in sandstone

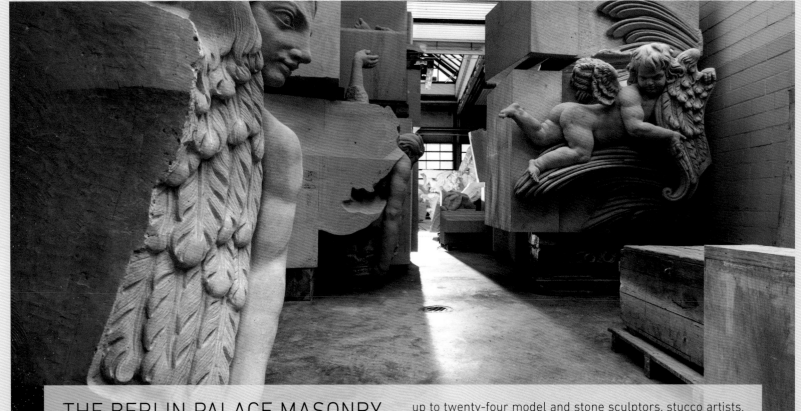

THE BERLIN PALACE MASONRY WORKSHOP

The Berlin Palace Masonry Workshop was set up in 2011 by the Berlin Palace Foundation – Humboldt Forum in a former Allied motor vehicle repair workshop in Spandau. Covering an area of roughly 2,400 square metres, the skylit hall with a gantry crane boasting a load capacity of up to five tons provides ideal working and studio space for all the trades involved – for sculpture and stonemasonry work as well as for plaster moulding and stone restoration. Thanks to an artistic and technical exchange of knowledge under the expert leadership of its director Bertold Just, who died much too early in 2018, an active centre of excellence for the reconstruction of baroque façade decoration was set up. At times, up to twenty-four model and stone sculptors, stucco artists, and restorers worked here.

The idea of the masonry works follows a centuries-old model. For example, the Cologne Cathedral Masonry Workshop has existed since the thirteenth century. This is because sculptural work especially of soft sandstone, on the cathedral façades requires ongoing restoration and renewal due to external damage from weathering and natural ageing. The balustrade figures for the exterior façades and portals are the next big task on the programme of the Berlin Palace Masonry Workshop, until later – hopefully not too soon – restoration work due to wear and damage will follow. The illustration above clearly shows the mighty stone block with the projecting putto. Built into the outer wall, it will hardly be visible. Covered over on the lower left are the original portal figures from the Schlüterhof, which were carefully restored in the Palace Masonry Workshop.

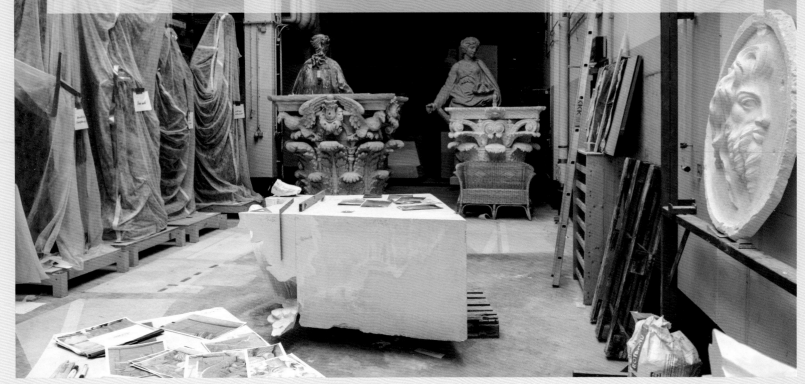

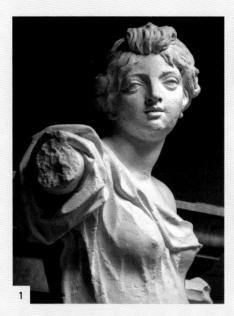

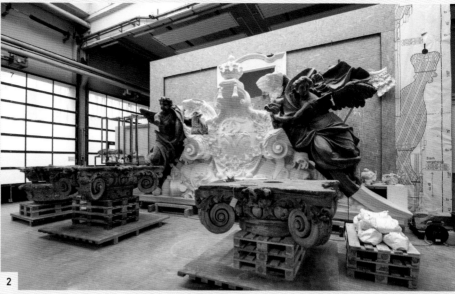

1 Plaster cast of a robed female figure for the courtyard side of Portal 1, the original of which is on display in the Sculpture Halll of the palace.

2 Work on the life-size model for the courtyard side of Portal 2 at the passage. In the foreground, the original column capitals, which were deposited in the park of the Märkisches Museum and in front of the ruins of the Klosterkirche after the palace was demolished in 1950.

3 The clay bozzetto for the colossal figure of Faith, which will later be placed on courtyard Portal 3. A historical photograph of the original sculpture can be seen in the background.

4 The plaster model and the sandstone version of the figure of Love, which is intended for Courtyard Portal 3, alongside three other sculptures.

5–9 The stonemason or stone sculptor sets a point on the plaster model with the pointing machine, which is then worked into the sandstone. The sandstone sculptures are created from the plaster models in the sculpture department of the Palace Masonry Workshop. In order to be able to move the blocks, joints run through the sculptural elements. In this way, individual wings, legs, torsos, and robes are created, which only come together on the façade to form a full figure.

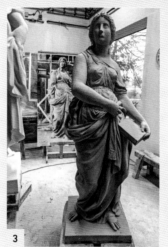

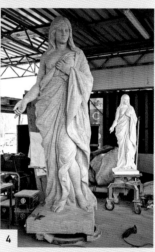

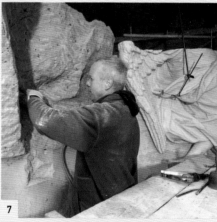

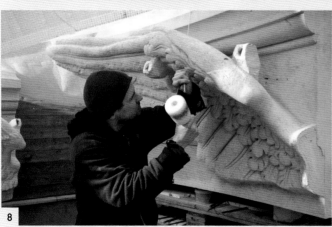

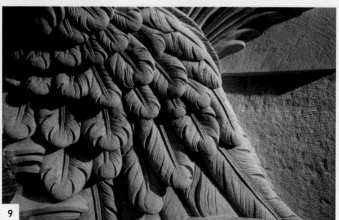

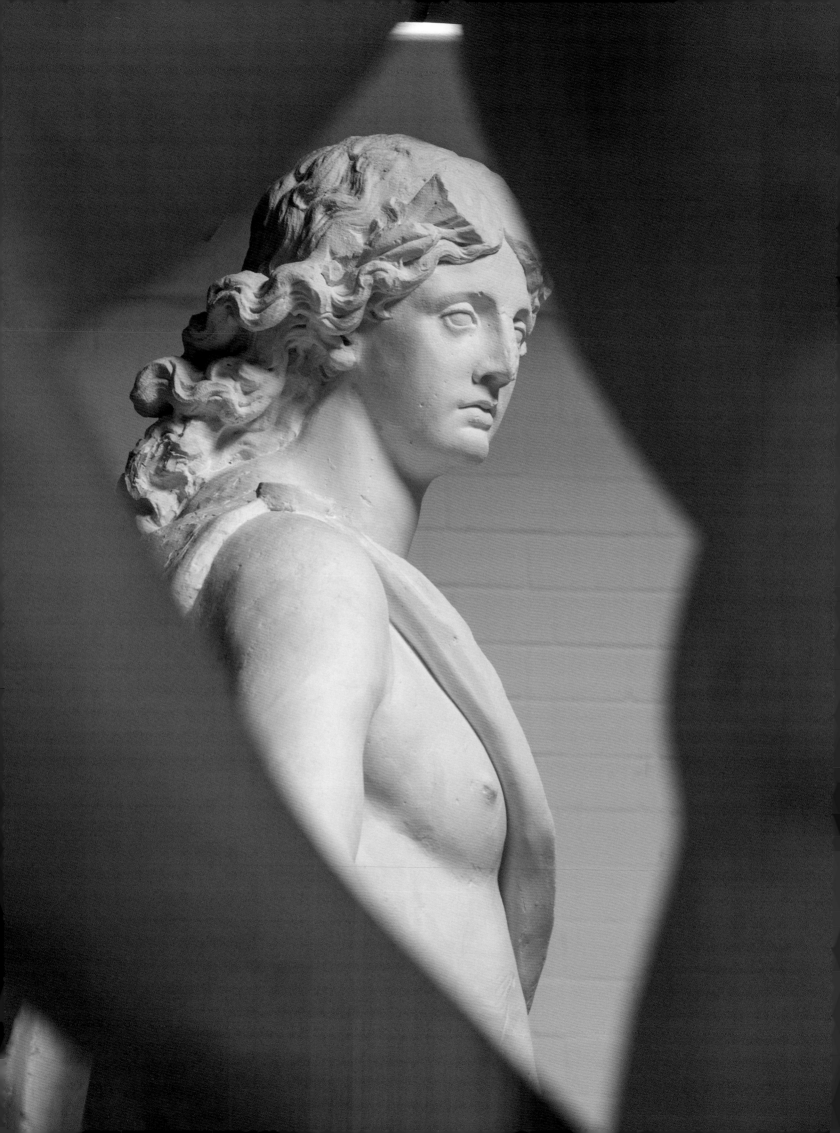

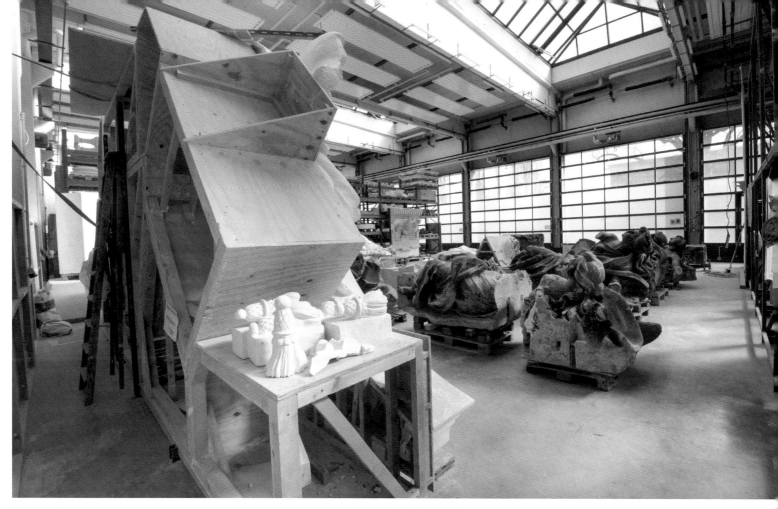

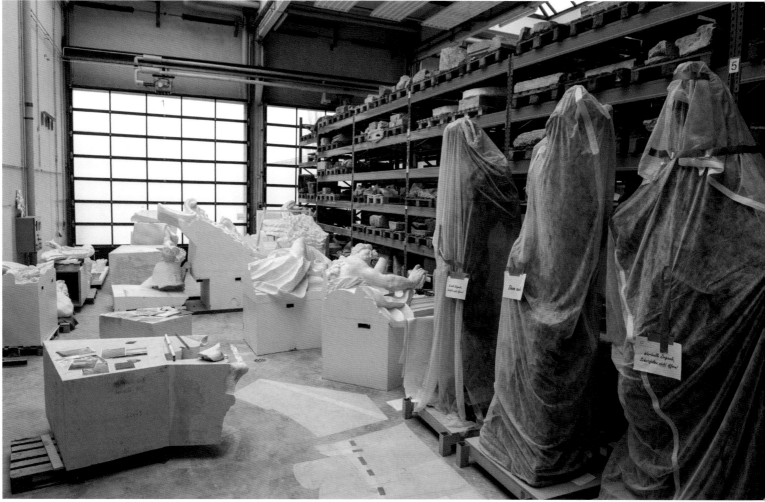

← Plaster cast of Apollo from a clay model for Portal 6 in the Schlüterhof

Top: View into the large hall of the Masonry Workshop with original portal sculptures and the back view of a reconstruction

Bottom: Storage shelf with originals and models; in front of this, the original figures for the Schlüterhof protected by plastic sheeting

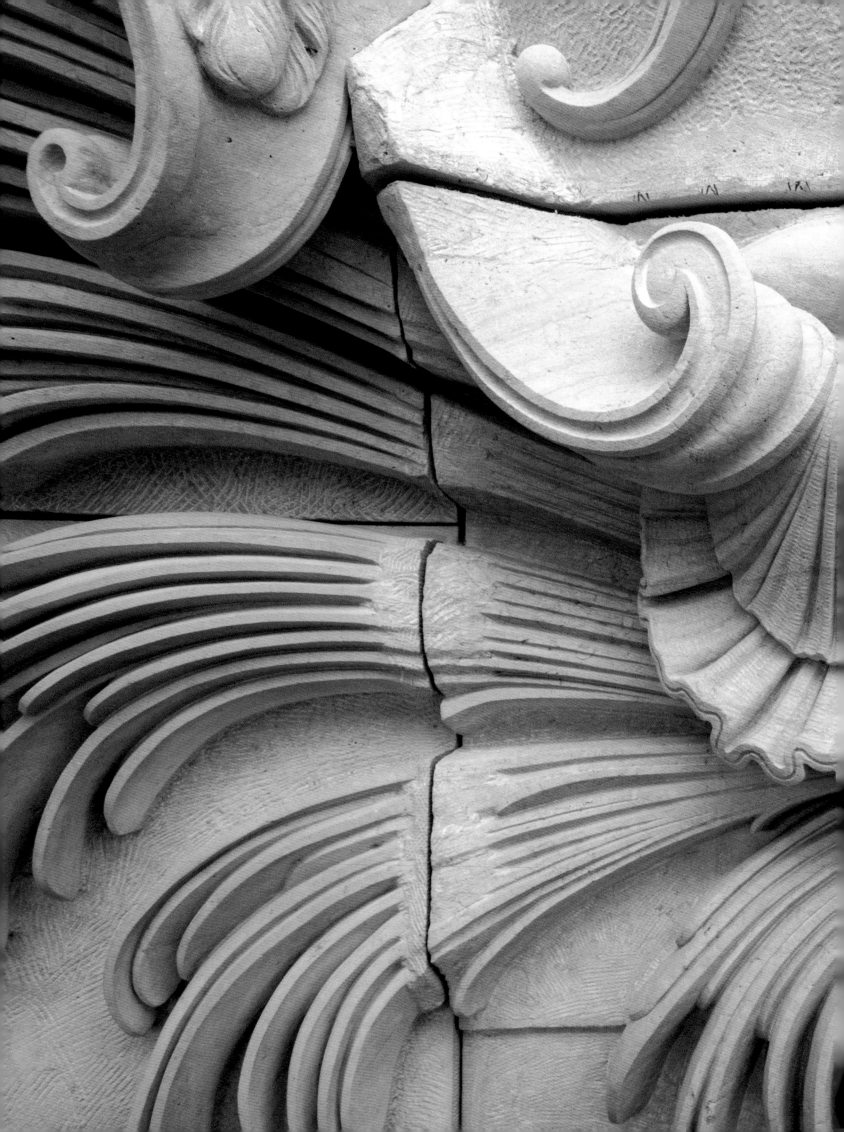

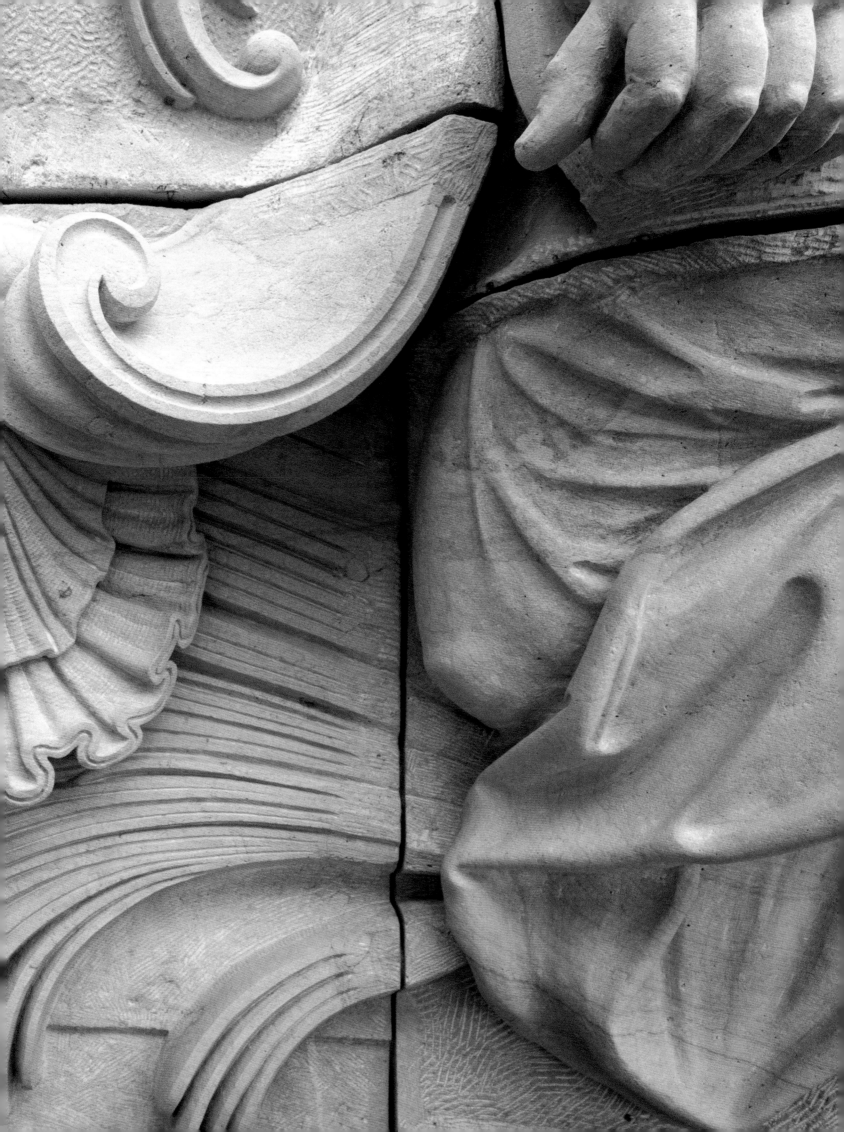

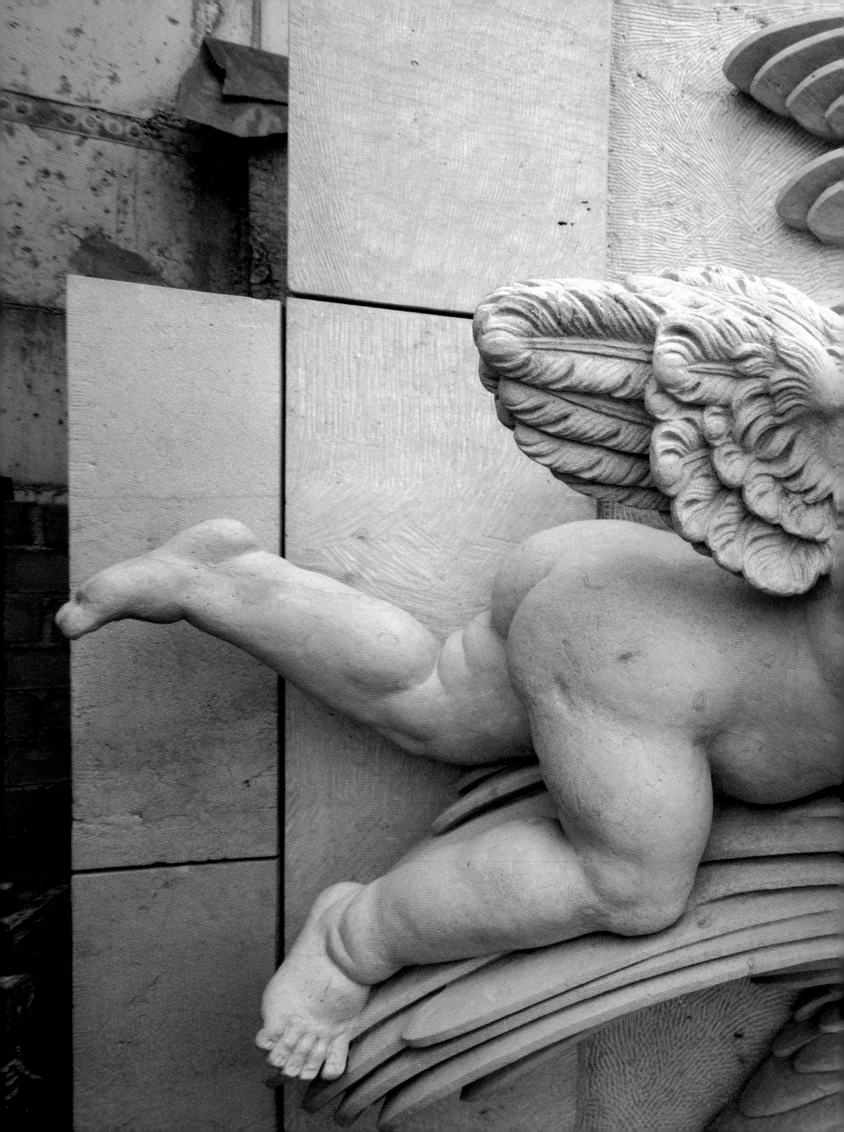

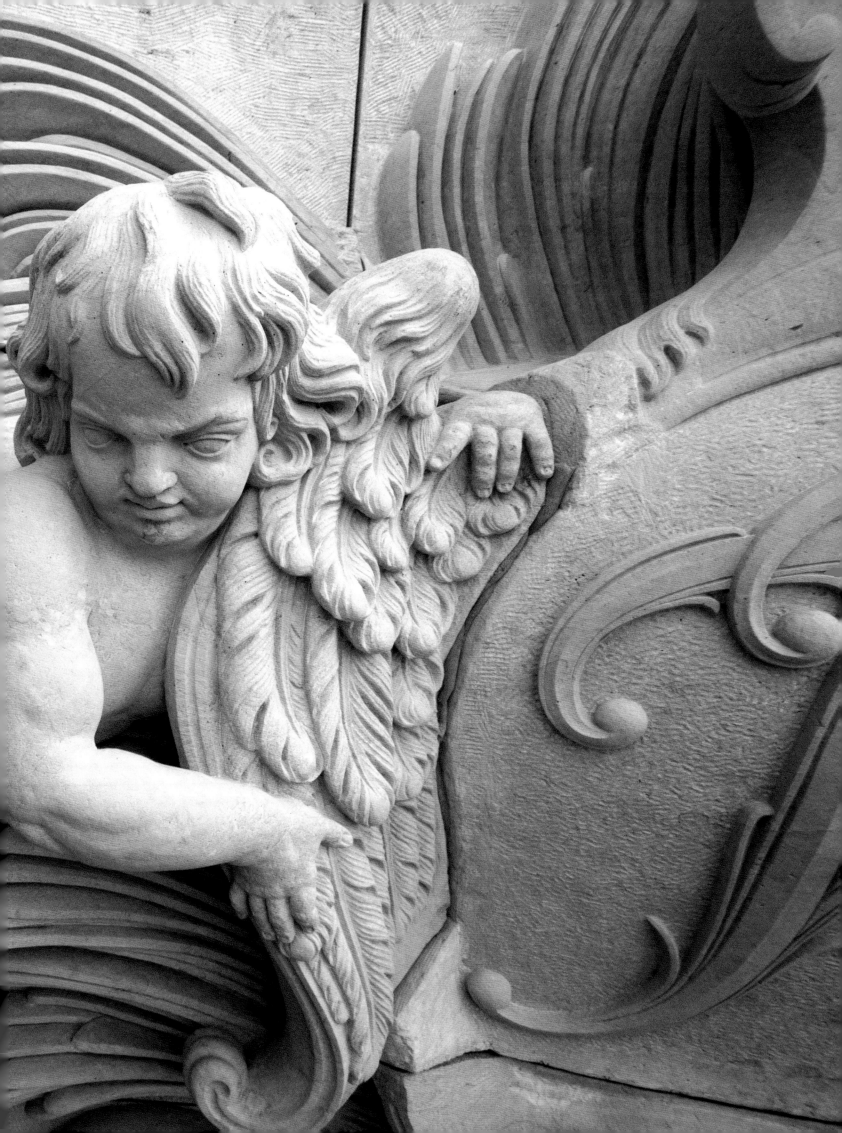

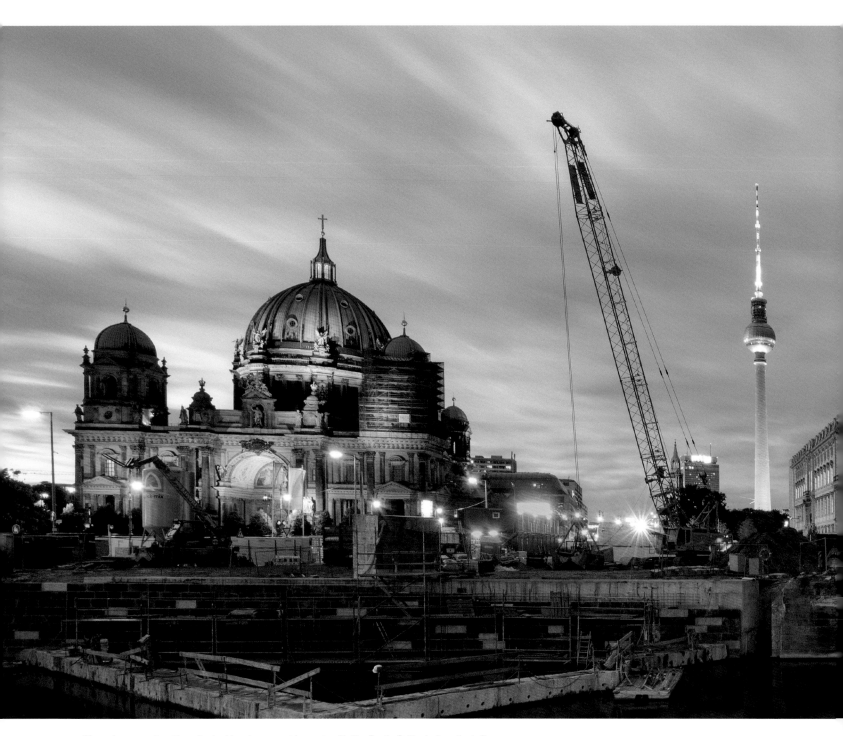

The palace construction site, looking from west to east, with the Berlin Cathedral on the left

← ← Details of the sculptural decoration on the Eosander Portal

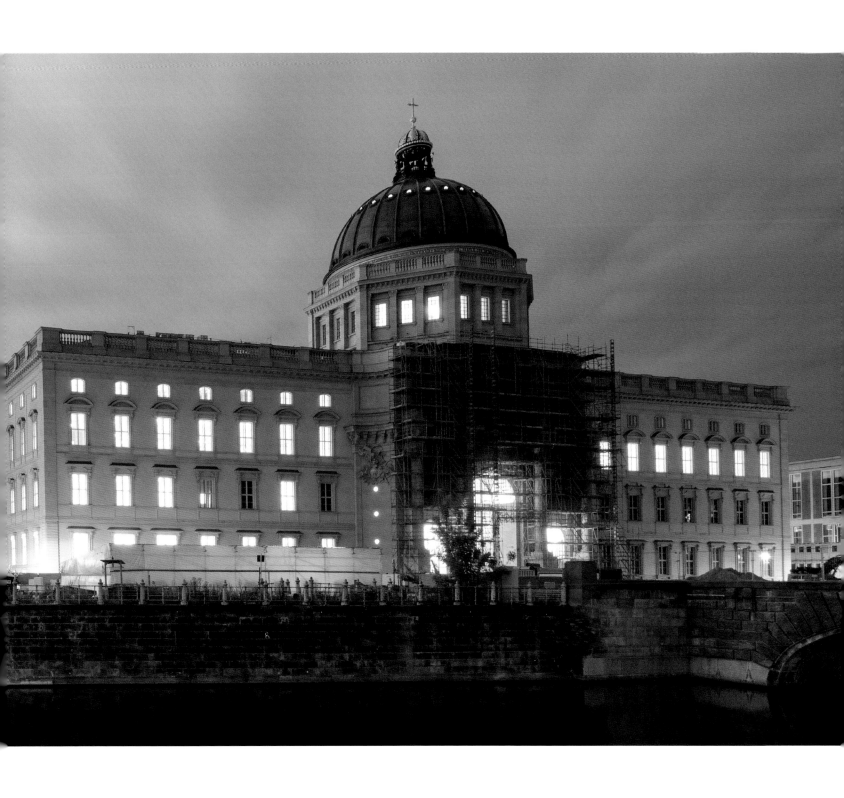

Reconstruction of the Eosander Portal →
During the construction phase on the roof of the palace, looking east with
St. Mary's Church, the television tower, the Rotes Rathaus, the St. Nicholas
Church, and the Altes Stadthaus (from left to right) → →
Reconstruction of the Lustgarten façade and the west façade → → →

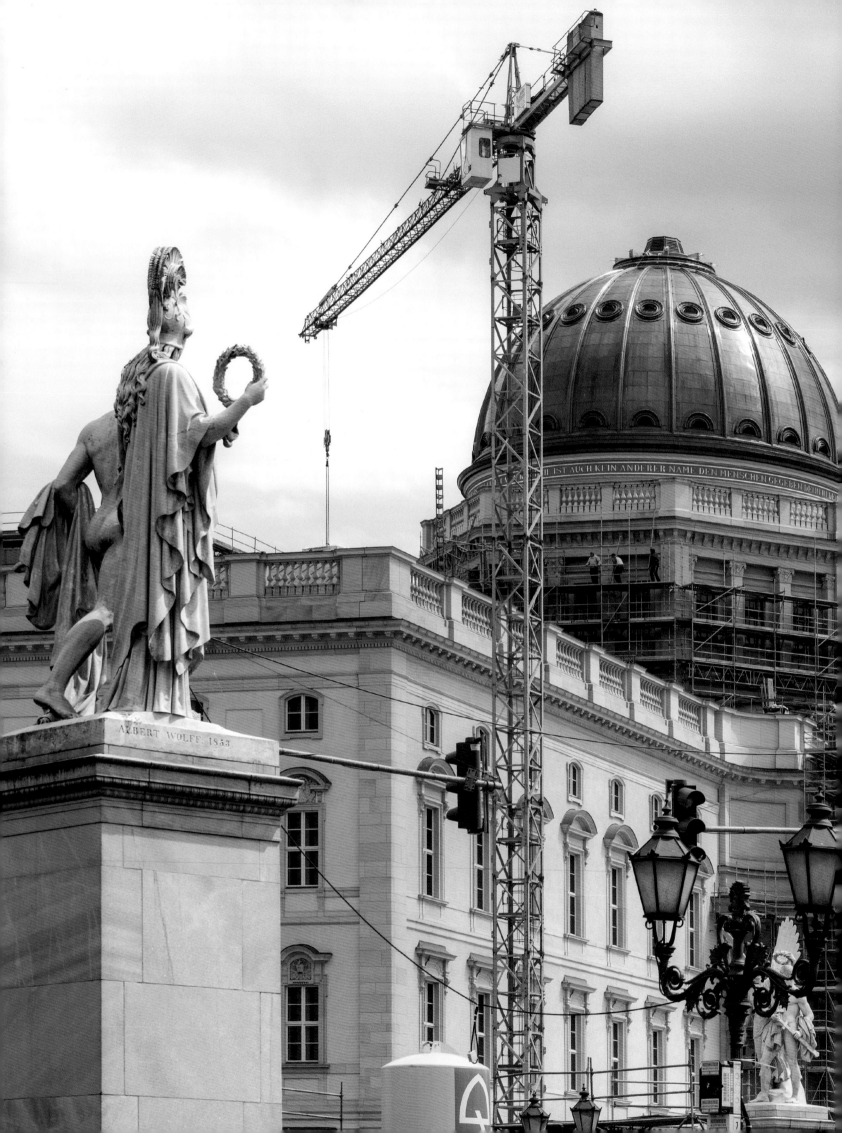

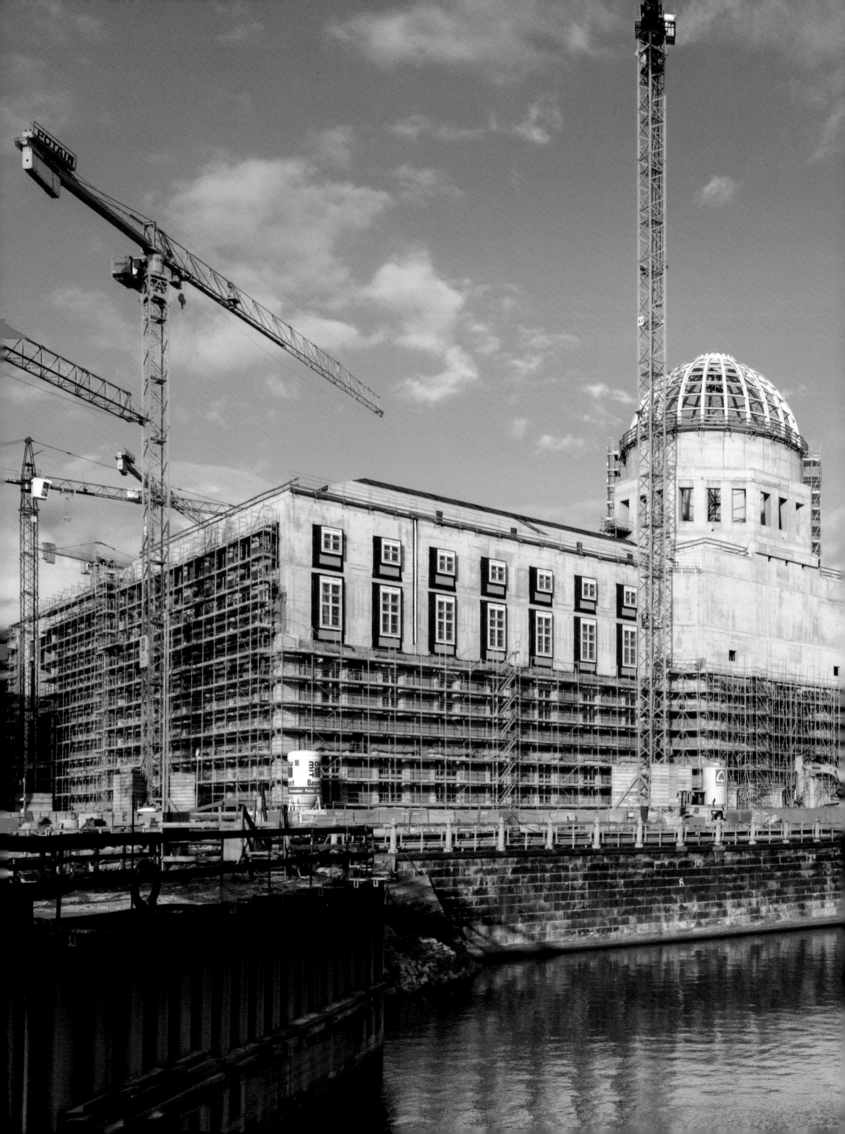

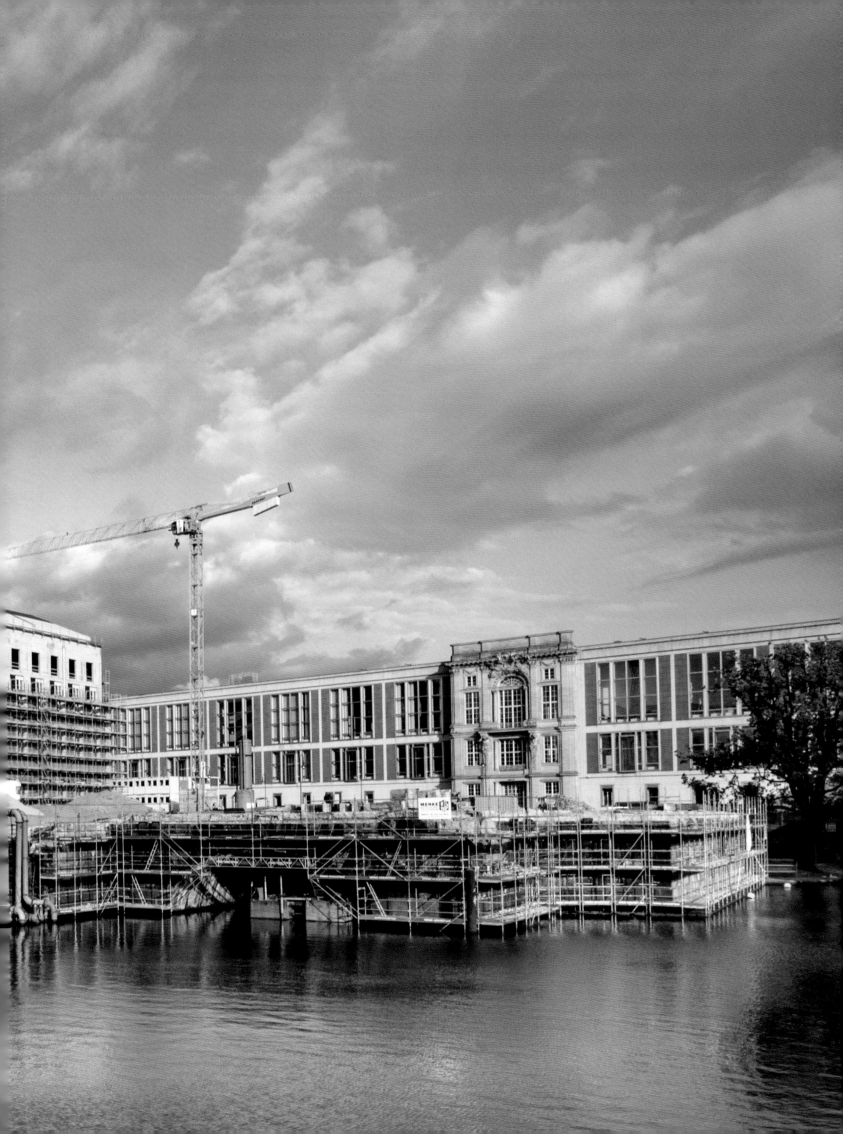

COLOPHON

Published by the Stiftung Humboldt Forum im Berliner Schloss

Photographs by
Leo Seidel
Authors: Hans-Dieter Hegner, Kathrin Lange, Bernd Wolfgang Lindemann, Franco Stella, Peter Stephan, Peter Westermann, Bernhard Wolter
Text on pages 30/31, 76-78, 116/117, 132/133, 138, 142/143:
Bernhard Wolter with Kathrin Lange

Project direction and photo concept
Kerstin Ludolph
Project management Hirmer
Karen Angne
Project management Humboldt Forum
Susanne Müller-Wolff, Bernhard Wolter
Picture editing Humboldt Forum
Barbara Martinkat
Translation from the German
Gérard A. Goodrow, Cologne
Copy-editing
Vanessa Magson, Munich
Graphic design, typesetting and production
Sabine Frohmader
Prepress and repro
REPROMAYER Medienproduktion GmbH, Reutlingen
Paper
Gardamatt Art, 150 g/m²
Set in
Din Next LT, TSTAR, Vendetta
Printed and binding
Eberl & Kœsel GmbH & Co. KG, Altusried-Krugzell

Printed in Germany

Bibliographic information published by the Deutsche Nationalbibliothek
The Deutsche Nationalbibliothek lists this publication in the Deutsche Nationalbibliografie; detailed bibliographic data is available on the Internet at http://www.dnb.de.

© 2021 Stiftung Humboldt Forum im Berliner Schloss, Unter den Linden 3, 10117 Berlin, Hirmer Verlag GmbH, Munich, and the authors
© 2021 Leo Seidel for the photographs

ISBN 978-3-7774-3217-5

www.humboldtforum.org
www.hirmerpublishers.com

Cover front:
View from the former GDR State Council Building in the direction of the Eosander Portal
Cover back:
A robed female figure and Mercury on Portal 6 in the Schlüterhof

IMAGE CAPTIONS, INTRODUCTORY PAGES

Front and back endpapers: various photographs by Leo Seidel depicting the process of reconstructing the façade.
p. 1: View onto the south façade from the former GDR State Council Building; on the right, the television tower on Alexanderplatz
pp. 2/3: Detail of the western corner of the south façade; behind this, the Friedrichswerder Church
pp. 4/5: The south façade, seen from the Rathaus Bridge
pp. 6/7: The modern east façade by Franco Stella
pp. 8/9: The modern east façade and the historic Lustgarten façade with the Liebknecht Bridge
pp. 10/11: Detail of the Lustgarten façade with Portal 5 (left) and Portal 4 (right)
pp. 12/13: View onto the Lustgarten façade from the portico of the Altes Museum; on the left, the Berlin Cathedral
pp. 14/15: Southern section of the west façade with a view of the St. Nicholas' Church towers
pp. 16/17: The Lustgarten façade and the west façade with the still scaffolded Eosander Portal; in the foreground, the Palace Bridge
p. 18: View over the sculptures of the Palace Bridge onto the Eosander Portal of the west façade; in the background, the former GDR State Council Building
p. 20: Portal 5 of the Lustgarten façade with the passage to the Schlüterhof
pp. 22/23: The Schlüterhof with a view of the courtyard side of Portal 5 with robed female figures and the sculptures of Hercules and Mercury

IMAGE CREDITS

The modern east façade as seen from the Liebknecht Bridge →

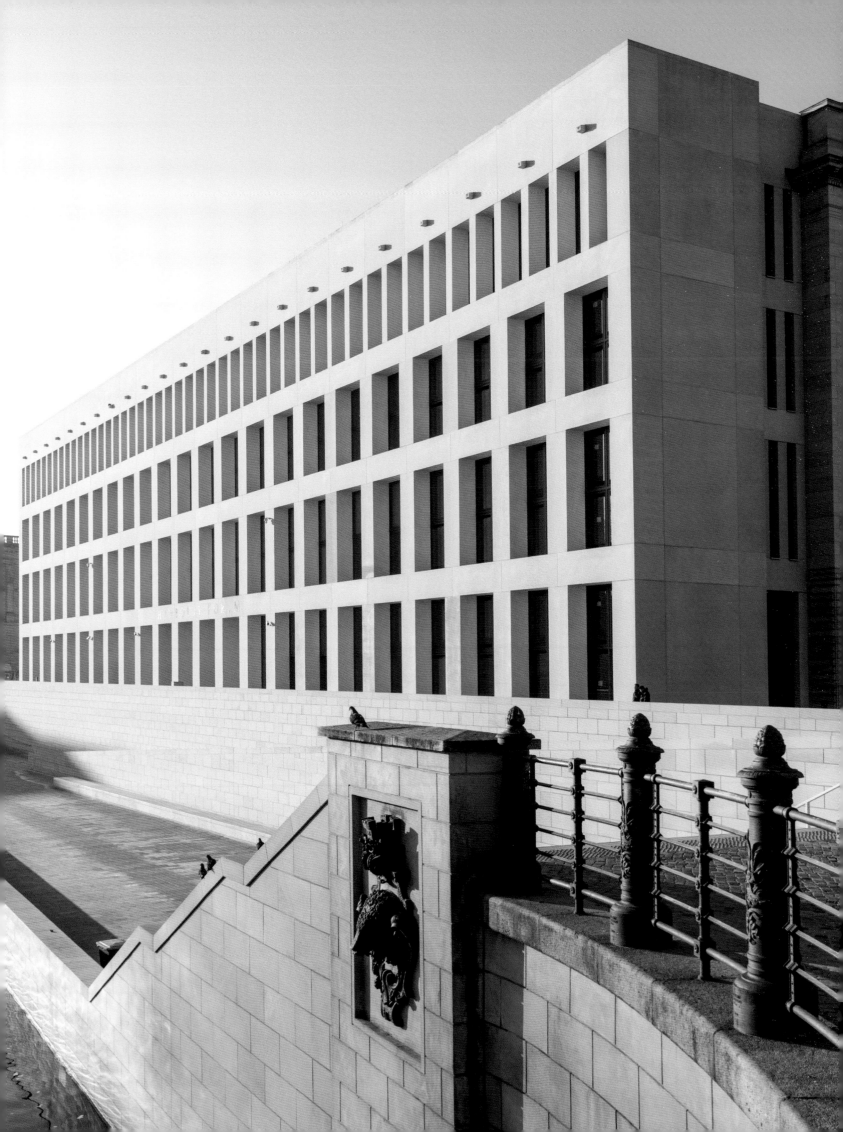

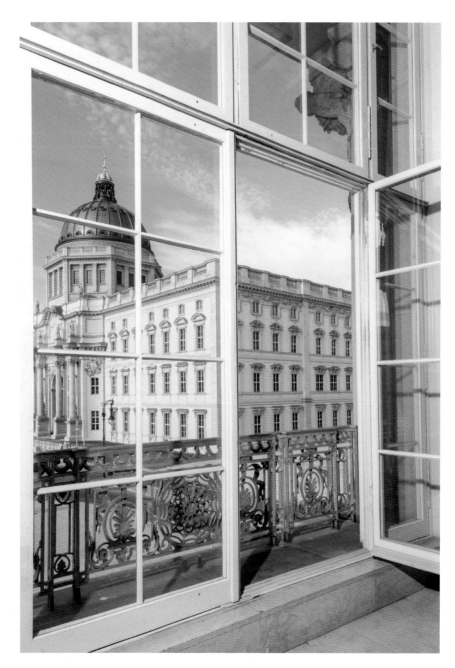

View through the largely original Portal 4 from the former GDR State Council Building in the direction of the Eosander Portal

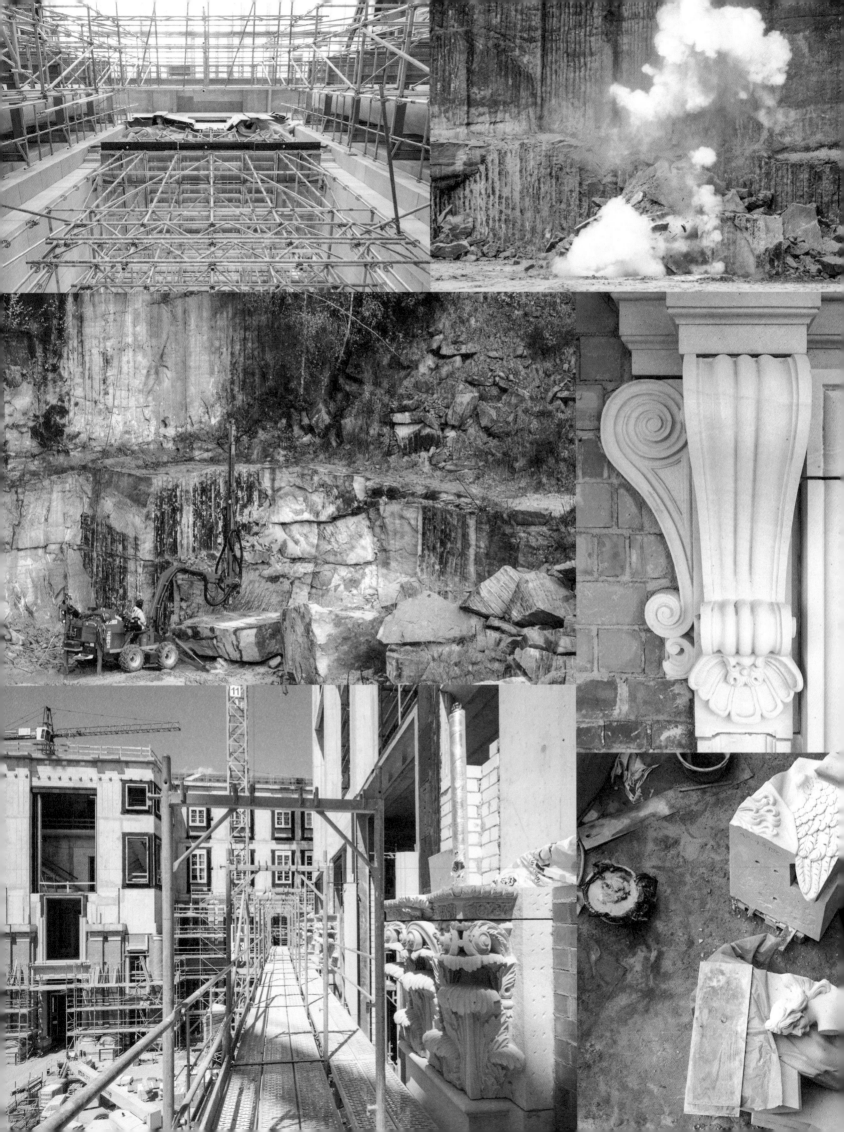